BRITISH
LANDSCAPE WATERCOLOURS
1600-1860

A gift from Sam Chestnut

to

Oreland Art Center

© 1985 Trustees of the British Museum
Published by British Museum Publications Ltd
46 Bloomsbury Street, London WC1B 3QQ

British Library Cataloguing in Publication Data

Stainton, Lindsay
 British landscape watercolours 1600–1860.
 1. Landscape painting, British—Exhibitions
 2. Watercolour painting, British, Exhibitions
 I. Title
 758'.1'0941 ND2243.G7

ISBN 0-7141-1622-X

Cover subject: Samuel Scott *St Paul's from the Thames* (no. 9)

Designed by Sebastian Carter
Set in Baskerville
by Goodfellow and Egan Ltd, Cambridge
Colour reproduction by Chelmer
Reproductions Ltd, Maldon, Essex
and printed in Spain
by Grijelmo S.A., Bilbao

Contents

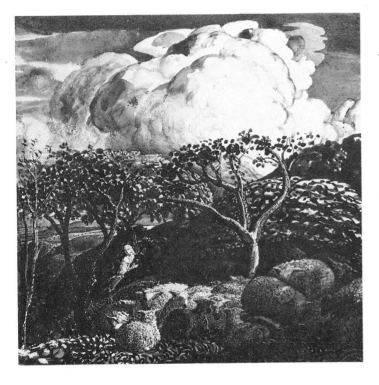

Samuel Palmer *Drawing for 'The Bright Cloud'* (no.174)

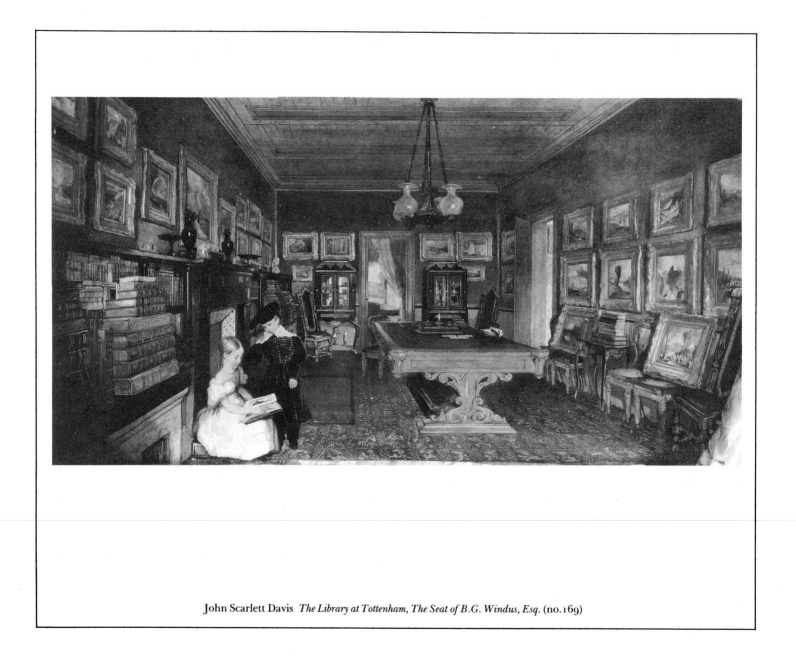

John Scarlett Davis *The Library at Tottenham, The Seat of B.G. Windus, Esq.* (no.169)

BRITISH LANDSCAPE WATERCOLOURS 1600-1860

LINDSAY STAINTON

PUBLISHED FOR THE
TRUSTEES OF THE BRITISH MUSEUM BY
BRITISH MUSEUM PUBLICATIONS LTD

Preface

The Department's holdings of British drawings are, perhaps inevitably, larger than those of any other school represented in the collections. The importance of the Old Master drawings, however, has tended to overshadow those by native artists and it is therefore perhaps not so surprising that in recent years there has been no Departmental exhibition devoted exclusively to British watercolours. The aim of this exhibition is to provide a survey of one aspect of the subject – the British landscape watercolour; it does not pretend to be a comprehensive history of the subject, but the deliberate decision not to ask for any loans enables the range of the Museum's collection to be seen and fairly assessed.

Many of the finest watercolours in the collection came to the Museum by gift or bequest; first that of Sir Hans Sloane (whose collections were to constitute the nucleus of the whole Museum) in 1753. This was followed by the bequest of the Rev. Clayton Mordaunt Cracherode in 1799, which included probably the first drawings by Gainsborough and J.R. Cozens to enter a public collection. In 1816 Francis Towne bequeathed his Roman watercolours to the Museum, the first such bequest by an artist. The next significant bequest was that of Richard Payne Knight in 1824; and in 1855 Chambers Hall presented his unrivalled collection of watercolours and drawings by Thomas Girtin. The acquisition in 1902 of the Reeve collection – the first significant purchase of a collection of English watercolours – brought to the Department a very large group by John Sell Cotman, among them several of his most celebrated Yorkshire subjects. Of subsequent bequests there are two that should be especially noted: the Salting Bequest of 1910, which included an important collection of watercolours by Turner, and, in more recent times, the Lloyd Bequest in 1958. This brought to the Museum the finest single group of Turner's watercolours for the *England and Wales* series, immeasurably enriching the Department's holdings. His anxiety to preserve the watercolours was reflected in conditions attaching to the Bequest and this exhibition provides a rare occasion to see a number of these watercolours on display.

Acquisitions in recent years have been fewer; the principle behind purchases is now chiefly to fill gaps in the collection (there is still no Alpine view by Towne, for example), and to preserve in a public collection works of the highest quality.

The organiser of the exhibition and author of this catalogue, Miss Lindsay Stainton, Assistant Keeper in the Department, has been greatly assisted in the preparation of the exhibition by colleagues in the Department of Prints and Drawings, in the Department of Scientific Research and Conservation and in the Photographic Service. Among the many individuals who have given invaluable advice are the following: in particular Mr J.A. Gere, my predecessor as Keeper of the Department, who has been kind enough to read the manuscript and to make a number of suggestions and Professor M.W.L. Kitson, whose knowledge of the wider aspects of landscape painting is reflected in the introduction. In addition, Miss Jenny Bell; Miss Frances Easton; Mr Paul Goldman; Mr Ralph Hyde of the Guildhall Library, who gave advice on questions of London topography; Miss Sheila O'Connell; Miss Emma Myers of British Museum Publications Ltd; Stephen Somerville; Miss Claudia Stumpf; Mr Andrew Wilton, who was particularly helpful with the selection of drawings to be included in the exhibition; and Mr Andrew Wyld.

J.K. Rowlands
Keeper, Prints and Drawings

Nature into Art

'I have begun to take off a pretty view of part of the village, and have no doubt but the drawing of choice portions and aspects of external objects is one of the varieties of study requisite to build up an artist, who should be a magnet to all kinds of knowledge; though at the same time, I can't help seeing that the general characteristics of Nature's beauty not only differ from, but are, in some respects, opposed to those of Imaginative Art; and *that*, even in those scenes and appearances where she is loveliest, and most universally pleasing.'[1]

Samuel Palmer is here restating the age-old problem of reconciling Nature with Art. He expresses this in the most intense and personal – and thus Romantic – way. His older contemporaries Turner, Constable and Cotman expressed similar views, but to artists of earlier periods the problem had seemed more straightforward.

Aristotle had propounded the theory that even the most beautiful natural forms were inherently deficient and were thus unsuitable material for serious art. It was the ideal of Nature that was identified with ideal beauty, not its tangible form. Reynolds, in the eighteenth century, agreed with this view, but as can be clearly seen in his *Discourses*, he elaborates upon and clarifies the theory. He builds upon the Aristotelian approach by defining what the ideal actually is. For him it can be achieved by the mental process of reducing Nature's visible form into a general one. Consequently the artist who faithfully reproduces Nature is inferior to the artist who idealises it.[2]

It was around the task of depicting the figure that the theory of ideal beauty, of the perfect state of nature, was originally evolved. Much later, during the Renaissance, when landscape, portraiture and still life became popular, a hierarchy of categories was established. History painting came first showing idealised figures taking part in some heroic or tragic story from the Bible, classical history or classical mythology and the other genres ranked in order below. At first, these genres were assumed not to require idealisation as it was foreign to their purposes. The portraitist represented an individual man or woman, not a type. The landscape painter depicted actual nature; or rather, since his compositions were often invented, he depicted naturalistic effects such as hazy distances, light on trees and light on water. Perhaps surprisingly, even such an obviously (to us) ideal landscape painter as Claude Lorrain was praised in his lifetime chiefly for his unrivalled skill in rendering these effects.

However, during the eighteenth century the principle of hierarchy began to be admitted into the minor genres themselves. The first to hint at this for landscape painting was Roger de Piles, who in his *Cour de peinture par principes* of 1709 (translated into English in 1743) distinguished between two different categories, the heroic and the pastoral or rural. In the first 'if nature appears not there as we everyday casually see her, she is at least represented as we think she ought to be', whereas in the rural style 'we . . . see nature simple, without ornament, and without artifice'.[3]

By the second half of the century, the hierarchy of landscape types was established. For example, in Salomon Gessner's *Brief an Herrn Fuesslin veber di Landschaftsmalerey*, 1770 (widely-read in England in a rough translation of 1776), the author tells how he had begun by imitating nature exactly but how this had only led him to become over-involved in detail; he then decided to follow a progressive sequence of the best masters, from the Dutch painters to Salvator Rosa and Rubens and finally to Claude and Poussin in whom he discovered 'the greatness, nobility and harmony' which his work had hitherto lacked.[4] Reynolds in his *Discourses*,[5] places landscape among the comparatively inferior branches of art, but sets out a graduated range of landscape styles. But, unlike Gessner, Reynolds was prepared

to find some merit in the work of the naturalists – 'let them [the Dutch painters] have their share of more humble praise'[6] – but he left no doubt as to where greatness lay:

'If we suppose a view of nature represented with all the truth of the *camera obscura*, and the same scene represented by a great artist, how little and mean will the one appear in comparison of the other, where no superiority is supposed from the choice of the subject! The scene shall be the same, the difference only will be in the manner in which it is presented to the eye. With what additional superiority then will the same artist appear when he has the power of selecting his materials as well as elevating his style? Like Nicolas Poussin, he transports us to the environs of ancient Rome . . . or, like Claude Lorrain, he conducts us to the tranquility of Arcadian scenes and fairyland'.[7]

Claude is no longer represented, as he had been by seventeenth-century critics, as a naturalist. On the contrary, said Reynolds, 'Claude Lorrain . . . was convinced that taking nature as he found it seldom produced beauty'.[8]

Almost wherever we look, we find the eighteenth century insisting that the good landscapist, like the serious figure painter, improves on nature[9] – a doctrine that also underlay the whole theory of landscape garden design for which the very word 'improvement' was a common synonym. The same notion runs through the literature of the Picturesque,[10] and was even more forcefully expressed in Fuseli's words of contempt for the practice of topography: he contrasts the 'classic or romantic ground' evoked by Titian, Poussin, Claude and Rubens with 'the last branch of uninteresting subjects, that kind of landscape which is entirely occupied with the tame delineation of a given spot'.[11] Even Samuel Palmer, in the same letter from which the opening passage of this essay is taken, was compelled in the end to admit that art was superior to nature, though for him the difference was one of kind rather than degree. However much he was instinctively drawn to the natural beauty which he saw every day around him at Shoreham, he was at heart a Platonist. 'Still, the perfection of nature is not the perfection of severest art; they are two things. The former we may like to an easy, charming colloquy of intellectual

friends; the latter is "Imperial Tragedy". *That* is graceful humanity; *this* is Plato's Vision'.

Nevertheless, the eighteenth-century belief in nature as an entity, as distinct from the ideal nature conceived and supposedly imitated by the artist, was very strong. Pope's couplet, 'First follow nature and your judgement frame/ By her just standard which is still the same', expressed a principle with which no British eighteenth-century painter or poet, at least until the time of Fuseli and Blake, would have disagreed, and it was always acknowledged that beautiful scenery was a source of inspiration to the landscapist. Some writers even assumed that the possession of such scenery was a direct cause of a country's excellence in this department of art. Both the Frenchman André Rouquet, in his *Present State of the Arts in England*, 1755, and the anonymous writer of the article *Paysage* in the *Grande Encyclopédie*, 1765, give the beauty of the English countryside as one reason for the success of landscape painting in Britain.[12] By the same token, it was asserted in the introduction to Earlom's publication of the *Liber Veritatis*, 1777, that the superiority of Claude's work was in part due to his access to the uniquely beautiful scenery of the Roman Campagna. To discover this scenery for themselves was undoubtedly a compelling reason for British landscape painters to study in Rome in the second half of the eighteenth century. Ever since Addison had eulogised it in *Remarks on Several Parts of Italy* of 1705, the Roman Campagna had been hallowed ground for all educated Englishmen. For Thomas Jones, who arrived in Rome in 1776, it was 'Magick land'.[13] However, in the Romantic period, Constable was to claim, with better reason than the eighteenth-century writers had shown in their equation of the standard of landscape painting with that of the scenery that inspired it, that his entire art owed its quality to a tiny area of his native Suffolk: 'Painting is but another word for feeling. I associate my "careless boyhood" to all that lies on the banks of the *Stour*. They made me a painter (and I am grateful) that is I had often thought of pictures of them before I had ever touched a pencil'.[14]

The problem of reconciling the increasing urge towards the freer interpretation of nature with the principle that

nature should not be imitated too closely was greater for the writer on art than for the literary critic. In the visual arts the Aristotelian principle of *mimesis* was more than a metaphor: it could have a literal application, and in certain types of landscape painting, namely that practised in the seventeenth century by the Dutch artists and in the eighteenth century by the British topographical school, this was precisely the application that it did have. When Reynolds advocated the imitation of ideal, not actual, nature, his warning that the two must not be confused acknowledged the necessity of the progression from one to the other. Towards the end of the eighteenth century, however, it came to be felt that nature required less in the way of alteration and improvement – a feeling that implied the rejection of the Aristotelian doctrine of perfect form residing in unstable matter on which rested the theory of ideal imitation. The doctrine collapsed under the twin assaults of natural science and the new German philosophy. Already in the theory of the Picturesque nature was acknowledged to be perfect in every respect but composition. Moreover, the Rev. William Gilpin, Uvedale Price and Richard Payne Knight defined the Picturesque in relation to the Burkean categories of the Sublime and the Beautiful, further undermining the concept of ideal imitation.[15] Price and Knight, for whom the practical application of the Picturesque aesthetic was confined to landscape gardening, were devotees of nature in the raw, the wilder and more untouched by art the better. They were also admirers of the seventeenth-century landscape painters, among whom they recognised differences in kind, not degree. They saw natural scenery in terms of Salvator, Claude, Rubens etc., and equated these with the Sublime, the Beautiful or the Picturesque, without considering any one category superior to any other. In their writing on gardening, they castigated the designers of the previous generation, above all 'Capability' Brown, for interfering with nature too much and also for failing to use landscape painting as a guide. Both Price and Knight wrote, in effect, that Claude could have taught Brown what nature really looked like:[16] a curious reversion to the seventeenth-century view of him as the supreme naturalist.

The way was now open for a wholly naturalistic approach to landscape painting. Constable's comment on visiting the Royal Academy exhibition of 1802, 'There is room enough for a natural painter (or *peinture*)' has often been quoted. His true originality may have resided not so much in what he did as in his motives for doing it. Throughout his life he urged that the aim of the landscape painter must be truth to nature in all its particularity, without deviation into 'manner' or falsification for the sake of a higher beauty. For him there was beauty and spirit enough in nature itself – and he translated this aim, sometimes with great difficulty, into his own art at all levels.

The naturalistic aesthetic dominated British landscape painting for most of the nineteenth century. Constable's own view had been expressed for the most part in private letters and remained largely unknown until the 1830s and 1840s, but by that time other artists and writers had taken up the cause. The intellectual climate was propitious, for the collapse of the philosophical basis of idealisation had allowed the British tradition of empiricism to assert itself without restraint. This tradition was in line with new forms of natural science, those most relevant to landscape painting being Geology and Meteorology, the sciences of earth and sky, and Optics, the science of light and sight. Art itself came to be considered as a branch of knowledge; Constable and Ruskin were in agreement that to draw or paint an object or scene was a means of discovering and stating the truth about it – an opinion that Turner would probably have shared. In the eighteenth century 'generalisation' had been the guiding principle; all nineteenth-century artists and critics, whatever their difference on other matters, united in substituting 'particularisation'. As Blake, neither a naturalist nor particularly interested in landscape, wrote in the margin of his copy of Reynolds's *Discourses*: 'To generalise is to be an idiot. To particularise is the Alone Distinction of Merit'. No painter of this period was able to ignore the particular, however temperamentally disposed to explore the world beyond phenomena. The Platonist, Palmer, was attracted by localised manifestations of nature's beauty, and expressed them in his art. Particular effects, in the form of minutely described natural details,

were also the starting point for the visionary landscapists Francis Danby and John Martin and were more than a starting point for Turner. A parallel can be drawn between Turner's fusion of exquisitely observed natural details with an overall poetic effect and Hazlitt's theory of the relationship between the realistic and the ideal in art, although Hazlitt was indifferent to Turner's work.[17] Hazlitt was an uncompromising champion of the naturalistic aesthetic without being an admirer of naturalistic landscape painting. His argument, directed against Reynolds, was that the ideal, far from requiring a rejection of individual particularities, was dependent on the immediate imitation of nature.[18] Ruskin also had much to say on distinctness and accuracy, specifically in relation to Turner,[19] but he returned to the contrast between lower and higher forms of imitation, though with different premises, and terminology. For him the lower form of imitation was mere 'imitation'; the higher was 'truth': 'Imitation can only be of something material, but truth has reference to statements both of the qualities of material things, and of emotions, impressions and thoughts'.[20]

There is one characteristic which the eighteenth-century fondness for idealisation would not lead us to expect. This was the popularity of topography. Topography, defined as the delineation and/or description of the features of a locality, made up well over half the output of British watercolourists before 1800 and even after that date probably not much less than a third.[21] The extent of their descriptiveness varies. Sometimes the artist depicts a complicated terrain with buildings, hills, water and evidence of human activity, drawn in detail and with a high degree of accuracy. At other times, a single recognisable feature, such as a castle or mountain, appears as the focal point of a generalised composition. In the first case, the end product is a representation of a kind of three-dimensional map; in the second, it is more like a 'view' in which the topographical features may be subordinated to the representation of a weather effect. 'Topography' is thus not an absolute term with clearly defined limits. Thus the study by Thomas Hearne of a bend of the River Teme shaded by trees on Payne Knight's estate at Downton hardly qualifies

as topography in the fullest sense of the term, nor do Constable's paintings and sketches of scenes on the River Stour. However great the accuracy with which they are represented it is significant that the general public at the time were rarely given an exact identification of the subjects of Constable's paintings.

The popularity of the topographical drawing throughout the greater part of the two and half centuries covered by this exhibition is inherent in two characteristics highly developed in British society: these are the love of travel and the concern with property. The love of travel whether at home or abroad came naturally to a trading nation; the eighteenth century enlightenment brought, in addition, a powerful thirst for information about the natural world. The importance attached to property had many roots, cultural, philosophical, economic, legal, dynastic, which are too complex to go into here.

The desire to record the impressions of travel was the basis for the first important sets of topographical watercolours produced for British patrons: Wenceslaus Hollar's *Views on the Rhine and the Danube* (1636; chiefly in the Prague National Gallery) were made for the Earl of Arundel; and the same artist's *Views of Tangier* (1669; chiefly in the British Museum), made for the British Crown. The latter were also concerned with property, since Tangier was part of the dowry of Charles II's Queen, Catherine of Braganza. Both series of watercolours are topographical in the sense of being fully descriptive. In detail, and with great clarity, relying on only the most discreet compositional aids, they explain the lie of the land and its relationship to the water, and the placing of the various buildings including (in the Tangier views) fortifications and harbour installations. In Hollar's watercolours we find other features that became recurring characteristics of the topographical drawing. The most important, if the most obvious, was the practice of making two drawings of each subject, a sketch executed on the spot and a finished watercolour worked up afterwards. So firmly did this take hold that it was still Turner's method in his late Swiss watercolours of the 1840s. (This is not to say that there was not a great difference in *style:* furthermore

Turner's habit was to make numerous rapid pencil sketches from which he would select a few to be worked up into finished compositions; Hollar, one feels, had chosen his final subject from the start.)

The practice of executing a watercolour in two or more stages had other consequences. For example, professional artists – even Girtin and Turner – were sometimes commissioned to produce finished watercolours on the basis of on-the-spot drawings by amateurs. Even as late as 1800 some doubt was felt as to whether a watercolour intended to be a work of art in its own right – not necessarily a 'finished' watercolour in the conventional sense – should be executed directly from nature. There are suggestions in Cotman's letters that this practice was unusual,[22] and the problem is one that concerns all British watercolourists of the period. Turner's many sketchbooks contain watercolours in varying stages of completion, but do not provide a clear answer, and Girtin's habits in the matter are completely mysterious. But the step from working out of doors to executing a finished watercolour in an inn-room on the same evening, or on a rainy day, was not a great one; in any case, the artist did not necessarily have to wait to get back to his studio. The dates on some of Hollar's finished views of the Rhine and the Danube show that they were executed during the journey.[23]

Engraving served as a natural link between the topographical artist and his audience. The subject matter of topography was, by definition, of interest either actually or potentially to a comparatively wide public but if there was no outside interest, and hence no market, the topographical artist had to rely on a patron. This was the case with views of the Swiss Alps in the 1770s and 1780s. William Pars visited Switzerland in 1770 with Lord Palmerston; J.R. Cozens in 1776 with Payne Knight and in 1782 with William Beckford. Both artists were able to find other private buyers for their finished watercolours of the mountains, and some of Pars's views were engraved, but there was no significant market. It is surely noteworthy that the third British artist to visit Switzerland in these decades, Francis Towne, did not have a patron, and that his Alpine views are as few in number as they are remarkable in style.

Even in the early nineteenth century there was little demand for engravings of Alpine scenery, and Turner's great series of watercolours made after his Swiss tour of 1802 were executed as finished works to be framed and hung, almost all for one patron, Walter Fawkes. Indeed, the patron played a crucial role, whether providing an artist with the experience of travel, acting as his host, buying his work or employing him as family drawing-master. All this is not to say that the relationship between artist and patron did not become freer as time wore on. Whereas Cozens and Pars had been treated as little better than servants, Turner's position was more that of an independent man of business.

Another important aspect of topographical drawing was military surveying and several eighteenth-century watercolourists were employed as military draughtsmen. The first great watercolourist of the British school, Paul Sandby began his career as draughtsman attached to the military survey of the Scottish Highlands carried out by the Duke of Cumberland after the defeat of the Jacobite rebellion in 1746. He afterwards became drawing master at the ordnance depot in the Tower of London and later still principal drawing-master at the Royal Military Academy, Woolwich.[24] Francis Place (1647–1728), a friend and admirer of Hollar was one of the first landscape artists to visit the remoter parts of the British Isles.[25] He had an eye for landscape, usually with a town on the skyline, and he made numerous pen and wash drawings in a style derived ultimately from Hollar, of views in the north of England, Wales and Ireland. In fact topographical landscape painting in Britain in the late seventeenth and early eighteenth centuries was dominated by painters in oil, the so-called 'estate cartographers'. These artists, notably Knyff and Siberechts, were of Dutch or Flemish origin, and specialised in bird's-eye views of country houses set in pleasure-grounds neatly fenced off from the encircling countryside.[26] Place's drawings remained unpublished and unknown, and the beginnings of a comprehensive topography of Britain or – to be precise – of British antiquarian remains, fell into the clumsy hands of the brothers Samuel and Nathaniel Buck. Between about 1720 and 1750, they produced over

500 engraved views of ruined abbeys, castles, cities and towns, all, so they claimed, based on drawings made in front of the buildings themselves. It was also with these views that topography first became closely linked with engraving.

Up till now the phrase 'topographical landscape' has been used interchangeably with 'topographical view' or simply 'view'. But these terms had now begun to connote slightly different meanings. 'Topography' has to do with the content and function of a visual image; 'view' with its composition. 'View' is the same word as the Italian *veduta*, and it was from Italy, in the second half of the eighteenth century, that there came an impetus towards idealisation that raised British topographical landscape to the level of an art form. The main focus of interest is placed in the middle distance; the eye is carried across the foreground and beyond the middle distance to the sky immediately above the horizon, which is the area of greatest light. The principal exponent of this type of composition was, of course, Claude Lorrain.[27] He himself seldom depicted actual views, but his convention was easily adapted to the purposes of the topographer. Topography came to share some of the characteristics of ideal landscape, not merely in composition but in sentiment: the soft and varied light, the pervading air of amenity and repose and the sense of a landscape at peace with itself. These qualities, no less than Claude's compositional methods, could be adapted to the placid landscape of the Midlands and Home Counties and to the more dramatic scenery of Wales and the Lake District.

The other main category of landscape of Italian origin was the *veduta* proper, brought to England by Canaletto in the 1740s, when he painted views of the Thames, Whitehall, Eton, Warwick Castle and other places. His Venetian views were also widely popular among English collectors. It is not too much to say that Canaletto 'launched' urban topography in England, but here it was taken up almost entirely by watercolourists. Just as Claude's conventions were adapted to the English countryside, so Canaletto's served to present clear, sharp, well-drawn and brightly coloured views of the new streets and squares of Georgian London and other cities.

The watercolourists most directly inspired by the example both of Claude and Canaletto in the third quarter of the eighteenth century was Paul Sandby. This is not to say that he was a *pasticheur*, for his style did not depend so much on direct copying of their compositional patterns as on his grasp of the principles that underlay them: the importance of balance in a composition, the value of creating a vista not necessarily at right angles to the picture plane, the use of silhouette, the principle of 'unity in variety' and, above all, the importance of the pellucid light of the sky. Sandby understood and exploited better than any other artist – except perhaps for Turner – the special quality of the watercolour medium – its transparency.

Although they differed in style from Sandby and from each other, the artists who worked in and around Rome at this time – Pars, J.R. Cozens, Towne, Warwick Smith and Thomas Jones – can legitimately be discussed in this context. They too borrowed fundamentally (not superficially) from Claude but only Cozens directly imitated his compositions; for the others, Gaspard Dughet was more of a model. But all followed the same underlying principles: a feeling for clarity and order, for the relation of parts to the whole, for the balance of form against form and light against dark, for the unifying power of light. Being nearer to the source, so to speak, than Sandby, these artists had a stronger sense of monumental form and – particularly evident in Towne – a love of block-like shapes. Their attitude to the topography of Italy was distinctive. With the exception, once again, of Cozens, these artists tended to ignore grand vistas, such as views across the Roman Campagna from Tivoli or the Bay of Naples. They treated cities as places to walk about in, the characteristic experience of which was the sight in close-up of small hills, roads passing by garden walls, classical ruins and modern churches and palaces glimpsed through trees, in short the characteristics of *rus in urbe*. Although Sandby, Towne, Pars, Cozens and the rest would have been regarded in their own day as practitioners of an inferior branch of landscape painting[28] (as watercolour itself was considered an 'inferior' medium), they too were not unaffected by the contemporary desire to create a superior and more beautiful kind of nature; but they

achieved this aim not so much by the adoption of recognised ideal style as by the imposition of a sense of order.

Meanwhile, an alternative aesthetic had emerged, which, while not overturning this order, had the capacity to muddle it up. This, of course, was the Picturesque.[29] The Picturesque was not a theory of art but a theory of vision. To be more precise, it was a set of rules for looking at nature; a question of 'art into nature' rather than 'nature into art', though the two were so close, indeed opposite sides of the same coin, that they were often confused. Gilpin defined 'Picturesque Beauty' (a term he invented) as 'that kind of beauty which would look well in a picture', but he did not specify the type of picture that he had in mind. This enabled a whole range of artists' styles to be used as criteria either for judging a natural landscape or as models to guide other artists. For the second purpose an amalgam of styles served, reduced to their lowest common denominator; this was certainly Gilpin's own practice, and he illustrated the books which he published from 1782 onwards – the *Observations on the River Wye, (or The Mountains and Lakes of Cumberland and Westmoreland, etc,) relative chiefly to Picturesque Beauty* with compositions simple enough to be comprehended and imitated by the sort of reader he had in mind, the 'traveller with a pencil'. It was in composition, it will be remembered, that Gilpin thought nature usually required adjustment – or 'cooking', as John Varley put it in one of his drawing manuals for amateurs.[30] Otherwise, provided the light was right – varied – and the season was right – autumn – nature performed very well on her own.

One point about which all writers on the Picturesque were agreed was that its main characteristic was the combination of 'roughness and variety'. In any book on British landscape watercolours the late eighteenth century section gives the impression of being a series of compositions of shaggy trees crowding in on cottages angled to display the greatest possible variety in their roof lines (while Gilpin disliked cottages, Uvedale Price and others recommended them). Michelangelo Rooker, Thomas Hearne, Dr Thomas Monro and Henry Edridge exemplify this type of Picturesque, and so, of course does Gainsborough, though what for others was merely a pictorial *cliché* was for him a

vehicle for poetry. Gainsborough knew Price in Bath in the early 1760s and went on expeditions with him into the country; Price was a much younger man, and it has been suggested that Gainsborough probably influenced his theory of the Picturesque.[31] The descriptions of scenery that Price cites as model examples of the Picturesque closely resemble Gainsborough's landscape paintings and drawings. Painters, like travellers to the Lake District, responded to the qualities of the Picturesque long before its codification into a theory. There were few British landscapists of the second half of the eighteenth century (with the possible exception of Towne) who were not to some extent affected by the taste for the Picturesque, which affected topographers and non-topographers alike and blurred the distinction between them.

The Picturesque, as an enhancement of travel and widely diffused fashion, had sharpened appreciation of natural scenery. Once provided with an appropriate vocabulary and standards of visual comparison, people learnt how to look. But these elaborately formulated aids to vision soon became a hindrance rather than a help to the more original minds of the time. Picturesque comparisons and a list of characteristics to watch out for took the observer only a certain distance. As an aesthetic of purely visual sensations, the Picturesque inhibited the deeper understanding of nature. One of the earliest protests is in Wordsworth's *The Prelude* (1805), where the poet regrets the insidious effect which Picturesque stock responses had had on his recollection of profound early experiences.[32] The same reaction showed itself in painting even earlier, towards the end of the 1790s, the decade in which the popularity of the Picturesque reached its height.[33] Specifically, this reaction can be seen in certain watercolours by Girtin and Turner.

It is widely agreed that these watercolours marked a new departure in British landscape painting. What was this change, other than a reaction against the Picturesque? In the first place, there was the important technical development by which watercolour painting took the place of tinted drawing. Instead of adding thin washes of colour to an already more or less complete monochrome drawing, executed in pencil or pen and ink and varying tones of

grey wash, the artist now applied colour more boldly and directly to the paper. Shadows are rendered as darker tones of the same colour as the form on which they fall, rather than by letting the grey show through from underneath. This led for a time to the use of superimposed washes of colour, as we see in the work of Girtin and in the earliest works of the longer-lived Cotman, Cox, Varley and De Wint. Another method of creating tonal variations, pioneered by Turner in his pre-1800 watercolour sketches, was to begin a wash with a strong, dark colour, having a sharp edge, and afterwards to let the wash become lighter and more transparent. Yet another method, also initiated by Turner, was to run one wash into another while the first was still wet. Both these latter methods were taken up by De Wint, in his mature work, and by Bonington. A further device was to introduce highlights by leaving small gaps between the washes or by wiping out with a damp sponge parts of a wash already applied, or even by scratching out with a knife.

These technical innovations produced a style of landscape watercolour of much greater power and vitality than any that had existed before. Colours were richer (not necessarily brighter), tone-contrasts stronger, and forms given greater fluidity. Girtin's forms are relatively contained, but Turner's are treated with the utmost freedom. Both artists achieved in their watercolours a breadth and monumentality and a variety in composition which owed something to the study of paintings by the Old Masters. The new techniques enabled them to depict phenomena that had hardly been seen before in landscape painting. This is particularly evident in their rendering of cloud formations and of complex, transient weather effects, and above all in mountain landscapes. The sky often dominates the composition, and throughout romantic landscape painting is treated with heightened interest both as a phenomenon deserving of study in its own right and as a pictorial element.[34]

Though technical advances made new attitudes to landscape painting possible, they cannot be said to have caused them. The two developments went hand in hand. The barrier to an understanding of nature set up by the Pictur-esque concentration on externals was replaced by a desire to understand nature from within. This was paralleled by the discoveries of natural science. Turner's feeling for the geological structure of mountains, revealed first in 1798 in his North Welsh views, is something quite new in art; at the same time, scientific investigation was beginning to reveal nature as the outcome of a continuous evolutionary process rather than as a static model of universal order. The descriptive mode of eighteenth-century 'tinted drawing' had been well suited to imitating that kind of order, just as it had been suited to idealising a view of a country estate or reproducing the irregular outlines characteristic of the Picturesque. The new conception of the evolutionary process of nature inspired a landscape art both more dynamic and more penetrating. The 'inner life' of nature became one of the prime concerns of romantic writers and artists in Britain and Germany. It is significant that the German scientist and amateur artist, Karl Gustav Carus should have wished to substitute for the passive word 'landscape' the awkward but more expressive term *Erdlebenbildkunst* ('painting of the life of the earth').[35]

How far British artists consciously shared these preoccupations is hard to say. Certainly, there is little overt symbolism in British Romantic landscape painting. What Lorenz Eitner has said of Constable might be said of all that artist's contemporaries except possibly Palmer and his friends at Shoreham: 'In contrast to the Germans, Constable refrained from dramatising the type of spirit which he, like them, sensed in nature, through outright symbolism or stylistic devices'.[36] Furthermore, it is unwise to assume that the attitude of writers and artists, however close the parallels, were identical, especially when there was no personal connection between them. Wordsworth's belief that it is the contemplation of the humblest objects in nature, – a daffodil for example – that enables us to see 'into the life of things' would not have been echoed by most German thinkers. Constable, equal to Wordsworth in his power of empathy with nature, identified the spirit of nature, not with an autononous living force, but with the presence of God; as, in his own way did Ruskin. Turner, by all accounts a man without religious belief, is credited with one cryptic remark

on the subject, uttered on his death bed: 'The Sun is God'.[37]

Even on a purely artistic level, there are differences between Constable's conception of truth to nature and what can be inferred of Turner's and that of other great watercolourists. For Constable, truth to nature was supreme, but for the others it appears to have been only one consideration among several. These included design, colour, movement, poetic content; rather a traditional list, in fact. Yet these artists were united in approaching nature on the basis of personal experience in expressing; – in their art if not always in words – their understanding of nature's processes as well as her superficial appearances; and in giving their work animation and breadth. Ruskin's already quoted definition of truth as distinct from imitation (for all that its terminology discouraged understanding of the seventeenth-century masters) is not a bad summary of the approach to landscape painting of the British artists of his own time: 'but truth has reference to statements both in the qualities of material things, and of emotions, impressions, and thoughts.'

It was Ruskin who, in his extended investigation of Turner's art in *Modern Painters* (1843–60), identified not one but many truths. Some of these are repetitive – truth of clouds, of vegetation, water etc. – but among them is the recognition of a truth that may be inferred from Turner's mature and finished watercolours. This is the truth which Ruskin called 'quantity in the universe'. Ruskin summarises Turner's second period, the 'Years of Mastership', 1820–35, thus: 'Colour takes the place of form. Refinement takes the place of force. Quantity takes the place of mass.' Quantity he defines in terms of the sheer number of objects in nature that Turner depicted. 'He had discovered, in the course of his studies, that nature was infinitely full . . . He saw there were more clouds in any sky than ever had been painted; . . . and he set himself with all his strength to proclaim this great fact of quantity in the universe.'[38]

Ruskin's admiration for Turner's power of rendering nature's infinity of detail while retaining his grasp of the whole became the basis of his more general statement that detail should be pursued for its own sake, as a moral act carried out from a sense of duty to God's creation. At the end of the first volume (1843) of *Modern Painters*, there is a famous paragraph which tells the artist 'to go to nature in all singleness of heart . . . , rejecting nothing, selecting nothing, and scorning nothing'. This caught the eye of the nineteen-year-old Holman Hunt who felt it had been written specially for him. It became the essential article of belief for the Pre-Raphaelites in their approach to landscape painting, with some examples of which the present exhibition closes.

At the beginning of this essay we saw Palmer puzzling over the problem of translating nature into art. It was suggested there that other artists experienced the same difficulty. Here is Constable: 'It is the business of the painter not to contend with nature and put this scene (a valley filled with imagery 50 miles long) on a canvas of a few inches, but to make something out of nothing, in attempting which he must almost of necessity become poetical'.[39] In Cotman's letters from Rokeby in 1804 we read of his struggles to capture 'Nature, that ficle Dame' in watercolour studies made out of doors.[40] Turner, characteristically, took a more positive attitude, and one – it must be said – that except for its stress on the practicable is not all that far from Reynolds: 'He that has that ruling enthusiasm which accompanies abilities cannot look superficially. Every glance is a glance for study: contemplating and defining qualities and causes, effects and incidents, and develops by practice the possibility of attaining what appears mysterious upon principle. Every look at nature is a refinement upon art. Each tree and blade of grass or flower is not to him the individual tree grass or flower, but what [it] is in relation to the whole, its tone, its contrast and its use, and how far practicable: admiring Nature by the power and practicability of his Art, and judging of his Art by the perceptions drawn from Nature.'[41]

The problem had become acute for the artist of the Romantic period because then there were no longer any generally accepted rules. All the same, it was salutary that the problem was felt to exist; it is, after all, as Sir Ernst Gombrich showed nearly 25 years ago in *Art and Illusion*, a very real one. Those artists who forgot about it or came to

believe that it was a chimera, and who felt that all the landscapist had to do was to sit down and draw what happened to be in front of him, brought about the noticeable decline in quality of much Victorian watercolour painting. The phrase 'the innocence of the eye' introduced in Ruskin's most Pre-Raphaelite book, *The Elements of Drawing* (1857), has a good deal to answer for.

NOTES

1. Letter to John Linnell from Shoreham, 21 December 1828
2. See Sir Joshua Reynolds, *Discourse III*, 1770
3. Quoted from E.G. Holt *Literary Sources of Art History*, Princeton, 1947, p.406. E.H. Gombrich, 'The Renaissance Theory of Art and the Rise of Landscape', *Norm and Form*, London, 1966, pp.107–21, has found the sources of De Piles's distinction in Vitruvius, but his suggestion that the ancient author considered one category of landscape superior to another could be disagreed with.
4. *New Idylls by Gessner, translated by W. Hooper MD, with a Letter to Mr Fuslin on Landscape Painting*, London 1776, p.96.
5. Sir Joshua Reynolds, *Discourse XIII*, 1786.
6. Sir Joshua Reynolds, *Discourse IV*, 1771.
7. Sir Joshua Reynolds, *Discourse XIII*, 1786.
8. Sir Joshua Reynolds, *Discourse IV*, 1771.
9. An exception is Hogarth, followed by Diderot. But Hogarth was not primarily concerned with landscape.
10. *Observations on the River Wye*, London, 1782. Quoted from the 5th edition, London 1800, pp.30 f.
11. *Lectures on Painting* IV, 1805 . . . Quoted from Eudo C. Mason, *The Mind of Henry Fuseli*, London, 1948, p.285.
12. Rouquet, *op.cit.*, p.59; for the article in the *Grande Encyclopédie*, see the essay by Gombrich cited above, note 3. The comments by these French authors are at variance with Horace Walpole's better known lament that 'in a country so profusely beautified with the amenities of nature, it is extraordinary that we have produced so few good painters of landscape . . . Our ever verdant lawns, rich vales, fields of haycocks, and hop-grounds, are neglected as homely and familiar objects'. (*Anecdotes of Painting in England*, vol. IV, 1771, p.64–5). But the reasoning behind all three observations is the same.
13. See Jones's 'Memoirs', ed. A.P. Oppé, *The Walpole Society*, vol. XXXII, 1946–8, p.55.
14. Letter to John Fisher, 23 October 1821.
15. This was much to the puzzlement of Reynolds, who in one of his last letters, written in acknowledgement of Gilpin's *Three Essays: On Picturesque Beauty*, 1792, said that he could not understand what all the furore was about; to him the Picturesque seemed merely one of the inferior branches of landscape.
16. Uvedale Price, *Essays on the Picturesque*, vol. I, London, 1810, p.121. *Cf.* Knight on Claude in *The Landscape: A Didactic Poem*, 1794: 'Nature's own pupil, fav'rite child of taste'.
17. '[His] pictures are however too much abstractions of aerial perspective, and representations not properly of the objects of nature as of the medium through which they were seen . . .', *The Examiner*, 1816. (Quoted by A.J. Finberg, *The Life of J.M.W. Turner*, 2nd ed., 1961, p.241)
18. 'It appears to me that the highest perfection of art depends, not on separating, but on uniting general truth and effect with individual distinctness and accuracy', 'The Fine Arts', article written for *The Encyclopedia Britannica*, 1816.
19. This is not to forget Turner's Reynoldsian definition of landscape painting in his *Backgrounds* lecture first given in 1811 – 'To select, combine and concentrate that which is beautiful in nature and admirable in art is as much the business of the landscape painter in his line as in the other departments of art' – nor his creation of the category 'E.P.' (elevated or epic pastoral) in his *Liber Studiorum*. Both these can be attributed to his love of tradition, which was, however, only one aspect of his complex, fragmentary and to a large extent pragmatic theory of art. For the *Backgrounds* lecture, see J. Ziff, 'Backgrounds, Introduction of Architecture and Landscape', *Journal of the Warburg and Courtauld Institutes*, XXXVI, 1963, pp.124–47.
20. *Modern Painters*, vol. I, 1843 (*The Works of John Ruskin*, ed. E.T. Cook and Alexander Wedderburn, vol. III, London, 1903, p.104).
21. For instance, of the watercolours in this exhibition, at least 85% might be described as topographical or topographically based.
22. See no. 122 in this exhibition.
23. In connection with Hollar's views on the Rhine and Danube, it has recently been suggested (A. Griffiths and G. Kesnerová, *Wenceslaus Hollar Prints and Drawings*, exhibition catalogue, British Museum, 1983, p.24 note) that these were never intended to be engraved.
24. As this sequence of events illustrates, military surveying became a lower and strictly utilitarian branch of topography; a necessary accomplishment for army officers, but no longer an occupation for artists. It is worth recalling, however, that the first British 'artists' in Spain, hitherto a country rarely visited by British travellers, were officers of Wellington's army taking part in the Peninsular Campaign (1808–13).
25. Place was of the same generation as those first literary explorers of Britain, Celia Fiennes and Daniel Defoe, who took little interest in uncultivated scenery, but were fascinated by towns, agriculture, industries and local customs. See Esther Moir, *The Discovery of Britain, 1540–1840*, London 1964.
26. See John Harris, *The Artist and the Country House*, London, 1979.
27. John Barrell in *The Idea of Landscape and the Sense of Place. . .*, Cambridge, 1972, demonstrates effectively that the foregoing was the aspect of Claude's compositional approach which struck eighteenth-century painters and poets.

28. It is interesting that Gainsborough, although appreciative of Sandby's 'genius', disapproved of the style of landscape he practised.

29. Although much has been written about the cult of the Picturesque and its personalities, very little of value has been noted about its impact on landscape painting. Peter Bicknell's catalogue to the exhibition, *Beauty, Horror and Immensity*, Fitzwilliam Museum, Cambridge, 1981, is a most valuable exception.

30. See *ibid*, p.33.

31. John Hayes, *The Landscape Paintings of Thomas Gainsborough*, vol. 1, London, 1982, p.163. Hayes also draws attention to an article in *The Repository of the Arts*, 1813, suggesting that it was really Gainsborough's sketches which created the taste for the Picturesque.

32. The cult of the Picturesque became a target of satire, which started in about 1810: the best known being William Combe's *The Tour of Doctor Syntax, in search of the Picturesque. A Poem*, first published in *The Poetical Magazine*, 1809–11. See Bicknell, *op.cit.*, p.44.

33. This was first suggested by John Gage in 'Turner and the Picturesque', *Burlington Magazine*, CVII, 1965, pp.18–25, 75–81.

34. Several of the characteristics described in this paragraph are already to be found, if not fully developed, in the work of J.R. Cozens. Cozens remained a fairly typical eighteenth-century artist from the point of view of technique, but partly anticipated the nineteenth century in his pictorial interests. Girtin and Turner gained an intimate acquaintance with his work while copying his drawings for Dr Monro.

35. Extracts in English translation from Carus's pamphlet *Nine Letters on Landscape Painting*, 1831, are published with a brief but valuable commentary by L. Eitner in *Neoclassicism and Romanticism*, vol. II, 1970, pp.47–52 (*Sources and Documents in the History of Art* series).

36. *Ibid*, p.61.

37. The source of this famous utterance is Ruskin, who quotes it in *Fors Clavigera* without comment; see *Works*, ed.*cit.*, vol. XXVIII, p.147.

38. *Ibid.*, vol. XIII, p.129.

39. Letter to John Fisher from Brighton, 29 August, 1824 (*John Constable's Correspondence*, ed. R.B. Beckett, 1962–75, vol. VI, p.172). Constable was evidently contemplating a painting of the Sussex Downs, a project which he did not take further.

40. See no. 122 in this catalogue.

41. Quoted from A.J. Finberg, *The Life of J.M.W. Turner RA*, 2nd ed., Oxford, 1961, p.230.

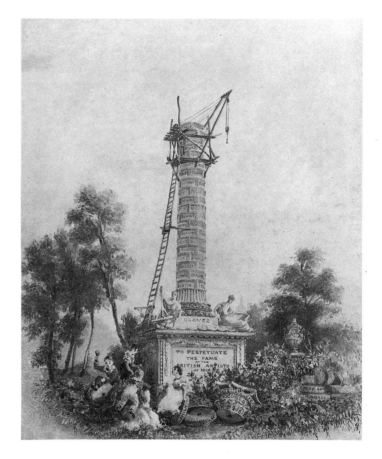

James Prinsep *A Monument to perpetuate the Fame of British Artists of 1828* (no.161)

The Catalogue

Joris Hoefnagel 1542–1600

1 *Nonsuch Palace, Surrey*

Pen and ink with brown wash and watercolour; 220×464mm
Inscribed: *PALATIVM REGIVM IN ANGLIAE REGNO APPELLATVM NONCIVTZ Hoc est nusquam simile* and signed: *Effigiauit Georgius Houfnaglivs Anno 1568*
1943-10-9-35 Bequeathed by P.P. Stevens *Plate 1*

Born in Antwerp, Hoefnagel travelled extensively and drew many of the views engraved in Braun and Hogenberg's *Civitates Orbis Terrarum*, 1572–1617. This drawing is an important document, not only as a record of the great Tudor palace of Nonsuch, but also as establishing that Hoefnagel visited England in 1568.

Henry VIII began the palace in 1538; it was incomplete at his death in 1547, but was finished by Henry FitzAlan, Earl of Arundel, who bought it from Mary Tudor in 1557. In 1592 Elizabeth I acquired Nonsuch, which became one of her favourite houses; Hoefnagel thus shows it as Lord Arundel's Palace, although it was Henry VIII who was responsible for the fantastic character of the towered façade, decorated with elaborate plasterwork in a Franco-Italianate style which recalls that at Fontainebleau. Nonsuch was demolished between 1682 and 1688.

This drawing, which Hoefnagel subsequently used in 1582 as the basis for an engraving in *Civitates Orbis Terrarum* (vol. v, pl. I), is often said to represent the arrival in state of Elizabeth I, although there is no record of her visiting Lord Arundel in 1568.

Wenceslaus Hollar 1607–1677

2 *'A Prospect of the Lands and Forts . . . before Tangier drawne from Peterborow Tower'*

Pen and brown ink with watercolour on nine conjoined pieces of paper; 281×1022mm
Signed and dated: *Wenceslaus Hollar, his Maj*^ties *designer, in September A°. 1669*
Sloane 5214–20 (L.B. 34(b); E.C.M. 31) *Plate 2*

Hollar was appointed 'King's scenographer or designer of Prospects' in 1667 and accompanied an expedition to Tangier two years later in order to make topographical records of the area and its fortifications, for which he was paid a fee of £100. Thirty panoramic views survive, including preliminary studies and finished watercolours of which this is an example; the series shows a skilful combination of the elements of military topography and pictorial landscape. Hollar published sixteen related etchings after his return to England.

Tangier had become a British possession in 1662 and as may be seen from the inscriptions on this drawing the forts along the defensive wall were given incongruously British names: Whitby, Kendall, Norwood, Monmouth. All were destroyed when the city was abandoned in 1683.

The commission was the last major one in Hollar's career. Born in Prague he had trained as a topographical draughtsman and etcher in Germany before entering the employment of Thomas Howard, Earl of Arundel, in 1636. He was introduced at court and became drawing-master to the young Charles II when Prince of Wales. The Civil War, however, disrupted his career and he died in poverty producing hack-work for publishers.

Thomas Wyck *c.*1616–1677

3 *A Distant View of London from Blackheath*

Brush drawing in brown and grey wash over pencil, on two conjoined pieces of paper; 300×795mm
Inscribed: *London Westminster, den Toor (?), paules*
1897-8-31-1 (E.C.M. 6, as by Jan Wyck) Presented by G. Mayer

Thomas Wyck was one of the many Netherlandish artists who arrived in England to take advantage of the new demand for their work after the Restoration of Charles II in 1660. He is best remembered for his prospects of London and the Thames. This drawing was formerly thought to be the work of the artist's son Jan (1652–1700) but the presence of Old St Paul's (demolished in 1668 after being damaged in the Great Fire) would make such an attribution most unlikely.

The flood plain of the Thames below London lends itself to treatment in the manner of a Dutch landscape, the broadly handled foreground contrasting with the distance where buildings and trees are rendered with a few light strokes. The drawing was in the collection of Paul Sandby who owned, and was clearly influenced by, a large number of landscapes by earlier masters.

John Dunstall d.1693

4 *A Pollard Oak near West Hampnett Place, Chichester*

Watercolour over black lead, touched with white on the figures, on vellum; 134×160mm
Signed: *John Dunstall fecit*
1943-4-10-1 (E.C.M. 2) *Plate 3*

Dunstall was one of a number of native-born seventeenth-century draughtsmen who came within the sphere of Hollar's influence. He published several small sets of etchings intended as copy-books for aspiring draughtsmen and a treatise on *The Art of Delineation*. The locality depicted in this charmingly naive drawing is established by his etching of Hampnett House, one of a series of five views in the neighbourhood of Chichester; the costume of the diminutive figures in the foreground suggests a date *c.*1660.

Jan Siberechts 1627–*c.*1703

5 *View of Beeley, near Chatsworth*

Watercolour and bodycolour heightened with white; 285×455mm
Signed and dated: *Bely in darbyshair 22 Augusti 1694 J. Sybrecht. f.*
1952-4-5-10 (E.C.M. 2) *Plate 4*

Siberechts settled in England in 1673. He had established a reputation in Antwerp for his paintings of pastoral subjects but in this country became popular for bird's-eye views of country houses. This drawing and two related studies (in the Rijksmuseum, Amsterdam and the Lugt Collection, Paris) are probably connected with an intended 'portrait' of Chatsworth. The method of drawing with the brush in colour differs from the usual practice at the period of laying in the tones in grey wash and adding the tints at a subsequent stage.

The village of Beeley lies immediately to the south of Chatsworth. It was not acquired by the Dukes of Devonshire until 1747 and the land remained unenclosed until 1811.

Francis Place 1647–1728

6 *York from St George's Close*

Pen and grey and brown inks, the foreground tinted in pale green, on two conjoined sheets; 174×750mm
Inscribed: *York S.E. by S.*
1850-2-23-837 (E.C.M. 27)

This drawing is one of a group of views of York datable *c.*1675. Place settled in the city after the Plague gave him an excuse for cutting short an uncongenial career as an attorney at Gray's Inn. While in London he had met Hollar whose topographical work had a lasting effect on his style, although it was later to be supplemented, under the influence of Netherlandish artists such as Wyck, by a greater concern with conveying light and shade and a tendency to abandon pen in favour of brush drawing in wash and watercolour. At the early stage represented by the group of views of York the watercolour is still dominated by detailed drawing in pen and ink.

Although Place was from time to time employed professionally on book illustration, he was essentially an amateur – a pioneer of mezzotint and an experimental potter as well as being the earliest English artist whose main preoccupation was with landscape. His travels (on foot) in Wales, Ireland, Scotland and his native Yorkshire anticipated the sketching tours of artists a century later.

Samuel Scott *c.*1702–1772

7 *Westminster Bridge with neighbouring Houses*

Indian ink and grey wash tinted with watercolour over pencil; 1110×351mm
Inscribed: *Westminster Bridge N.B. in a small (?) . . . of Wind the Water (?) . . . of the sky Westminster Bridge*
1865-6-10-1324 (L.B. 2)

Until the 1740s Scott was almost exclusively a marine painter in the tradition of Willem van de Velde, whose work was to remain a dominant influence throughout his career. It is often said that in his London views Scott was emulating Canaletto who came to London in 1746, but the dating on external topographical grounds of his preparatory drawings establishes that he was making sketches of London in the early 1740s. If there were a foreign influence it could equally well be the townscapes of contemporary Dutch painters, such as Van der Heyden. While Scott's paintings frequently include capricious or inaccurate details, studies such as this example (which should be compared with Sandby's views of the Thames, see no. 21) appear to be truthful. The precision of outline in this drawing, as well as its considerable size, suggest that it was not made on the spot, but worked up from such a sketch as no. 9. Although there is no documentary evidence, Scott may have used (as Canaletto certainly did) a *camera obscura*.

The view is of the Westminster bank of the Thames and to judge from the progress of the building of the bridge, this drawing would seem to date from before January 1745. The paintings based on this drawing are generally dated in the 1750s.

Samuel Scott *c.*1702–1772

8 *The Thames below Rotherhithe*

Ink and grey wash tinted with watercolour; 341×522mm
Oo 5–8 Payne Knight Bequest, 1824

Plate 5

Scott's view looks West, probably from near the present Upper Globe Wharf. On the left is a timber-yard and in the distance is Rotherhithe, with the tower and spire of St Mary's Church; this drawing cannot be dated before the late 1740s or early 1750s since the spire was not completed until 1747. Scott may have used this drawing when painting a view of Wapping in 1756, where the same buildings can be seen on the horizon.

This study appears to have been drawn on the spot, although the delicate touches of colour would probably have been added later.

Samuel Scott *c.*1702–1772

9 *St Paul's from the Thames*

Pencil, pen, ink and watercolour, squared for enlargement; 179×444mm
Verso: A plan of a theatre, a row of windows and a diagram in pencil and watercolour, inscribed *Scott*.
1868-3-28-338 (L.B. 1)

Unlike no. 7 this drawing has every appearance of being made on the spot. The presence of Blackfriars Bridge, completed in 1769, in the background to the right provides a *terminus post quem* for dating the drawing. The squaring suggests that Scott intended to enlarge the composition either in a more finished drawing or as an oil-painting, although no related picture is known.

Scott's viewpoint is in mid-stream near the Temple: from left to right are the Temple Stairs, the spires of St Bride's and St Martin's, St Paul's Cathedral and in the distance the City churches.

William Taverner 1703–1772

10 *A Sandpit at Woolwich*

Bodycolour and watercolour, on three conjoined sheets of paper; 363×702mm
Inscribed: According to the catalogue of the Percy collection, Christie's, April 1890, the *verso* of the old mount was inscribed *taverna* [sic] *Sand Pitts* [sic], *Woolwich*
1890-5-12-140 (L.B. 4)

Plate 6

11 *A Country Road leading to a Church*

Watercolour; 215×289mm
Inscribed: 57 on the old mount
1983-10-1-4

Plate 7

Taverner was by profession a lawyer and must therefore be considered as an amateur, but he enjoyed a considerable contemporary reputation as a landscape artist. George Vertue noted in 1743 that he had 'an extraordinary Genius in drawing and painting Landskips. Equal if not superior in some degree to any painter in England'. To judge from the small amount of his work that survives he seems to have been one of the earliest English artists to use pure watercolour without pen outlines, and also bodycolour; the latter perhaps in emulation of Marco Ricci, whose gouaches were much admired by English collectors. He occasionally painted in oils, and here his inspiration was Gaspard Dughet whose reputation in England was at its highest during the 1730s and 1740s. The drawings exhibited reveal

two distinct aspects of his style: the *Sandpit at Woolwich*, executed mainly in bodycolour and on an unusually large scale for an English drawing of the period is a formal, finished work with echoes both of Ricci and of Dutch and Flemish naturalistic painting. At one time it belonged to Paul Sandby, whose own work reveals the influence of Ricci and of Taverner. The other is perhaps one of the watercolours of views in the environs of London included in the artist's sale in 1776. It is strikingly direct and unmannered for the period, and foreshadows Gainsborough's landscape drawings in the absence of any obviously topographical content.

Alexander Cozens 1717?–1786

12 *Mountain Peaks*

Brown wash on pale buff prepared paper; 229×303mm
Signed below mount: *Alex' Cozens*
1928-4-17-4

Born in Russia, the son of one of Peter the Great's English shipbuilders, Alexander Cozens came to England *c*.1742 and was in Rome in 1746. Thereafter he lived in England, employed as a drawing master at Christ's Hospital and Eton, as well as instructing private pupils. This experience as a teacher, combined with a personality described by his friend and patron William Beckford as 'almost as full of systems as the universe' led him to publish a number of instructional books on drawing, with illustrations by himself. Of these, the most important was *A New Method of Assisting the Invention in Drawing Original Compositions of Landscape*, *c*.1784. The essential feature of the method was the 'blot', a free composition in Indian ink wash which, as Cozens explained, the artist should make as instinctively as possible, controlling the movement of his hand only in accordance with some 'general idea' which he should first have in his head. This done, the accidental shapes of the washes would suggest features for a more finished drawing, creating a landscape of abstract rather than specific character. The mysterious quality and inherent ambiguity of his landscapes, which though they have a restraint characteristic of the eighteenth century, are almost never topographical, are always empty of figures, and can be taken to mean very much what the person looking at them wants them to mean, are among the earliest expressions of the Romantic imagination. The present drawing, related to a plate in the *New Method*, makes an intriguing parallel with the Alpine subjects painted by his son in the 1770s and 1780s, and suggests that each absorbed something from the example of the other.

Thomas Sandby 1723–1798

13 *'View from the North Side of the Virginia River near the Manour Lodge'*

Watercolour, with touches of bodycolour, pen and ink, over pencil and grey wash on two conjoined sheets of paper; 455×755mm
Inscribed faintly in pencil with numbers at the edges of the paper to assist squaring-up
1868-3-28-303 (L.B. 7) *Plate 8*

Thomas Sandby's technique was based on the tradition of drawing developed for military surveying and for the making of architectural views in perspective. After being apprenticed to a surveyor, Thomas Sandby accompanied the Duke of Cumberland's campaigns in Scotland and the Netherlands in the capacity of Ordnance Draughtsman, and when the Duke became Ranger of Windsor Great Park he was appointed as Draughtsman and subsequently as Deputy Ranger. Much of his time was spent at Windsor, where his first major undertaking was to remodel the grounds; this involved the creation of Virginia Water, then the largest artificial lake in the country. The present watercolour is one of a series engraved by his brother Paul, *Eight Views in Windsor Great Park*, 1754; it shows George II (in a plum-coloured suit) in the centre, with his younger son, William Duke of Cumberland pointing to the lake, on which can be seen the Chinese junk (in fact an old hulk dredged from the Thames and decorated in the newly-fashionable chinoiserie style), and at the left a crowd of spectators. The authorship of the figures in drawings of this type is still a matter of dispute; certainly there are sketches by Paul Sandby for several of the figures used in this composition (they also reappear in other drawings), which suggests that the brothers collaborated here.

A more coarsely executed version of this watercolour, differing in some details of composition, is in the Royal Library at Windsor; its attribution to Thomas Sandby is perhaps doubtful.

Thomas Sandby 1723–1798

14 *The Piazza, Covent Garden*

Watercolour with pen and ink; 510×675mm
Crowle-Pennant Vol. VI, 25 (L.B. 18) Crowle Bequest, 1811
 Plate 9

Attributed to Thomas Sandby 1723–1798

15 *Beaufort Buildings, looking towards the Strand*

Watercolour with pen and ink; 451×616mm
1880-11-13-2854 (L.B. 135 as Paul Sandby) Crace Collection

It was in his capacity as an architect that Thomas Sandby was among the founder members of the Royal Academy in 1768, and was from its inception Professor of Architecture. His architectural drawings have an attractiveness of precise line, sharp contour, flat wash, clearly defined shadows and finely drawn detail which, combined with picturesque incident in the depiction of figures (often supplied by his brother Paul) distinguishes them from the works of most of his contemporaries. The detailed observation of architectural detail, and the clear precision with which light and shade is depicted in no.15 is extremely effective. A characteristic of his work demonstrated in no.14 was the frequency of unfinished repetitions of certain compositions, with some parts of a drawing fully elaborated and other areas left blank, suggesting to Paul Oppé (*The Drawings of Paul and Thomas Sandby at Windsor Castle*, 1947, p.12) 'either idleness or an amateurish diffidence which caused him to discontinue his work'. There are numerous variants of views of the Covent Garden Piazza; this example probably dates from the mid-1760s – save for details of the figures it is close to Edward Rooker's engraving of the subject after Thomas Sandby published in the six London views of 1766.

William Gilpin 1724–1804

16 *Landscape Composition: a Lake Scene*

Ink wash and pen on yellow paper, oval; 244×330mm
1871-8-12-1718 (L.B. 4)

Gilpin's influence on contemporary taste was out of all proportion to his intrinsic merit as an artist; he was by profession a clergyman and practised drawing only as an amateur. In his formulation of the theory of the Picturesque (most notably in his *Observations on the River Wye . . . relative chiefly to Picturesque Beauty*, 1782) he categorised various types of landscape for the benefit of the aesthetic tourist. His books were abundantly illustrated with aquatints based on his own monochrome drawings, which offer a pale and simplified reflection of Alexander Cozens's systematisation of nature. 'The most useful illustrations of local scenery are those which give the *character* of the views by a pleasing arrangement of ideas taken from the general face of the country' he noted. 'I am so attached to my picturesque rules, that if nature gets wrong, I cannot help putting her right'.

Thomas Gainsborough 1727–1788

17 *A Cart passing along a winding Road*

Watercolour heightened with touches of white bodycolour over black chalk; 237×317mm
Stamped with the artist's monogram *TG* in gold
Verso: A study of a tree against a hilly background
1899-5-16-10 *Plate 10*

Gainsborough hardly ever concerned himself with topography in the sense of making views of particular places, nor, save in disguised form, with the Italo-French tradition of ideal landscape. He concentrated instead on pastoral fantasies that embodied many of the characteristics later singled out as 'picturesque' by the theoretical writer Uvedale Price, who as a boy had accompanied him on sketching excursions into the countryside around Bath: 'all intricacies . . . all the beautiful varieties of form, tint, and light and shade; every deep recess, every bold projection – the fantastic roots of trees – the winding paths of sheep'.

This is a rare example of Gainsborough's use of full watercolour; but he is known to have admired Paul Sandby's work, and was perhaps influenced by the example of artists like William Taverner as well as by seventeenth-century Flemish landscape drawings in watercolour of the type traditionally attributed to Van Dyck.

Thomas Gainsborough 1727–1788

18 *A Rocky Wooded Landscape with a Figure driving Sheep*

Black chalk and stump heightened with white (partly oxidised) on blue paper; 302×420mm
1910-2-12-260 *Plate 11*

The imagery of this drawing, which dates from the later part of Gainsborough's life, affords a parallel with one aspect of the theoretical writings of the Picturesque movement. Although Gainsborough's inclinations were not literary, neither was he wholly the instinctive and unacademic artist he often made himself out to be: for instance, it is clear from his correspondence

that he had read Dr John Brown's descriptive guide to the Lake District before going there in 1783. Drawings like this example suggest that he also knew the series of 'Picturesque Tours' which the Rev. William Gilpin began to publish in the early 1780s. While Gainsborough may have agreed with many of Gilpin's observations, it would, however, have been uncharacteristic of him to derive his subject matter directly from such a source; and in fact many of the landscape features singled out by Gilpin as being particularly picturesque had figured in Gainsborough's work from the 1750s onwards. It is in his later and more generalised landscapes that his imagery comes closest to Gilpin's, in its emphasis on 'the castle, or the abbey, to give consequence to the scene', the irregular silhouettes of distant mountains and rocky clefts overhung with trees. No less important for Gainsborough at this period, as indeed for Gilpin, was the influence of the Old Masters, seen particularly in their preference for artificial compositions, not based on direct observation of nature but intellectually conceived, and for the technique of black chalk on coloured paper. The present idealised composition is at least partly inspired by Gaspard Dughet, but may also reflect Gainsborough's 'habit of making what might be called models for landscapes, which he effected by laying together stones, bits of looking glass, small boughs of trees, and other suitable objects, which he contrived to arrange, so as to furnish him with ideas and subjects for his rural pictures' (Edward Edwards, *Anecdotes of Painters*, 1808, p.135).

Paul Sandby 1730–1809

19 *A Draw-Well at Broughton, near Edinburgh*

Watercolour with pen and ink over pencil; 165×230mm
Signed and dated: *P. Sandby delint 1751* and inscribed on the
*verso: To George Fern, Esquire. Prospect of a Draw-well at Broughton,
near Edin*
1904-8-19-95 (L.B. 1a) Bequeathed by William Sandby

Trained as a surveyor and military draughtsman, Paul Sandby was employed on the Military Survey of Scotland set up after the defeat of the Jacobite uprising at Culloden in 1746. But he soon outgrew the conventions of cartographic representation, making numerous informal landscape and figure studies and also developing his skills as an etcher. His knowledge of Dutch landscape engravings (and possibly paintings) is evident in this early watercolour, which also makes an interesting comparison with exactly contemporaneous landscapes by Thomas Gainsborough, also at this early period much influenced by the Dutch school.

In 1758 Sandby used this watercolour to provide the background for one of his etched illustrations to Allan Ramsay's poem, *The Gentle Shepherd*, which is set in the vicinity of Edinburgh.

Paul Sandby 1730–1809

20 *The Gate of Coverham Abbey, Yorkshire*

Watercolour and bodycolour; 265×384mm
1904-8-19-32 (L.B. 39) Bequeathed by William Sandby
Plate 12

Although Sandby never travelled outside Britain, he treats this gateway of a twelfth-century abbey almost as if it were an Italian ruin – an illusion helped by the massive style of the architecture and the absence of obviously medieval features. As in Italian seventeenth-century landscape drawings, the forms of the building and trees are rendered as clear masses with a bold pattern of light and shade and broadly handled detail.

This drawing which, though not engraved until 1773 for Grose's *Antiquities*, was probably executed in 1752, marks an early stage in Sandby's career and in the development of the English watercolour school as a whole. It reflects the Italianate strain in English landscape and the artist may well have had in mind the gouaches of Marco Ricci (1676–1729). Yet in later years Sandby was more responsible than anyone else for freeing English watercolour from Italian influence and for developing a distinctly native approach.

Attributed to Paul Sandby 1730–1809

21a *View from the Gardens of Somerset House, looking West*

Watercolour with pen and grey ink over pencil; 483×1951mm
(made up from five pieces of paper)
1984.U.1 (L.B. 8 as Thomas Sandby) Crowle Bequest, 1811
Plate 13

b *The same, looking East*

Watercolour with pen and grey and black ink over pencil on four conjoined sheets of paper; 530×1916mm
1984.U.2 (L.B. 9 as Thomas Sandby) Crowle Bequest, 1811
Plate 13

The bend in the Thames at Somerset House affords an extensive view which has appealed to many artists. It has often been suggested that such river scenes owe a debt to Canaletto's visit to England from 1746 to 1750 but, although his pair of views in the Royal collection are the finest of the genre, Canaletto did not invent this type of oblique composition: an engraving by J. Maurer dated 1742 is so close in many details to Sandby's view towards the west as to suggest that it may have been a source for the composition. The present drawings may also be seen as precursors of the vogue for city panoramas at the beginning of the nineteenth century (see, in particular, Girtin's watercolours, nos. 82a–f, 83).

Authorship of these views has been attributed variously to Thomas and Paul Sandby, both of whom would have been equipped by their early training as military topographers to handle perspective on a large scale. The precise treatment of the architecture recalls the work of Thomas Sandby but the figures are almost certainly by Paul; a number of the figures appear in his studies in the Royal collection (see A.P. Oppé, *Sandby Drawings at Windsor Castle*, 1947, nos 225, 240, 244 and 33b). Related drawings attributed to one or other brother exist in a number of collections: Windsor (nos 161, 162, 163 and 241); the Victoria and Albert (D.1832–1904, 1835–1904); Sir Brinsley Ford; and the British Museum (Paul Sandby, L.B. 131, L.B. 132; Thomas Sandby L.B. 21). Another view of Somerset House from the gardens was reproduced by William T. Whitley in *Artists and their Friends in England 1700–1799*.

The attribution of these drawings to Paul Sandby now follows that of J. T. Smith, Keeper of Prints at the British Museum from 1816 to 1833, who knew both brothers (*A Book for a Rainy day*, 1845, p.287). Traces of vertical folds result from the fact that they were inserted together with a number of other important watercolours in J.C. Crowle's extra-illustrated copy of Pennant's *London*.

Paul Sandby 1730–1809

22 *The Iron Forge at Barmouth*

Watercolour over pencil; 203×298mm
1904-8-19-21 (L.B. 48) Bequeathed by William Sandby
Plate 14

In August 1771 Paul Sandby accompanied his patron Sir Watkin Williams-Wynn, a landowner in Denbighshire, on what was probably the first 'picturesque tour' of North Wales for the purpose of admiring the wild scenery of the country. By the nineteenth century such tours would be considered commonplace, but at the beginning of the 1770s Wales was largely unknown, save through Richard Wilson's paintings of Snowdonia and Thomas Gray's poem recalling ancient Welsh nationalism, *The Bard* (1757). It has been suggested on the one hand that an interest in ancient British history and on the other that the beginnings of industrialisation may have first prompted travellers to visit Wales, but the dramatic, unexplored landscape of mountains, wooded valleys and mysterious castles and abbeys soon became admired for its own sake. Sandby was above all a topographer, and treated all aspects of the landscape in order to produce as complete a record as possible: not only mountains, ancient ruins, bays, lakes and cottages, but also industrial subjects such as ironworks, quarries and kilns. He published three sets of aquatints (among the earliest made in England) of views in Wales, 1775–7, using his earlier drawings as a basis. In the meanwhile, the first volume of Thomas Pennant's popular guidebook, *A Tour in Wales*, with illustrations after drawings by Moses Griffith, appeared in 1773.

The present drawing is traditionally said to represent the iron forge at Barmouth on the Merionethshire coast, and may be related to the plate in the 1776 series of aquatints entitled *The Iron Forge between Dolgelli and Barmouth*. But in the aquatint the anecdotal detail of the sketching party is omitted, the essential elements of the composition are reversed, and the forge, larger and more factory-like, has become the central feature, seen from a different angle, dramatically lit from inside and with a plume of smoke streaming across the sky.

Paul Sandby 1730–1809

23 *Windsor Bridge from Datchet Lane*

Watercolour, heightened with bodycolour, pen and ink, over pencil; 277×564mm
1878-7-13-1280 (L.B. 109)

24 *Julius Caesar's Tower, Windsor Castle*

Watercolour over pencil; 344×503mm
1878-7-13-1279 (L.B. 110)

Paul Sandby spent much of his time at Windsor, where his brother Thomas was in royal employment (see no. 13). He seems to have been mostly active there between c.1760 and 1771, although he continued to repeat his views of Windsor for many years, exhibiting them between 1763 and 1807, first at the Society of Artists, and later at the Royal Academy of which he was a founder member. Surprisingly, there is no evidence

that any of his Windsor views were acquired for the Royal Collection before the sale held two years after his death, when the Prince Regent made a number of purchases.

In terms of composition both no. 23 and no. 24, probably dating from the 1770s, show the influence of contemporary European *vedute* painting, notably Canaletto's views of English houses and castles (including Windsor). Although Sandby sometimes used oil, his achievement was to have raised the status of watercolour as an exhibition medium in its own right, by developing the tradition of the tinted topographical drawing with a new sophistication and assurance. Sandby did not always date his watercolours and the various versions of a composition cannot always be placed in chronological order, but it would seem that no. 23, with its exceptional clarity of light and colour, is probably the earliest version of a view that he continued to repeat throughout his life. A larger version in bodycolour is signed and dated 1798 (Paul Oppe, *Sandby Drawings at Windsor Castle*, 1947, no. 76, p.31). The view shows Windsor Bridge in the middle distance, the river and houses of Eton to the right. On the extreme left the west corner of St George's can be seen above the houses of Datchet Lane. It has been noted elsewhere (nos. 12a,b,13) that for the figures in their landscapes the Sandbys used a repertoire of studies, many of which are now in the Royal Library, Windsor and at the British Museum. In no. 23, for example, the figure of the seated stonecutter appears in an aquatint of 1776, and in a view of Julius Caesar's Tower (Oppé, *op. cit.*, no. 33, p.25), the preliminary drawing probably being one in the Victoria and Albert Museum (D 167–1901). In no. 24 the focus of the design is Julius Caesar's Tower, one of three built 1227–30, which has been the belfry of St George's Chapel since c.1475; the old bell-cage and cupola seen in the drawing remain enclosed in the additions of 1863. In the near foreground Sandby has characteristically introduced the genre motif of a woman with a small boy dressed as a soldier with a toy sword and large three-cornered hat. Although both watercolours are primarily topographical in intention, Sandby's sensitivity to atmosphere is apparent. As his son noted: 'he aimed at giving his drawings the appearance of nature as seen in a camera obscura with truth in the reflected lights, clearness in shadows and aerial tint and keeping in the distance and skies'.

Paul Sandby 1730–1809

25 *The Artist's studio, St George's Row, Bayswater*

Watercolour and bodycolour on grey paper; 229×280mm
1904-8-19-63 (L.B. 19) Bequeathed by William Sandby
Plate 16

Paul Sandby moved to 4 St George's Row, Bayswater in 1772; later known as 23 Hyde Park Place, the house was demolished in 1901. This informal sketch, taken from a back window of the house looking down the garden towards his elegant studio, apparently newly built in the neo-classical style, is characteristic of his late work at its most appealing. A weaker version, with different figures, is in the Castle Museum in Nottingham.

Paul Sandby 1730–1809

26 *Bayswater*

Watercolour; 183×204mm
Signed and dated: *Bayswater 1793 P.S.*
1904-8-19-67 (L.B. 21) Bequeathed by William Sandby
Plate 15

One of the many views by Paul Sandby of the surroundings of his house in Bayswater (see no. 25), then a still rural village to the north-west of London. The inscription establishes that it was drawn in 1793; otherwise its freshness and almost naive charm would suggest a considerably earlier date. It seems to reflect the artist's admiration for the unaffected quality of Dutch landscape painting.

James Miller *fl.*1773–1791

27 *A Suburban Scene, probably beside the Thames*

Grey and brown wash with watercolour and pen and grey ink; 198×293mm
1948-10-9-16 Bequeathed by Mr P.C. Manuk and Miss G. M. Coles through the National Art—Collections Fund *Plate 17*

Miller exhibited a number of London subjects at the Society of Artists from 1773 to 1791 and at the Royal Academy from 1781 to 1788 but little of his work is known today. His watercolours – tinted drawings in the traditional manner, often enlivened by anecdotal incident – are close in style to the work of Paul Sandby and no doubt many have been wrongly attributed to that artist.

Samuel Hieronymus Grimm 1733–1794

28 *The Encampment in the Garden of Montague House, the British Museum, 1780*

Pen and grey ink and watercolour heightened with white;
381×533mm
Signed: *S H Grimm fecit 17*- (the date altered to *[17]80 June*)
1984-5-12-4

Though Grimm was a native of Switzerland and did not settle in this country until he was thirty-five, his topographical work is typically English. He was employed by *virtuosi* to make drawings of views in England and Wales, among the most interesting of these series (although not the largest) being those for Gilbert White's *Natural History of Selborne*. White described his technique: 'He first of all sketches his scapes with a lead-pencil; then he pens them all over, as he calls it, with Indian-ink, rubbing out the superfluous pencil-strokes; then he gives a charming shading with a brush dipped in Indian ink; and last he throws a light tinge of watercolours over the whole.'

Grimm's views of London are of great historical interest. The present drawing, and also two in the Royal Collection exhibited at the Royal Academy in 1781, show the encampment of the York Regiment in the garden behind Montague House following the Gordon Riots (29 May – 8 June 1780). That camp and the others in St James's Park, Hyde Park and Blackheath remained for two months and all four were drawn and aquatinted by Paul Sandby.

Montague House was the original home of the British Museum, and was replaced by the present neo-classical building from 1823 onwards. The garden has since been built over, the part shown in the drawing now being occupied by the Edward VII Galleries. To the East beyond the camp can be seen, from right to left, houses in Southampton Row and Queen Square, the Foundling Hospital, Sadler's Wells, and a recently built terrace in Gray's Inn Road. The drawing is close-framed as would originally have been intended.

Jonathan Skelton *c.*1735–1759

29 *A Sandpit near Croydon, Surrey*

Watercolour: 191×322mm
Signed and inscribed on a separate piece of paper: *A Sand pit near Croydon in Surrey J. Skelton 1756*
1909-4-6-10

30 *The Medway near Sheerness*

Watercolour over pencil; 257×570mm
Inscribed on the *verso*: *Sheerness from y^e Tower of Gillingham Church near Rochester, I.S. 1757*
1909-4-6-12 *Plate 18*

Almost nothing is known of Skelton's life before he went to Italy in 1757 (see no. 31); and his work was entirely forgotten until 1909, when a group of eighty-four drawings appeared at auction. Of his surviving works, the earliest dated drawings are from 1754. An inscription on one provides a clue to Skelton's identity and circumstances, suggesting that the artist was a servant in the household of Thomas Herring, Archbishop of Canterbury. Skelton's movements, as recorded by inscribed drawings, accord with this statement; the Archbishop's usual residence was at Croydon Palace, or occasionally Lambeth, and he visited Rochester, on the Medway, the deanery of which he retained. Additionally, the patron who financed Skelton's visit to Italy was a cousin of the Archbishop, William Herring of Croydon.

It is possible, according to several references in his letters from Italy, that Skelton had been a pupil of George Lambert. He seems also, to judge from watercolours like no. 30, to have known the work of Samuel Scott. In some ways, however, Skelton's watercolours surpass theirs in subtlety of conception and execution. Indeed, no. 30 seems almost a prefiguration of J.R. Cozens. In Italy, he was to paint from nature, and it is possible that he may have begun to do so while still in England. Both this study of a sandpit and the view over the Medway appear to have been drawn on the spot, although they may well have been coloured later on.

Jonathan Skelton *c.*1735–1759

31 *Tivoli*

Watercolour, with pen and ink; 264×370mm
Inscribed *verso: a part of Tivoli Part of Tivoli J:Skelton. 1758*
1909-4-6-11

Skelton arrived in Rome at the end of 1757 and died there in January 1759. His all too brief stay in Italy is fully documented in the letters that he addressed to his patron, William Herring. These give a detailed account of his day to day life, his experiments with various techniques, his attempts to improve his figure painting, his exploration of the Roman Campagna, and even the political intrigues of the Jacobite exiles surrounding the young Pretender. It appears that he visited Tivoli twice, briefly in April 1758 and again towards the end of July when

he stayed for about two months. As he told Herring, 'This ancient city of Tivole I plainly see has been ye only school where our two most celebrated Landscape Painters Claude and Gasper studied'. The influence of Gaspard Dughet in particular is evident in his views of Tivoli. Compared with his landscape on the Medway of the previous year (no. 30), these are much more elaborately conceived and sometimes even include an element of the *capriccio* that may also suggest knowledge of the work of Giovanni Paolo Pannini (1690/1–1765), the most fashionable Roman *vedutista* of the day. 'I am . . . taking all opportunities of making drawings from Nature', Skelton wrote, 'some in Indian ink, and some in Colours where I find the colouring very fine in Nature'. The greater part of the present watercolour does look as if it had been drawn on the spot, though the foreground is obviously contrived according to a standard pictorial convention. Skelton's letters also reveal that he experimented with open-air sketching in oil, a procedure that he seems to have found unsatisfactory: 'in the open daylight [oil-colours] shine so much when they are wet that there is no such thing as seeing what one does'. None of his oil sketches have yet been identified.

Like the other watercolours by Skelton in the exhibition (nos 29 and 30), this came from the Blofeld Collection at Hoveton House, which had been unknown to students until 1909.

Francis Towne 1739/40–1816

32 *SS Giovanni e Paolo, Rome*

Watercolour with washes of ink and pen outlines; 317×471mm
Signed and dated: *F. Towne delt Rome. Novr. 20 1780. No. 13*, and inscribed on the backing sheet *From Mount Palatine. Rome. Francis Towne delt 1781* (in a different ink; added inaccurately by the artist at a later date) *From 12 o'clock till 2*
1972.U.613(L.B. Album 1(12)) Bequeathed by the artist, 1816
Plate 20

The *Memoirs* of Thomas Jones, who lived in Italy from 1776 to 1783, record numerous sketching expeditions in Rome and the surrounding countryside in the company of J.R. Cozens, William Pars and 'Warwick' Smith. To judge from the Roman watercolours by Smith and Towne now in the British Museum, these artists would go on sketching expeditions together and there exist several examples of the same subject, apparently drawn on the same occasion. That one artist did not simply copy the other can be seen quite clearly by comparing their watercolours which show that they placed themselves at different points (no.

52). Here, Towne appears to have been seated lower down the Palatine than Smith, who drew a more panoramic view.

The church of SS Giovanni e Paolo was built above the house of these two saints, murdered by Julian the Apostate in 361 AD. At the left of Towne's watercolour is the fragment of the Claudian Aqueduct which is the subject of no. 35.

Francis Towne 1739/40–1816

33 *Near the Arco Oscuro*

Watercolour with pen outlines; 322×472mm
Signed and dated: *F. Towne delt. Rome Novr 28 1780. No 14* and inscribed on the backing sheet *No. 14 Near the Arco Scuro. Rome. Francis Towne delt.*
1972.U.730 (L.B. Album 1(13)) Bequeathed by the artist, 1816
Plate 19

Towne's distinctive style began to evolve in the late 1770s, but found its fullest expression in the years 1780–1 when he visited Rome and Naples and returned to England by way of Switzerland with John 'Warwick' Smith. On his death in 1816 Towne left his Italian watercolours to the British Museum, the first such bequest by an artist. In fact, his work was not greatly appreciated in his lifetime, perhaps because he deliberately rejected currently fashionable picturesque notions in favour of a spare, linear style, dependent on bold pen outlines and flat washes of colour, often ignoring conventional ideas of perspective and recession. Towne's preoccupation with outline tempts one to consider him closer in spirit to contemporary figure-draughtsmen, notably Flaxman and Blake, than to most late eighteenth-century landscapists. Although many of his watercolours were drawn on the spot, and carefully annotated with the date, time and light conditions, their appearance of spontaneity is misleading. He imposed a ruthless selectivity on his material, excluding all unnecessary detail in the interest of his overall pattern.

Towne arrived in Rome in October 1780 and towards the end of November spent several days sketching in the area of the Arco Oscuro, a half-buried Roman arch forming a tunnel near the Villa Giulia, just outside the Porta del Popolo. Unlike most of his contemporaries working in Rome, Towne has chosen a subject with no historical, classical or literary associations, and with no obviously topographical content: the autumnal hedgerow could almost have been in England. His choice of motif is not very different from his pre-Italian period, when he made studies of trees and foliage in Devonshire and Wales.

Francis Towne 1739/40–1816

34 *A Gateway of the Villa Ludovisi*

Watercolour with pen outlines; 464×321mm
Signed and dated: *F. Towne delt No 19 Dec 9 178[0]* and
inscribed on the backing sheet *No 19 Going into the Villa Ludovisi
Dec 9 1780 Rome Francis Towne delt*
1972.U.731 (L.B. Album I (18)) Bequeathed by the artist, 1816
<div align="right">*Plate 22*</div>

Towne's developing interest in unconventional spatial juxtapositions is well illustrated here: few other eighteenth-century artists would have conceived such an idiosyncratic composition, dominated as it is by an enormous expanse of sky against which a group of cypress trees is silhouetted. Towne must have calculated the design with care – the tallest cypress is placed at the exact centre of the paper, and it is apparent that his concern was above all with the pattern he was making.

This watercolour seems to have been among those included by Towne in the exhibition he organised of his work in 1805. He never became a member of the Society of Painters in Water-Colours, who, coincidentally, were to hold their first exhibition later in the same year; no greater contrast can be imagined than that between Towne's refined patterns and the richly coloured, ornately framed works exhibited by members of the new Society. Lack of appreciation from his contemporaries – he was also an unsuccessful candidate for election as an Associate of the Royal Academy on several occasions – seems to have embittered Towne, who in his lifetime enjoyed only a local reputation as a drawing master in and around Exeter.

Francis Towne 1739/40–1816

35 *The Claudian Aqueduct, Rome*

Watercolour, pen and ink over pencil; 327×473mm
Signed: *F. Towne delt. Rome No. 29* and inscribed on the *verso*:
From 10 till 12 o'clock.
1972.U.624 (L.B. Album II (3)) Bequeathed by the artist, 1816

From the second of the artist's Roman albums in the British Museum, in which most of the drawings are inscribed with dates in the early months of 1781. With its dramatically close-up viewpoint, Towne's rendering of a massive fragment of one of ancient Rome's greatest aqueducts (completed in 50 AD to carry water to the imperial palaces on the Palatine Hill) suggests a knowledge of Piranesi's prints of Roman ruins, but in place of Piranesi's sombre, atmospheric grandeur Towne stresses the

sculptural quality of the arches and the effect of sunlight on the masonry, which he captures in sharp focus. A later replica, dated 1785, is in the Yale Center for British Art.

Francis Towne 1739/40–1816

36 *Ariccia*

Watercolour with pen outlines; 321×468mm
Signed and dated: *Larice July 11 1781 Francis Towne delt.* and
inscribed on the backing sheet *Italy Laricea July 11 1781
Morning Sun breaking over the Church & Buildings. Francis Towne
delt. A copy of this painted on canvas for James Curtis, Esqre 1784*
1973.U.1348 (L.B. Album III (14)) Bequeathed by the artist, 1816
<div align="right">*Plate 23*</div>

Ariccia, a small town in the Alban Hills to the south of Rome, was a resort for Romans and visitors seeking to escape the summer heat of the city. As Towne's annotation indicates, early morning sunlight is shown striking the foreground and cupola of Bernini's S. Maria dell'Assunzione, while the dark olive-green trees still retain their coolness.

By comparison with drawings made at the outset of his visit to Rome in the autumn of the previous year, the bold pattern and simplified and contrasted masses of colour in this view of Ariccia show the development of Towne's highly personal manner. Striking though such drawings are, however, their exaggerated stylisation (e.g. in the all-purpose convention for foliage) and emphasis on compositional pattern-making tend to obscure the individual qualities of the place represented.

Francis Towne 1739/40–1816

37 *Lake Albano with Castel Gandolfo*

Watercolour with pen outlines on two pieces of paper
conjoined; 321×702mm
Signed and dated: *No 7 Francis Towne delt July 12 1781* and
inscribed on the backing sheet *Italy No. 7 Lake of Albano taken
July 12th 1781 Francis Towne Morning light from the left hand*
1972.U.646 (L.B. Album III (11)) Bequeathed by the artist, 1816
<div align="right">*Plate 24*</div>

This watercolour is one of the last painted by Towne before he left Rome to return to England in the company of John 'Warwick' Smith. On the way back he made a small group of drawings in the Alps which are rightly considered his master-

pieces (the British Museum, unfortunately, has no examples).

The view of Lake Albano is immediately familiar from the watercolours of J.R. Cozens but it is unlikely that Towne then knew these. Cozens returned from his first visit to Italy early in 1779, and there is no evidence, either stylistic or documentary, that Towne had seen any of the resulting finished watercolours before he himself left for Italy in 1780. Towne's whole approach was quite unlike that of Cozens; his careful definition of form through outline is the opposite of Cozens's subtle modulation of surface texture by means of tiny strokes of related colours. Towne is interested in light rather than atmospheric effect. All his forms are distinct, though drawn with increasing delicacy as they recede towards the background.

John Hamilton Mortimer 1740–1779

38 *Carrion Crows hovering over a Skeleton on a Seashore*

Watercolour and pen; 273×426mm
1975–u.1591(37) Payne Knight Bequest, 1824 *Plate 25*

Mortimer was regarded by many of his contemporaries (and also probably by himself) as a latter-day Salvator Rosa, both in his choice of subject matter, which was often bizarre – 'Representations of Banditti or of the transactions recorded in history, wherein the exertions of soldiers are principally employed, as also incantations, the frolics of monsters, and all those kind of scenes, that personify "Horrible Imaginings"' (Edward Edwards, *Anecdotes of Painters*, 1808, p.63) – and in his way of life, which was said to be 'intemperate'. His fascination with the macabre and exotic give his work a powerfully imaginative quality quite unlike that of most of his contemporaries, with the exception of Fuseli (who is said to have disliked him intensely) and, slightly later, Blake. Mortimer's few landscape drawings reveal the same predilection for horrific subjects. This example comes from the important collection of his drawings assembled by Richard Payne Knight. A similar subject by Mortimer, *A Skeleton on a Seashore* (BM, 1981·1·24·3) was reproduced, *c.*1771, in one of the first aquatints made in England, by Peter Perez Burdett (*c.*1735–93).

John Alexander Gresse 1741–1794

39 *A River Scene with a Water Wheel and Pumping Works*

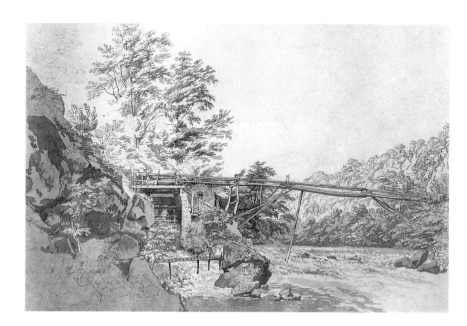

John Alexander Gresse *A River Scene with a Water Wheel and Pumping Works* (no.39)

Pen and ink with grey wash and watercolour; 193×282mm
1890·5·12·92 (L.B. 1)

Drawings certainly identifiable as by Gresse are very rare but he had a considerable reputation in his day as a drawing-master, counting members of the Royal Family among his pupils. The style of this drawing continues the tradition of the tinted drawing, exemplified in much of the work of Paul Sandby, whose interest in rugged scenery and industrial subjects (see no. 22) Gresse seems to have shared. The precise pen outlines may reflect the artist's early training as an engraver. A drawing in the Victoria and Albert Museum (1731–1871) of Llangollen bridge shows that, like Sandby, Gresse visited Wales, and it is possible that the present drawing may also be of a Welsh subject.

Thomas Jones 1742–1803

40 *Lake Nemi*

Watercolour over pencil; 286×428mm
Inscribed: *On the Banks of the Lake of Nemi* and indistinctly
dated, probably *1777*
1984-6-9-12 *Plate 26*

The main formative influences on Jones's development were
the period he spent as a pupil of Richard Wilson from 1761 to
1763, and his visit to Italy from 1776 to 1783. Even in Italy
Jones was at first still under Wilson's spell and saw the landscape
through his eyes: as he noted in his memoirs – 'In fact, I had
seen and Copyd so many Studies of that great Artist Mr *Richard
Wilson* which he had made here, and was so familiarized with,
& enamoured of *Italian* forms, that I enjoyed pleasures unfelt
by my Companions'.

In his memoirs Jones records that he stayed at Genzano
between 29 April and 24 May 1777, in company with William
Pars and his wife and various other friends, sketching in the
neighbourhood of Lake Nemi and Lake Albano. It is interesting
to compare his watercolour of the lake with the more panoramic
views by J.R. Cozens (nos 58,59) which are probably based on
sketches made in April of the same year. Although Jones
records sketching in the area with 'little Couzins' in June 1778,
they do not seem to have worked together in 1777. The
difference between the two artists in vision and technique is
clearly illustrated by comparing their views: Jones recorded
exactly what he saw, including the unbeautiful scrubby terrain,
and annotates his drawing with the names of the principal
features in the landscape. Cozens, on the other hand, concen-
trates on evoking atmosphere and melancholy beauty.

Thomas Jones 1742–1803

41 *Houses in Naples*

Oil on paper; 254×381mm
Signed and dated on the *verso*: *Naples August 1782 TJ*
1954-10-9-12 *Plate 27*

Though the publication of Jones's memoirs in 1948 belatedly
made his name known as a source for students of eighteenth-
century English art, his reputation as an artist dates from even
later, with the appearance in the saleroom in 1954 of a group
of about fifty of his remarkable landscape sketches in oil on
paper. Inscriptions show that most of these, including the
present example, were executed in Naples in the years 1780–83.

In Jones's case, the origin of the practice is a matter of interesting
but inconclusive speculation. Among French landscape painters
there had been an established tradition of sketching directly
from nature in oil since at least the time of Jean-François
Desportes (1661–1743); it was carried on, particularly in Rome,
by many French artists, especially Joseph Vernet, in the 1750s,
and in the 1770s and 1780s Pierre Henri de Valenciennes
(1750–1819). Jones's master, Richard Wilson, had known Vernet
in Rome, but there is no evidence that he ever followed
Vernet's precept, as recorded by Joshua Reynolds – 'paint from
nature instead of drawing': he seems always to have rec-
ommended to his pupils his own practice of drawing from
nature in black and white chalk on tinted paper. Similarly,
Jones himself was in Rome at the same time as Valenciennes
but he makes no reference to the French artist in his memoirs
and there is nothing to suggest that the two were ever acquainted.
Some of Jones's sketches are in fact dated before his departure
for Italy, and no evidence has yet come to light to disprove the
possibility that he evolved the technique independently.

Jones recorded in his memoirs that on 8 June 1782 he moved
into the third floor, 'reckoned the genteelest and consequently
the dearest . . . with the exclusive use of the Lastrica', of a
house in the Vicolo del Canale below Capodimonte, opposite a
church which he called S. Maria della Segola (i.e. S. Maria
Antesecula, destroyed by bombing in 1943). 'From this *Lastrica*
by which term the flat roofs of the houses in Naples . . . are
called . . . you Commanded a view over great part of the City . . .
on the other Side, the Rocks, Buildings & Vineyards about
Capo di Monte – and where I spent many a Happy hour in
painting from Nature – . . . It was in this House I may say, that
I spent by far the more agreeable part of my time during my
Sojourn in Naples'.

Jones's Neapolitan sketches are indeed his most brilliant and
spontaneous. The fact that the group sold in 1954 were in the
possession of his descendants, shows that they were made by
the artist for his own instruction and pleasure, rather than for
sale. In this way they are comparable with the group of about
120, mostly of Rome or its immediate environs, by his younger
contemporary, Valenciennes. The comparison cannot be pushed
beyond a certain point, however, for Valenciennes was concerned
above all with seizing transient effects of light and atmosphere.
Some of his sketches are cloud studies, in which the sky,
lovingly and precisely studied, is the principal element. Jones,
whose skies are treated conventionally, had a strong sense of
pictorial structure and a great feeling for architectural form,
and was above all concerned with the relation between solid
objects. Eight years older than Valenciennes, he remains an
essentially eighteenth-century artist, whereas the other seems
to anticipate the fully-developed romantic approach to nature
of Constable and his contemporaries.

William Pars 1742–1782

42a *The Theatre at Miletus*

Watercolour with pen and grey ink and some gum arabic;
296×471mm
Mm. 11–63 (L.B. 15) Presented by the Society of Dilettanti,
1799 *Plate 28*

b *A Sepulchral Monument at Mylasa*

Watercolour with pen and grey ink with some bodycolour and
gum arabic; 285×471mm
Mm. 11–73 (L.B. 17) Presented by the Society of Dilettanti,
1799 *Plate 29*

c *The Stadium at Laodicea*

Watercolour with some pen and grey and brown ink and gum
arabic; 300×476mm
Mm. 11–70 (L.B. 20) Presented by the Society of Dilettanti,
1799

d *The Temple on the Acropolis in Athens known as the Erectheum, looking towards the West*

Watercolour over pencil; 310×547mm
Mm. 11–4 (L.B. 2) Presented by the Society of Dilettanti,
1799 *Plate 30*

In 1764 William Pars, aged twenty-two, was commissioned by
the Society of Dilettanti (a group of noblemen and gentlemen
founded in 1733, whose aims included a furthering of the
appreciation of the Antique) to accompany Chandler and
Revett's expedition to Asia Minor, in order to record the sites
they visited: they were to return in 1766. Hitherto, Pars seems
to have practised as a portrait painter and to have aspired to
history-painting; there is little evidence of any accomplishment
as a topographical or landscape artist before this expedition.
His Ionian watercolours are therefore even more remarkable
achievements. In them Pars rose to the challenge of his first
major commission, developing both the extreme precision
necessary in an archaeological draughtsman and a sensitive
response of the exotic landscape and its inhabitants. After his
death in Italy in 1782 (from an illness apparently contracted
from standing in the cold water at Tivoli while sketching) his
close friend Thomas Jones wrote that Pars had 'an inward bias
in favour of Landscape, though brought up to Portrait . . .

though in a fit of splean, he would sometimes curse his Fate in
being obliged to follow such trifling an Employment; as he
called it – it was with the greatest difficulty his Friends could
detach him from his favourite Study'.

Richard Chandler's account of the expedition, *Travels in Asia
Minor*, 1775 (reprinted in abridged form in 1971, with a
commentary on Pars's watercolours by Andrew Wilton) de-
scribes the expedition's itinerary, while Pars's watercolours (of
which seventeen are in the Department) were engraved both in
Ionian Antiquities (VOL. I, 1769; VOL. II, 1797), published by the
Society of Dilettanti, and as aquatints by Paul Sandby between
*c.*1777 and *c.*1780. The first drawing, no. 42a, shown at the
Royal Academy's very first exhibition in 1769, depicts members
of the expedition boarding the ferry to cross the River Maeander
(the Englishmen have grown moustaches like their Turkish
companions); the topographical element – the theatre at Miletus
– has been relegated to the middle distance. In no. 42b the
central focus of the composition is a tomb of Hellenistic or
Roman date, which still stands complete just outside the ancient
city of Mylasa; the burial chamber is in the lower storey. Pars's
view of the stadium at Laodicea, no. 42c, is perhaps the most
remarkable of the series both in terms of composition and his
sensitivity to the nuances of atmosphere. On the return journey
to England, the party stopped briefly in Athens, where Pars
made several studies, including this view of the Erectheum, no.
42d. Colour notes inscribed in pencil suggest that Pars did in
fact work on his watercolours in front of the motif at least to a
fairly advanced stage.

William Pars 1742–1782

43a *The Lower Part of the Valley of Chamonix*

Watercolour, pen and black ink with touches of gum arabic
over pencil; 330×484mm
1870-5-14-1220 (L.B. 25)

b *The Rhone Glacier and the Source of the Rhone*

Watercolour, pen and black ink, with touches of gum arabic
over pencil; 331×488mm
1870-5-14-1219 (L.B. 33)

c *A Bridge near Mont Grimsel*

Watercolour with pen and black ink and touches of gum
arabic; 333×484mm
1870-5-14-1222 (L.B. 34) *Plate 31*

d *The Valley of Lauterbrunnen and the Staubbach*

Watercolour, pen and grey ink over pencil; 332×487mm
1870-5-14-1218 (L.B. 30)

The group of Swiss watercolours which Pars exhibited at the
Royal Academy in 1771 were the first specifically Alpine views
to be seen publicly in England. They anticipated by several
years those by John Robert Cozens (see nos 56, 57) and Francis
Towne. In 1770, four years after his return from Turkey and
Greece (nos 42a–d), Pars was engaged by Lord Palmerston,
who as a member of the Dilettanti Society would have known
his Ionian watercolours, to accompany him on a journey through
Switzerland. Palmerston's detailed account of their itinerary,
which enables these four drawings to be arranged in their
probable chronological order, reveals what the party found
most noteworthy (see Andrew Wilton, *William Pars, Journey
through the Alps*, 1979). For some of the time they were joined by
Horace Bénédict de Saussure (1740–99), a naturalist and geol-
ogist whose *Voyage dans les Alpes* was to be published between
1779 and 1796, who guided them around the glaciers of the
Alps. Though Pars seems to have been expected to record such
natural phenomena in an objective and scientific spirit, in the
resulting watercolours he succeeded in conveying the scale and
grandeur of the Alps in a way that makes the best of his Swiss
drawings extraordinarily impressive.

Michael 'Angelo' Rooker 1743–1801

44 *Entrance to a Park*

Pen and ink with watercolour; 457×351mm
Inscribed (? in a later hand): *M. A. Rooker*
1889-6-3-261 (L.B. 5)

Rooker was taught engraving by his father Edward Rooker and
drawing by Paul Sandby, who gave him the nickname Michael
'Angelo'. In both technique and choice of subject matter Rooker's
work is a development of Sandby's; he was chiefly a topograph-
ical draughtsman, combining accurate description with a new
feeling for the inherently picturesque value of ruined buildings
and details of landscape. His early employment as an engra-
ver for such publications as *The Copper Plate Magazine* is reflec-
ted in the delicate, near-monochrome tones and precise
handling of this watercolour. Rooker was also closely associated
with the theatre, and was regularly engaged as a scene painter
at the Haymarket Theatre. According to Edward Dayes, Rooker
was disappointed by 'the neglect of an undiscerning public' and
'drooped into eternity'.

Thomas Hearne 1744–1817

45 *Newark Castle, Nottingham*

Watercolour over grey wash and pencil; 203×254mm
Signed: *Hearne*
1859-5-28-201 (L.B. 9) Presented by John Henderson

Plate 32

46 *Elvet Bridge, Durham*

Watercolour with touches of ink over grey wash; 203×255mm
1859-5-28-207 (L.B. 6) Presented by John Henderson

Hearne was one of the leading topographical draughtsmen of
his day; in the early 1770s he spent almost four years in the
West Indies as draughtsman to the Governor of the Leeward
Islands (a view of Antigua is in the British Museum). On his
return he devoted himself almost exclusively to British anti-
quarian subjects and landscape, his most ambitious project
being the joint publication with William Byrne of *The Antiquities
of Great Britain*, issued in parts between 1777 and 1806. *Newark
Castle*, drawn in 1777 but not published until 1796, illustrates
his power of conveying a sense of scale and grandeur within a
small format. *Elvet Bridge* is a later and more elaborate version
of a watercolour dated 1781 (Ashmolean Museum, Oxford),
which the artist probably made in the 1790s for one of his
patrons, John Henderson, by whose son it was presented to the
British Museum. Hearne used watercolour with great delicacy,
restricting himself to a limited range of colours – in this case
chiefly blue, grey and buff, with an occasional touch of red –
and concentrating on tonal values to suggest the glow of light,
reflections in water and the varying textures of rough surfaces.
This emphasis on tone rather than on colour characterises the
work of a number of water-colourists of the period and derives
from J.R. Cozens; it was to become a particular feature in the
early works of Girtin and Turner, both of whom were influenced
by Hearne. His feeling for atmosphere enabled him to transcend
the limitations of the topographical genre, and his work was
much admired by discerning collectors, in particular Sir George
Beaumont and Dr Thomas Monro, the physician and amateur
draughtsman who established an informal academy for young
artists in his house in the Adelphi.

Thomas Hearne 1744–1817

47 *An Oak Tree*

Pen and brown ink, watercolour; 506×343mm
Inscribed: *Hearne*
Oo.5–37 Payne Knight Bequest, 1824 *Plate 33*

This is one of a number of watercolours made by Hearne between 1784 and 1786 recording the landscape at Payne Knight's Herefordshire estate, Downton Castle; the main series of twelve watercolours, showing his improvements to the park, is in the collection of his descendant, Denis Lennox. In his didactic poem, *The Landscape*, published in 1794, Payne Knight attacked the style of landscape gardening practised by 'Capability' Brown and his followers: '. . . wrapt all o'er in everlasting green,/Makes one dull, vapid, smooth, unvaried scene.' Instead, he advocated variety, irregularity and the evocation of wild, natural scenery, ideas which he had developed in the course of building the new house at Downton and altering the grounds in the 1770s and early 1780s. The dramatic setting on the banks of the River Teme was described by one visitor as 'the most wild, rich, and solitary path I ever trod', while 'the walk through the wood surpasses anything I have ever seen of the kind' (*Greville Memoirs 1824–1860*, 1938, vol. IV, p.182).

William Hodges 1744–1797

48 *View on the Island of Otaheite (Tahiti)*

Brush drawing in grey wash with watercolour over pencil; 369×538mm
Inscribed on the *verso: A View in the Island of Otaheite from the Land looking towards the Reef & Sea. and which has much the appearance of the Low coral Reef Islands, the Plants as Coco Nut Trees. & Plantain which are indiginous there. Drawn from Nature by W Hodges in Year 1773.*
1890-5-12-107 (L.B. 2) *Plate 34*

Hodges accompanied, as draughtsman, Captain Cook's second expedition to the South Seas, 1772–5. Cook's voyages were the first to be systematically recorded by complementary visual and written accounts. Between 1768 and 1780 as many as 3,000 drawings were made of discoveries in the spheres of natural history and anthropology, as well as of the landscapes of the countries visited.

The present drawing, however accurately observed, is more than a straightforward topographical record. Hodges's approach is conditioned by current notions of composition – the tall tree to the left acting as a framing device – and the influence of the rococo landscapes of his master Richard Wilson can be seen in the sinuous lines of the coconut palms silhouetted against the sky. A version of the drawing now in the Honolulu Academy of Arts was used as the basis for William Wollett's engraving of a *Toupapow in Tahiti* (see Isabel Combs Stuebe, *The Life and Work of William Hodges*, 1979, nos 95, 95 bis and 97).

Hodges became a Royal Academician in 1787, exhibiting regularly from 1776 to 1794. His reputation is chiefly as a painter of exotic subjects worked up from studies made during Cook's voyage and during a visit to India between 1780 and 1783.

John Cleveley the Younger 1747–1786

49 *The 'Racehorse' and 'Carcass' forcing their way through the Ice, August 10th 1773*

Watercolour and wash with pen outlines; 363×460mm
Signed: *Jnº Cleveley Jun.'. Delint*
1888-12-11-2 (L.B. 2) *Plate 35*

The son of a draughtsman and shipwright, Cleveley was a pupil of Paul Sandby who between 1768 and 1796 was chief drawing-master at the Royal Military Academy, Woolwich. Through Sandby, Cleveley was introduced to Sir Joseph Banks, President of the Royal Society and the leading natural historian of the day. In 1772 Cleveley accompanied Banks to the Orkneys and Iceland, and in 1773 was appointed draughtsman to Commodore Phipps's expedition which was intended to 'make discoveries towards the North Pole', including, it was hoped, a northerly passage to India. In fact, the ships foundered in the ice-floes off Spitzbergen and were forced to return, but Phipps's journal of the voyage, and the official account published in 1774 and illustrated with engravings after Cleveley's drawings, aroused considerable public interest in such journeys of exploration.

This drawing (there are others connected with Phipps's expedition in the National Maritime Museum and in the Victoria and Albert Museum) shows the two sloops *Racehorse* and *Carcass* (on which Nelson was serving as a midshipman) making their way through the ice near Spitzbergen. It was probably worked up from a sketch made on the spot in 1773, and seems to have been exhibited at the Royal Academy in 1774; it was etched by P.C. Canot for the *Voyage towards the North Pole . . .*, 1774.

Thomas Malton 1748–1804

50 *St Lawrence Jewry and the Guildhall*

Watercolour with pen and ink; 329×478mm
1880-11-13-3594 Crace Collection *Plate 36*

The son of a minor artist who wrote a work on perspective, Thomas Malton followed his father's speciality of architectural subjects, especially the streets, squares and important buildings of London. His views derive from the type established by Canaletto in the 1740s, and are similarly based on long receding perspective lines often with a building in shadow cut off at one side in order to lead the eye into the composition. In this drawing, the sunlit Guildhall on the far side indicates, as it were, the way out.

Between 1792 and 1801 Malton published a series of one hundred aquatints based on his drawings, *A Picturesque Tour through the Cities of London and Westminster*. Here he is exploiting a phrase popularised by the Rev. William Gilpin, although as used by Malton it means no more than 'illustrated'. These aquatints form the fullest record of the appearance of London at that period. This watercolour, dated 1783, shows Wren's church of St Lawrence Jewry with the old Guildhall on the right. In the aquatint, published in 1798, Malton followed it closely. He brought the dress of the figures up to date and altered the background on the right in order to take into account the new façade of the Guildhall added by George Dance in 1789–90.

Malton also painted scenery for Covent Garden, and in 1789 opened an evening drawing school, where one of his pupils was the youthful Turner whose architectural subjects of the 1790s reflect his influence particularly in their low, often oblique, viewpoint.

John 'Warwick' Smith 1749–1831

51 *The Church of SS Trinità dei Monti, Rome*

Watercolour over pencil with pen outlines; 341×541mm
Inscribed: *13*
1936-7-4-22 *Plate 37*

'Warwick' Smith was sent to Italy in 1776 by the second Earl of Warwick; he stayed until 1781, when he returned to England in the company of Francis Towne. The finest of his Roman watercolours remained in the Warwick collection until 1936, when they were acquired by the British Museum.

Glimpses of Smith's life in Rome are to be found in the memoirs of Thomas Jones and these provide a possible date for this watercolour. In July 1779, Jones recorded: 'Smith returned from Naples where he had sojourned ever since March last twelvemonth – and took *Appartments* at the *Monaco*, a house standing singly under the hill of the *Trinida de Monti*. On top of this house was a delightful Loggia or Open Gallery where we spent many agreeable Evenings *with Song and Dance &c.*' A watercolour by Jones of almost exactly the same view was doubtless taken from the same vantage point.

Stylistically, this watercolour has more in common with the precisely drawn and delicately tinted urban views by such artists as Dayes (no. 64) or Malton (no. 50), than with Smith's own more broadly handled and atmospheric studies of a year or so later.

John 'Warwick' Smith 1749–1831

52 *SS Giovanni e Paolo, Rome, with S. Stefano Rotondo in the distance*

Pencil, watercolour and ink; 380×529mm
Inscribed *verso*: *Part of Monte Caelio Rome J Smith 193*
1936-7-4-24 *Plate 21*

This drawing was almost certainly made on the same occasion as another recording the same subject by Francis Towne (no. 32) – 20 November 1780. Smith's watercolour, which he left unfinished, is a more panoramic view than Towne's, extending the composition at the right to include the church of S. Stefano Rotondo. Smith worked on a broader and bolder scale than Towne in a manner which anticipated the atmospheric watercolours of the next generation, in particular Girtin and Turner. This drawing also has something in common with oil-sketches made from nature by contemporaries such as Thomas Jones and Valenciennes. Smith's subsequent work, dating from the years after his return to England in 1781, is by comparison much more conventional, and his reputation has suffered from the many indifferent repetitions he made of earlier watercolours.

John 'Warwick' Smith 1749–1831

53 *An Arcade of the Colosseum*

Watercolour and indian ink over pencil; 512×668mm
Signed: *IS* (in monogram)
1936-7-4-10

54 *Stonework in the Colosseum*

Watercolour and indian ink over pencil; 390×533mm
Inscribed *verso: In the Colosseum Rome 176*
1936-7-4-13 *Plate 38*

The Colosseum, in its picturesquely overgrown and ruinous
state, was a popular sketching ground for artists from the
sixteenth century until the late nineteenth century, when the
luxuriant growth of plants and flowers which gave the ruin
much of its romantic quality was finally cleared away. In their
sense of scale, Smith's drawings of the Colosseum have
a sublime quality that anticipates Turner's early large-scale
watercolours.

John Webber *c.*1750–1793

55 *View in Nootka Sound, on the Pacific Coast of
North America*

Pen and black ink over pencil with grey wash and watercolour;
515×368mm
Signed and dated: *J Webber. del. 1778*
1859-7-9-102 (L.B. 11) *Plate 22*

Webber succeeded William Hodges as draughtsman on Captain
Cook's third and last voyage to the South Seas, 1776–80; he
was among those who witnessed Cook's death in Hawaii in
February 1779. The present watercolour was made in the
course of the expedition, such studies forming the basis of
larger and more elaborate compositions which were sub-
sequently engraved for the official account of the journey,
published in 1784. This publication was intended for a serious
audience, but in 1808 Boydell issued a further series of engrav-
ings catering to a less scientific interest in the exotic.

John Robert Cozens 1752–1797

56a *View on the Linth*

Pen and ink with grey wash; 234×357mm
Inscribed on the *verso: 46*
1900-4-11-9

b *Fall on the Linth*

Pen and ink with grey wash and watercolour; 355×231mm
1900-4-11-16

These two drawings are part of a series of twenty-four acquired
by the British Museum in 1900. They are recorded as having
come from an album containing fifty-seven such drawings, in
which was inscribed: *Views in Swisserland, a present from R.P.
Knight, and taken by the late Mr Cozens under his inspection during a
tour in Swisserland in 1776.* Such evidence as there is bears out
the statement that Cozens accompanied Payne Knight to Italy
in 1776 and made the drawings for him, and that the album
was not included in Payne Knight's bequest of his collections to
the British Museum in 1824 because he had given it away to a
friend, apparently the collector John Towneley of Chiswick, in
whose sale in May 1816 it was lot 394.

Cozens's Alpine views played an important part in encouraging
the taste for dramatic landscape. They were later to be admired
and copied by Turner and Girtin when youthful students in Dr
Monro's academy. These drawings have in the past been re-
garded as the original sketches made directly from nature, on
the spot, but Paul Oppé (*Alexander and John Robert Cozens*, 1952,
p.128) has argued convincingly that 'their general uniformity,
the deftness of the handling and the assurance of the compo-
sition would suggest that the series was made at one time, as a
souvenir of the journey'. As he did on his second visit to Italy
with Beckford in 1782–3 (*cf* no. 60) Cozens presumably made
rapid sketches in pencil and perhaps monochrome wash, re-
cording the essential facts of the composition; but whereas
Beckford acquired and preserved the later group of sketch-
books, the earlier ones have disappeared (though see nos 58,
59). The drawings in the Payne Knight series stand out from
most of Cozens's work in being not watercolours so much as
tinted pen drawings (a fact that no doubt encouraged the belief
that they were the original sketches). They suggest a quality of
considered simplification, with a consequent grandeur which is
cumulatively impressive. The emphasis on outline suggests the
possible influence of the slightly earlier Alpine views by William
Pars (*cf* no. 43a–d), a group of which had been exhibited in
1771. Pars was in Rome from 1775 until his death in 1782, and
Cozens certainly knew him.

John Robert Cozens 1752–1797

57 *From the Road between the Lake of Thun and
Unterseen*

Watercolour; 237×365mm
1910-2-12-242 Salting Bequest *Plate 40*

This is one of a number of more elaborate watercolours based on studies made by Cozens in Switzerland in the late summer of 1776 (see nos 56a, b). Other comparable examples are dated 1778 and 1779, which shows that he must have worked up some at least of these subjects while he was in Rome between the autumn of 1776 and April 1779. This watercolour is an elaborated version of a composition of which there is also a drawing belonging to the same series as the twenty-four Payne Knight drawings now in the British Museum (nos 56(a), (b)). This drawing, now in the Yale Center for British Art, is inscribed on the *verso* in the artist's hand with the topographical details.

Comparison between the studies made for Payne Knight and the softer, more atmospheric and romantic character of this watercolour, show Cozens's developing mastery of subtle effects of light and tone despite the use of a very limited range of colour – soft greys with touches of blue.

John Robert Cozens 1752–1797

58 *Lake Nemi, looking towards the Palazzo dei Cesarini*

Watercolour over pencil; 370×534mm
Gg 3–395 Cracherode Bequest, 1799

59 *Lake Nemi*

Watercolour over pencil; 360×522mm
1958-7-12-332 Lloyd Bequest *Plate 41*

Cozens, who had accompanied Payne Knight to Italy in the autumn of 1776 (see no. 56) was in Rome by 27 November, when Thomas Jones records meeting him with other 'Old London Acquaintances', at the English Coffee House. Dated inscriptions on drawings in a volume in the Soane Museum show that he was sketching in the Alban Hills in April 1777, and there are glimpses of him in Jones's memoirs. On 1 June 1778 Jones records 'many very agreeable excursions to a Villa near S'a Agnese without the Porta Pia', belonging to a Signor Martinelli with whom 'Little Couzins the landscape painter lodged in Rome'. On 8 April 1779 he recorded Cozens's departure for England.

The Alban Hills, extinct volcanoes the craters of which had become lakes, had attracted artists since the seventeenth century, and from the 1750s onwards the area became a favourite with French and British artists in Rome. Cozens's views of Lake Albano and Lake Nemi were his most popular and frequently repeated subjects; in some cases there are as many as eight or nine slightly different versions of the same composition. They are not easy to date, for Cozens's work is not susceptible to straightforward stylistic analysis. In some ways, his art is more closely dependent on the then received conventions of picture-making than, say, Thomas Jones's oil sketches or Francis Towne's watercolours. Cozens was deeply influenced by the work of Claude, not only in his compositions – the *repoussoir* motifs which he often employs and a similar treatment of receding, misty distances – but also, to some extent, in mood. The origin of the uniquely melancholy beauty of Cozens's art may be seen in the elegiac quality of many of Claude's paintings. Cozens's achievement lay in the transformation of such classical prototypes into genuinely romantic works.

No. 58 was bequeathed to the British Museum, two years after the artist's death, by the Rev. Clayton Mordaunt Cracherode, who had been one of the subscribers to a fund for Cozens's support during his last years of insanity. Cozens died in the care of Dr Thomas Monro, in whose collection the young Girtin and Turner studied his work.

John Robert Cozens 1752–1797

60 *The Castle of St Elmo, Naples*

Watercolour over pencil; 305×450mm
Signed and dated: *J. Cozens 1790* and inscribed on the *verso*, *Castle of S'. Elmo at Naples Mrs Mo. . .ters* (indistinct)
1981-3-28-1 *Plate 39*

Cozen's second visit to Italy in 1782 was in the entourage of his father's friend and patron, the young millionaire William Beckford, collector and author of the fantastic oriental novel *Vathek*, and future creator of the no less fantastic Fonthill Abbey. Beckford's letters and the seven sketchbooks filled by Cozens during the tour (subsequently in the possession of Beckford's descendants, the Dukes of Hamilton, and now in the Whitworth Art Gallery, Manchester) record their progress through Germany and the Alps and then by way of Venice and Rome to Naples. They arrived there early in July and based themselves at Sir William Hamilton's villas at Posilippo and Portici. Beckford remained in Naples only until September. He was temperamental, whimsical and spoilt, and was not the easiest of patrons; but though he was later to refer to Cozens as 'an ungrateful scoundrel', at the time he seems to have valued his ability to express in visual form those sentiments of poetic melancholy that suffuse his own letters and travel-journals. For the melancholic and physically frail Cozens (he suffered from fever in Naples) the departure of his patron can only have been

a relief: Thomas Jones, who was also then in Naples, noted in his journal, 'Cousins once more a free Agent and loosed from the Shackles of fantastic folly and Caprice'. He stayed on until the beginning of December and then returned to Rome, where he remained until the following September. By November 1783 he was back in London.

As he did after his first visit to Italy (see nos 58 and 59), Cozens used his sketches as the basis for finished watercolours. Like the present example, inscribed with the date 1790, these were often made long after his return; and in the case of the more popular subjects, in more than one version, sometimes in as many as eight or nine. Beckford owned a matchless collection of ninety-four watercolours of Italian subjects, many of which were presumably drawn on the spot since there are no corresponding sketches. He and Alexander Cozens were intimate friends, but it is clear that he found the son temperamentally unsympathetic. His name is conspicuously absent from the list of those who subscribed to support J. R. Cozens in his last years, and as his taste for the gothic and the exotic developed he must have found the drawings increasingly old-fashioned, for in 1805 he dispersed the whole collection at auction.

The watercolour of the Castle of St Elmo, based on a sketch dated 10 November 1782, is the only known finished drawing of the subject. It is among the most striking and austerely beautiful examples of the artist's later style, and in its almost abstract treatment of forms and spatial relationships it suggests a parallel with Thomas Jones's Neapolitan oil sketches made at much the same time (cf no. 41). Cozens has allowed nothing to distract attention from the cliff-like wall of the Castle, which he treats as if it were an Alpine precipice, its towering scale exaggerated by the introduction of the diminutive shepherd in the foreground. It is hardly surprising that such an uncompromisingly stark and sublime image failed to attract commissions for other versions.

Francis Nicholson 1753–1844

61a *Stourhead: the Lake and Bridge, with the Temple of Apollo and the Pantheon*

Watercolour with ink wash; 406×555mm
1944-10-14-137 Presented by Miss M.H. Turner

b *Stourhead: The Bristol High Cross*

Watercolour over pencil with ink wash: 405×552mm
1944-10-14-139 Presented by Miss M.H. Turner *Plate 42*

c *Stourhead: View of Alfred's Tower*

Watercolour with ink wash; 410×561mm
1944-10-14-143 Presented by Miss M.H. Turner

These watercolours are part of a series of twenty-five, all now in the British Museum, which record the appearance of the grounds at Stourhead at the period of their full maturity, *c.* 1813–16. This celebrated landscape garden, with its temples and a grotto grouped round a lake, was mainly created by Henry Hoare the younger (1705–85), who had inherited the estate in 1741. His intention was to create a real landscape in imitation of the idealised Virgilian scenes painted in Rome in the previous century by Claude Lorrain, Nicolas Poussin and Gaspard Dughet (see Kenneth Woodbridge, *Landscape and Antiquity*, 1970). From the 1760s onwards, however, he began to introduce into his landscape a number of exotic features, some Gothic and some oriental, which can be seen in these watercolours.

In 1783 Henry Hoare made over Stourhead to his grandson, the antiquary and historian of Wiltshire, Richard Colt Hoare (1758–1838) and it was he who commissioned the series of views from Francis Nicholson. He made a number of changes to the landscape, in an effort 'to render the design of these gardens as chaste and correct as possible', and in the early 1790s embarked on a massive planting programme which was to give the lakeside its present character of an arboretum. Some of these developments can be seen in no. 61a, where the Temple of Apollo appears almost to float above the densely grouped trees.

The cycle of nature and art at Stourhead came full circle in Nicholson's watercolours, in which the landscape garden, itself based on art, is translated back into a series of ideal landscape compositions. Nicholson might almost have been thinking of Henry Hoare's principles of planting when painting the series: 'The greens should be ranged in large masses as the shades are in painting, to contrast the *dark* masses with the *light* ones, and to relieve each darkness itself with little sprinklings of lighter greens here and there'. A founder member of the Old Water-Colour Society in 1804 and a fashionable drawing-master, Nicholson was essentially a rather old-fashioned artist whose style seems to have been crystallised in the picturesque manner of the 1780s and 1790s; his drawing manual, *The Practice of Drawing and Painting Landscapes from Nature in Water Colours* was published in 1820.

Thomas Stothard 1755–1834

62 *The Avon at Clifton*

Pen and watercolour; 200×265mm
Inscribed: *Oct 9 & 11 1813*
1884-2-9-25 (L.B. 139) Presented by Professor Colvin
Plate 44

Stothard was above all a figure-painter, draughtsman and prolific book illustrator working in a style influenced by that of Blake and Flaxman; his occasional landscapes are little known. His attachment to nature (he was fascinated by butterflies and in 1809 discovered one previously unknown in England, the Mountain Ringlet) and his life-long practice of sketching were noted by early biographers.

As a boy Samuel Palmer received advice from Stothard, who was a friend of his grandfather, although there is no evidence that he knew Stothard's landscapes.

William Blake 1757–1827

63 *Beatrice on the Car, Matilda and Dante*

Pen and watercolour over pencil; 367×520mm
Inscribed: *P-g- Canto 29*
1918-4-13-5
Plate 45

Though Blake himself can hardly be thought of as a landscape artist, he was a powerful influence on a group of younger painters whose perception of landscape was in great measure shaped by his vision – John Linnell and his son-in-law Samuel Palmer and the latter's circle, the so-called 'Ancients'. It was through Linnell, his most loyal supporter and patron in the 1820s, that Blake was commissioned to illustrate Thornton's *Virgil* (1820–1), and it was Linnell who in 1824 commissioned his final project, a series of watercolours to be engraved as illustrations to Dante's *Divine Comedy*, which he left unfinished at his death. For the young Samuel Palmer, the designs for Thornton's *Virgil* were '. . . visions of little dells, and nooks, and corners of Paradise: models of the exquisitest pitch of intense poetry'. Palmer may have added something of his own vision of landscape to his interpretation of the Virgil series, for a note in Blake's hand on one of the Dante watercolours suggests that his own view of nature was more equivocal: 'Every thing in Dante's Comedia shows that for Tyrannical Purposes he has made This World the foundation of All, & the Goddess Nature Memory is

his Inspirer & not the Imagination the Holy Ghost'. Nevertheless, Blake also had an intense delight in, and identification with, the natural world. Palmer later recalled to Blake's biographer, Alexander Gilchrist: 'To walk with him in the country was to perceive the soul of beauty through the forms of matter'.

In this watercolour, an illustration to *Purgatorio*, XXIX, 13–150, Matilda, seen standing in the Earthly Paradise, bids Dante heed the approaching procession, described with many allusions to the Book of Revelation, from which are taken the seven-branched candlestick, the four and twenty elders, and the chariot drawn by a gryphon. Beatrice is on the chariot; Virgil and Statius, Dante's companions, stand at the right.

Edward Dayes 1763–1804
and Robert Thew 1758–1802

64 *Hanover Square*

Pen and ink with watercolour, lightly squared for transfer; 385×545mm
Inscribed: *Thew* and *Dayes*
1880-11-13-4535 (L.B. 6) Crace Collection
Plate 43

Dayes was one of the leading topographical artists of the late eighteenth century. His technique for this type of drawing, which he described in *Instructions for Drawing and Colouring Landscapes*, was essentially a development of that practised by the Sandbys (see nos 13, 21): to a careful outline drawing of the composition he first added the dead colouring with blue and grey wash, and finally the warm colour over the preliminary washes of cold colour, taking care to avoid 'introducing the colour of an object in its shade' (a technique which, like Girtin and Turner, he largely abandoned in the 1790s).

Although Dayes was not primarily an urban togopgrapher, this drawing of Hanover Square was one of a series of four such views he made in the late 1780s, the others being Bloomsbury Square, Grosvenor Square and Queen Square. They were engraved in aquatint by Dodd and Pollard between 1789 and 1791, and Dayes also repeated the compositions in oil paintings. To judge from the joint inscription, the figures – which add much to the liveliness and charm of the composition, even though they are somewhat out of scale – were by Robert Thew. Like Malton's views, published a little later (see no. 50), Dayes shows London as a clean, bright, elegant city under sunny skies; his detail is sharp and so complete that nothing is left to the imagination. In a way, such artists were unconscious propagandists for the speculative builders and their clients who were developing and populating the expanding city.

Edward Dayes 1763–1804

65 *Corwen, Merionethshire*

Pencil, grey wash, watercolour and bodycolour; 223×272mm
Signed: *E Dayes*
1861-8-10-85 (L.B. 2(b))

In the course of the 1790s, Dayes abandoned the precisely outlined, tinted drawing manner illustrated by no. 64 for a bolder and more atmospheric approach. This view of a cottage in Wales is close in style to the work of his pupil Girtin, whose influence it may reflect. It probably dates from the mid-1790s, when Girtin and Turner were developing a bolder handling and a more dramatic treatment of light and shade. Dayes, on the other hand, seems not to have shared their taste for 'sublime' subjects – the rugged landscapes of North Wales and Northern England – but restricted himself, as here, to picturesque motifs. The cottage is seen from a low viewpoint which allows only a glimpse of the rocky hillside and the eye is focused on the irregular shapes and outlines, the rough and varied textures, and the broken colours – in short, on all the elements that at the end of the eighteenth century would have seemed 'picturesque'.

William Alexander 1767–1816

66 *Pingze Men, the Western Gate of Peking*

Watercolour over pencil with touches of black ink:
284×448mm
Signed and dated: *W. Alexander. f. 1799*
1882-8-12-225 (L.B. 13) *Plate 46*

Alexander was the first Keeper of Prints and Drawings at the British Museum, being appointed in 1808. He had had a respectable career as a draughtsman of topographical subjects and for the previous six years had been Master of Landscape Drawing at the Royal Military College, Great Marlow. Although his own style was not innovative he associated with, and to some extent was influenced by, the most progressive young artists of the day, being a member of Girtin's Sketching Club, and copying drawings in the collection of Dr Monro where his fellow-students included Turner and Cotman.

It is for his Chinese subjects that Alexander is best known. He accompanied Lord Macartney's embassy to Peking in 1793–4 and was the only artist of the period to visit the interior of China. After his return to England he made numerous drawings

worked up from sketches taken on the spot, publications including engravings after his views of China continuing to appear as late as 1814. Another version of the present drawing is in the Museum and Art Gallery at Maidstone (Alexander's home town); an engraving by J. Dadley, dated 1796, appears as Pl. xx to Sir George Staunton's *Authentic Account of an Embassy from the King of Great Britain to the Emperor of China.*

Pingze Men, the main western gate of Peking, was demolished in the 1950s together with the walls shown in the drawing, but the bridge in the foreground still stands.

George Barret the Younger 1767–1842

67 *Willesden*

Pencil and watercolour; 239×349mm
Inscribed: *The Village of Wilsden Augst 10 1826*
1910-2-18-25 Presented by Mrs Robert Low

Barret is best known for the elaborate, idealised Claudian compositions emulating the effect of oil paintings, which he exhibited at the Society of Painters in Water-Colours from the mid-1820s, but his informal studies from nature of landscapes around London, coast scenes and views in Wales have an attractive quality of direct observation.

John Glover 1767–1849

68 *A Rocky Gorge*

Watercolour; 107×183mm
1948-4-10-12 Presented by F. J. Nettlefold *Plate 47*

One of the founder members of the Society of Painters in Water-Colours, and a prolific contributor to their early exhibitions (he showed 176 works between 1805 and 1812), Glover was the leader of the group who broke away in 1813 to set up the rival Society of Painters in Oil and Water-Colours. His public style (rather like that of William Havell) was the classic pastoral landscape conceived in emulation of Claude, which made him popular with conservative-minded patrons but earned him the criticism of more forward-looking artists like Constable, who considered Glover a mere pasticheur. However, Glover also made numerous small-scale studies, which are striking in their freshness and immediacy. He was well known for his technique of dividing the hairs of the brush into small sections

George Barret the Younger *Willesden* (no.67)

Cristall was one of the original members of the Society of Painters in Water-Colours, founded in 1804; he was unusual, however, in being essentially a figure-painter.

It was probably at the suggestion of one of his patrons, James Vine, who lived at Niton on the Isle of Wight, that Cristall visited the island in 1812. This watercolour (which is in particularly good condition, having been kept in an album), exhibited at the Society of Painters in Water-Colours in 1815, makes an interesting link between the eighteenth-century rustic genre scenes of Francis Wheatley and George Morland and their Victorian counterparts such as Birket Foster and Helen Allingham. Ackermann's *Repository of the Fine Arts*, in a note on a similar work by Cristall remarked: 'Such as we wish to meet in every village are here represented by the elegant mind of this artist . . . the group of figures, nay, the whole picture, raises in the mind of the spectator none but images of pleasure'. This idealised view of the supposed charms of rural life was characteristic of many writers and painters of the period.

Samuel Owen *c*.1768–1857

70 *Loading Boats in an Estuary*

Medium; 595×864mm
Signed and dated: *S. Owen 1809*
1872-2-10-1 (L.B. 3) *Plate 50*

The long-established tradition of marine painting in England was given new life by Turner, some of whose earliest important works were of this genre. Among his contemporaries, Samuel Owen (who outlived him, although fourteen years older) is representative of the more conventional approach to such subjects. The present watercolour, however, shows that he was capable of absorbing Turner's example without descending to pastiche. The large scale of this drawing reflects the desire felt by many watercolourists at the beginning of the nineteenth century to challenge the effects of oil paintings.

and going over the surface of his watercolours with scumbled, feathery strokes of black or grey Indian ink to suggest the play of light, a device clumsily imitated by numerous followers, but, as in this study, capable of achieving considerable liveliness.

Glover emigrated to Tasmania in 1831, where he painted some of his most original works; whether or not this watercolour shows an English or Tasmanian view is uncertain.

Joshua Cristall 1768–1847

69 *A Cottage at St Lawrence, Isle of Wight*

Watercolour touched with white over pencil; 326×466mm
Signed and dated: *Joshua Cristall 1814*
1980-10-11-1 *Plate 48*

Henry Edridge 1769–1821

71 *Singer's Farm, near Bushey, Hertfordshire*

Watercolour over pencil; 314×469mm
Inscribed on the *verso* of the old mount: *Oct 17 1811 Singers or Sherwoods Farm Bushey*
1845-8-18-7 (L.B. 34)

Edridge worked chiefly as a portraitist in pencil and wash but he was associated with Dr Monro's circle and made a number of landscape watercolours. The rich colours of the present drawing are typical of his palette in contrast to the cooler blues and greys used by most of his contemporaries.

He rented a cottage at Bushey in 1811 and made at least one other watercolour of Singer's or Sherwood's Farm (*Farmhouse with Pigs* in the Victoria and Albert Museum, dated 15 October 1811). It also appears in a drawing in the Victoria and Albert Museum by Thomas Hearne, in a version of the present watercolour attributed to William Henry Hunt (Yale Center for British Art), and in a drawing by Dr Monro's son Henry in a private collection (reproduced in Andrew Wilton, *British Watercolours 1750 to 1850*, 1977, pl.61).

Dr Monro's circle treated the cottage subject with a realism totally at odds with the sentimentality of Cristall's idealisation (no. 69). Edridge's particular notion of the Picturesque is indicated by a revealing parallel expressed in a letter to Dr Monro written in 1817 describing his delight with what he saw in France: 'Magnificence and Filth – the Formal and the Picturesque' (quoted in Hammond Smith, 'The Landscapes of Henry Edridge, A.R.A.', in *The Old Water-Colour Society's Club*, Vol. LII, 1977, pp.9–24).

Joseph Michael Gandy 1771–1843

72 *Landscape with Temples*

Pen, ink, watercolour and bodycolour with gum arabic;
441×666mm
1958-7-12-6 Presented by Miss J. Martin *Plate 49*

Gandy was trained as an architect first in James Wyatt's office, subsequently at the Royal Academy schools (where he was awarded a Gold Medal), and then in the office of Sir John Soane. He practised with little success, however, for he belonged to the generation that came to professional maturity during the French Revolutionary wars, when resources and attention were diverted from architectural patronage. As Sir John Summerson, who gives an account of Gandy's few executed buildings (these were, as one would expect, in the neo-classic, Soanesque style) commented, 'there was too much to think about, to little to do. It was an age for poets rather than architects' (*Heavenly Mansions*, 1949, pp 111 ff). Gandy took to making drawings of architectural fantasies, of which this is a characteristic example, supported by Soane who employed him to make drawings of his more imaginative and unrealisable designs as they would have looked if they had been carried out. Gandy's *Pandemonium*,

1805, anticipates the grandiose architectural sublime of John Martin.

Thomas Girtin 1775–1802

73 *Wetherby Bridge, Yorkshire*

Watercolour with pen and ink; 319×521mm
1855-2-14-7 (L.B. 40) Presented by Chambers Hall *Plate 51*

Compositionally this watercolour is indebted to the example of Canaletto, whose paintings and drawings were extremely influential on the young Girtin. The use of the arched shapes of the bridge, seen in close-up, to frame the background was probably derived from Canaletto, who employed this device to more overtly dramatic effect in *St Paul's seen through an arch of Westminster Bridge*, engraved in 1747. English artists who developed similar compositions included Samuel Scott and William Marlow, whose paintings Girtin doubtless knew. The inclusion of the two women framed in the right-hand arch recall staffage groups in French and Italian seventeenth-century landscapes and suggest that Girtin was trying to achieve an idealised Picturesque idiom.

Thomas Girtin 1775–1802

74 *An old Cottage at Widmore, near Bromley*

Watercolour; 308×516mm
Signed: *Girtin*
1958-7-12-346 Lloyd Bequest

One of a number of watercolours made by Girtin *c*.1798–9 in the area around Bromley, where his pupil Amelia Long, Lady Farnborough, lived. This is among the most consciously Picturesque of Girtin's works, and perhaps reflects the influence of his patron Dr Thomas Monro. Another protégé of Monro's, Henry Edridge, is represented in this exhibition by a watercolour of a very similar subject (no. 71).

Thomas Girtin 1775–1802

75 *Near Beddgelert*

Watercolour; 168×223mm
1855-2-14-18 (L.B. 11) Presented by Chambers Hall

Plate 52

76 Near Beddgelert

Watercolour; 290×432mm
1855-2-14-52 (L.B. 39) Presented by Chambers Hall *Plate 53*

In 1798 Girtin made a tour of North Wales, exhibiting at the Royal Academy in the following year two works each entitled *Beth Kellert, North Wales*; it is probable that no. 76 was the study for one of these two exhibits. Both watercolours shown here seem to be connected with this sketching tour, although it is difficult to know to what extent they were made in front of the motif; no. 75 – perhaps a leaf from a small sketchbook – is among Girtin's most subtly expressed depictions of the misty, rain-laden atmosphere of the Welsh mountains. No. 76 has a grandeur and sublimity new to Girtin's work, and is in some ways a bolder interpretation of the wildness of the landscape than the more refined, finished watercolour of the same subject (Girtin and Loshak, *The Art of Thomas Girtin*, 1954, Fig. 45). The critic of *The True Briton* in his review of the 1799 exhibition noted of Girtin's *Beth Kellert* that 'it exhibits all the bold features of genius' – a comment equally applicable to this study.

In the autumn of 1799 Turner visited the same area, and made a group of large studies from much the same viewpoint, perhaps influenced by the example of Girtin. Turner's response to the landscape of Snowdonia, however, had a different emphasis: he seems consciously to have perceived it as a visual metaphor for the historical and mythological themes which preoccupied him at this period.

Thomas Girtin 1775–1802

77 Cayne Waterfall, North Wales

Pen and ink with watercolour; 502×604mm
1855-2-14-2 (L.B. 55) Presented by Chambers Hall *Plate 54*

A more developed watercolour of the same subject and of exactly the same size is in the J. Leslie Wright Collection in the Birmingham City Museum and Art Gallery. The present unfinished study was probably made during or shortly after Girtin's tour in North Wales in 1798. It is not clear whether he was here working in colour directly from nature, but the unwieldy size of the sheet suggests that he probably was not. Ruskin's sympathy with his careful attention to geological detail led him to near-ecstatic praise: 'There is perhaps no greater marvel of artistic practice and finely accurate intention existing'. What is certainly striking is the monumental scale with which Girtin has treated an isolated natural motif.

Thomas Girtin 1775–1802

78 The Great Hall, Conway Castle

Watercolour; 368×209mm
Signed: *Girtin*
1855-2-14-63 (L.B. 37) Presented by Chambers Hall *Plate 56*

There is uncertainty about the dating of this watercolour: it has been related to Girtin's tour of Wales made in 1798 and also to a supposed visit in 1800, when he may have stayed with Sir George Beaumont, who spent much of that summer near Conway. The castle was a popular subject with topographical artists: Sandby made several views of Conway, and both De Loutherbourg and Turner exhibited paintings of the castle *c.*1801–3. Girtin's choice of motif here, however, is very different from theirs, and instead of showing the castle as the focus of a landscape composition, he chooses to place himself inside the Great Hall – not, as an architectural topographer like Malton might have done, in order to render a detailed drawing of the building – but rather to suggest the essential character of the crumbling yet beautiful structure.

Thomas Girtin 1775–1802

79 Kirkstall Abbey

Watercolour over pencil; 320×518mm
Signed: *Girtin 1800*
1855-2-14-53 (L.B. 38) Presented by Chambers Hall *Plate 57*

This is one of two late views of Kirkstall Abbey by Girtin (his earliest was a copy after Edward Dayes, *c.* 1792). The other, in the Victoria and Albert Museum, is undated but was probably also painted *c.*1800 – that is, during the brief period of Girtin's full maturity. This type of apparently straightforward topographical composition, when compared with the work of most of Girtin's contemporaries, explains Farington's comment in 1799 that he was being spoken of as 'a genius'. Many of the drawings by Girtin in this exhibition are sketches or working studies: this, on the other hand, would have been regarded by his contemporaries as a finished watercolour. At first sight this seems a quintessentially picturesque view – an ancient abbey set in a wide valley through which meanders a river, a background of hills with their neatly intersecting outlines and variegated clumps of trees, peopled by farm-labourers about their work – but Girtin's treatment is wholly unpicturesque in its directness and breadth. The composition has unity as well as variety; and

while, characteristically, he represents a panorama, the spectator's eye is not encouraged to travel slowly across it. The view can in fact be taken in at a glance: the whitened ruins in the middle distance on the right, and in the same plane on the left, the bend in the river which catches the light, capture the spectator's attention at the same moment. The sweeping simplicity and grandeur of the landscape are emphasised by the distribution of light and shade, which cut across the lie of the ground and swallow up the smaller details or run them together in a band of shadow; and the sky (as one might expect from his earlier Yorkshire and Welsh sketches) plays an essential part in the total effect.

Thomas Girtin 1775–1802

80a *Gordale Scar*

Watercolour; 137×194mm
Inscribed: *Gordale Scar*
1855-2-14-19 (L.B. 15a) Presented by Chambers Hall

b *Above Bolton*

Watercolour; 142×202mm
Inscribed: *above Bolton*
1855-2-14-10 (L.B. 15b) Presented by Chambers Hall

Plate 55

These sketches are thought to have been made during Girtin's final visit to the North in the spring of 1801. They have a boldness of impact and a suggestion of scale which belies their small size – they must have been leaves in a sketchbook – characteristic of Girtin's later work. (a) may be compared with the very large partly coloured study of *Cayne Waterfall* (no. 77), which is rather earlier in date. (b) was used by Girtin as the preparatory study for *Stepping Stones on the Wharfe* (in the collection of Tom Girtin), one of his most striking watercolours. (a) and (b) have all the characteristics of studies made in front of the motif.

Thomas Girtin 1775–1802

81a *Denbigh Castle*

Watercolour; 159×267mm
1855-2-14-49 (L.B. 2) Presented by Chambers Hall

b *Hills and River*

Watercolour; 149×256mm
1855-2-14-12 (L.B. 4) Presented by Chambers Hall

Plate 58

c *Landscape with Hill and Cloud*

Watercolour; 153×235mm
1855-2-14-58 (L.B. 7) Presented by Chambers Hall

Plate 59

Like many other artists of the period, Girtin made annual sketching tours; initially, as in his tour of the Midlands, made in 1794, these were in search of antiquarian and architectural subjects, which formed the basis of finished exhibition watercolours. However, by 1796, when he visited Yorkshire for the first time, he came into contact with a type of landscape – broad stretches of moorland punctuated by barren hills, low horizons and rolling skies – that evoked a new and profound response. Studies of the type exhibited here, dating from the late 1790s, have almost no topographical identity. They are suffused with a powerful sense of solitude, isolation and sometimes melancholy, effects enhanced by his use of a deliberately limited range of colours – grey, dark green, blue. They are among the most remarkable watercolours hitherto painted, infinitely more expressive in their understanding of atmosphere, and only rivalled by Turner's exactly contemporary studies.

Thomas Girtin 1775–1802

82a *Westminster and Lambeth*

Watercolour and pen; 291×524mm
1855-2-14-23 (L.B. 31) Presented by Chambers Hall *Plate 60*

The group of five studies and a related pen and wash drawing for Girtin's *Eidometropolis* or panorama of London are some of the most remarkable achievements of the British watercolour school. They also provide the only reliable surviving evidence for the appearance of the circular panorama, which Girtin probably completed shortly before he went to Paris late in 1801. His early training as an architectural draughtsman clearly influenced his decision to undertake the project, which was to be executed on a truly enormous scale (his 1802 press announcement described it as 108 feet long and eighteen feet high) for which his previous experience had in no way prepared him, and apparently in oil – the only recorded instance of his use of the medium. While many previous artists had found the banks

of the Thames a rich source of subject matter, Girtin's immediate inspiration must have been the detailed large-scale panorama of London from the Albion Mills which Robert Barker and his son Henry exhibited in 1792.

The *Eidometropolis* was exhibited at Spring Gardens from August 1802 until early in 1803, and is said to have been sold to a Russian nobleman in about 1825. Girtin brought to the panorama, hitherto conceived only in terms of dry topographical realism, an entirely new understanding of atmosphere, light and distance which gave the spectator the illusion of being present in the scene itself. A review in October 1802 noted: 'the artist . . . trusted to his eye, and has by this means given a most picturesque display of the objects that he has thus brought into his great circle; and, added to this, he has generally paid particular attention to representing objects of the hues which they appear in nature, and by that means greatly heightened the illusion. For example, the view towards the east appears through a sort of misty medium arising from the fires of the forges, manufacturers etc.'.

In this section we are looking towards Westminster: St John's, Smith Square is in the centre and Westminster Hall and the Abbey to the right. A study of Girtin's and Barker's panoramas from the topographical point of view by Hubert Pragnell was published in 1968 by the London Topographical Society.

Thomas Girtin 1775–1802

82b *The Thames from Westminster to Somerset House*

Watercolour; 240×539mm
1855-2-14-27 (L.B. 32) Presented by Chambers Hall *Plate 61*

One of the most atmospheric of the studies for the *Eidometropolis*. It shows the sweep of the Thames between the now demolished Adelphi Terrace (where the artist's early patron Dr Thomas Monro lived) and the long façade of Somerset House which dominates the surrounding buildings. The church spires in the distance include St James's Piccadilly on the far left; St Martin-in-the-Fields behind the Adelphi; behind it to the left, St Giles-in-the-Fields; and to the right of Somerset House glimmering in the hazy sunlight, St Mary le Strand. In the left foreground, on the Surrey side, is the Shot Tower, and the chimneys of Lukin's Iron Foundry, belching out the black smoke which gives this watercolour its quality of immediacy. The freedom of handling in this drawing – note the expressive strokes of colour to suggest the boats in the foreground and the wake of the one in mid-stream – suggests a late rather than an early dating for the *Eidometropolis*.

Thomas Girtin 1775–1802

82c *The Thames from the Temple to Blackfriars*

Watercolour over pencil; 211×484mm
1855-2-14-25 (L.B. 33) Presented by Chambers Hall

At the left, the tower of St Clement Danes; the Inner Temple buildings and King's Bench Walk can be seen behind Temple Stairs. To the right are timber wharves and Whitefriars Dock, while in the distance on the right is the tower of St Andrew, Holborn. Girtin's characteristic low horizon and his power of suggesting a landscape stretching away into an infinite distance, is nowhere more clearly seen than in this watercolour.

Thomas Girtin 1775–1802

82d *Blackfriars Bridge and St Paul's*

Pencil, pen and brown ink with grey wash, squared for enlargement; 356×515mm
1855-2-14-26 (L.B. 34) Presented by Chambers Hall *Plate 62*

No watercolour for the fourth section of the *Eidometropolis* is known, but this working drawing (marked by oil-stains, which suggests that the final version was painted in oils rather than distemper, as has been thought) shows Girtin's mastery of the essentials of architectural draughtsmanship. In this study, his technique is derived from Canaletto, whose drawings and etchings he had copied as a student, adopting a similar technique of short lines interspersed with dots. While other contemporary artists – Joseph Farington for example – turned this into an irritating mannerism, it was developed by Girtin and Turner into an expressive and personal language.

Many City landmarks are recognisable in this drawing; on the extreme left (the west) is the spire of St Bride's, Fleet Street. In the far distance, the towers of St Sepulchre-without-Newgate; St Martin Ludgate; and Christchurch, Newgate Street. St Paul's dominates the skyline and must have created a particularly dramatic effect in the completed panorama, but its scale is slightly exaggerated. The amount of exact detail in this drawing suggests that Girtin may have used a camera obscura or some similar optical apparatus, although one contemporary account stated that 'The artist, it seems, did not take the common way of measuring and reducing the objects, but trusted to his eye'. This may have been a case of the art that conceals art. The squaring-up was obviously an essential stage in the development of Girtin's panorama from the initial small-scale rough sketches which he presumably made, but which have not survived, to the final canvases.

Thomas Girtin 1775–1802

82e *The Thames from Queenhithe to London Bridge*

Watercolour over pencil; 206×444mm
1855-2-14-28 (L.B. 35) Presented by Chambers Hall *Plate 63*

This study, for the fifth section of the panorama, is the most dramatic of the series. The spires and towers of the city churches punctuate the horizon, which is further dramatised by the threatening storm clouds. Towards the right is the Monument, and on the extreme right, London Bridge and a glimpse of the Tower.

Girtin and Loshak (*The Art of Thomas Girtin*, 1954, p164) note the existence of a squared working drawing for this section, in the Guildhall Library. They argue that such detailed studies must have preceded the watercolour studies and were made in preparation for them, but each kind of drawing surely had a distinct purpose; in the pen and ink drawings Girtin is concerned with establishing the correct relationship of the elements of the composition, while in the watercolours he is striving after atmospheric effect.

Thomas Girtin 1775–1802

82f *London: The Albion Mills*

Watercolour over pencil; 327×539mm
1855-2-14-24 (L.B. 36) Presented by Chambers Hall

A study for the sixth section of the panorama, compositionally perhaps the most striking in the series. The view is dominated by the derelict Albion Flour Mills, designed by Samuel Wyatt and John Rennie and opened in 1786. Five years later the building was gutted by fire, but the walls remained standing until well into the nineteenth century. The Mills conceal a large part of Southwark: above the parapet at the left can be glimpsed the tower of St Saviour's and to the right is St George-the-Martyr. The immediate foreground, Albion Place, is only lightly sketched in: Girtin's viewpoint for the *Eidometropolis* was the roof of a terrace of houses on the west side of Albion place. The seventh and last part of the panorama, which completed the circle, is now known only through a pen and ink drawing, squared for transfer, sold at Sotheby's on 22 December 1965. This showed Great Surrey Street and the tower of Christ Church, Southwark.

Thomas Girtin 1775–1802

83 *View of Paris from Chaillot*

Grey wash over soft-ground etched outline; 200×577mm
1965-6-12-9

In the autumn of 1801 Girtin went to Paris, where he stayed until May 1802. During his visit he made a large number of pencil drawings of the city and its environs, many of which are in the British Museum. After his return to London, he etched twenty of these subjects (later aquatinted by other hands) before his death in November 1802, and they were published posthumously by his brother in March 1803. Contemporary references, including a letter from the artist to his brother, suggest that Girtin originally intended to work on a panorama of Paris, similar to the *Eidometropolis* (see no. 82), but hearing that another artist was working on such a project, he seems to have decided instead to make a series of engraved views. Compositionally, the etchings share many of the features of the studies for the *Eidometropolis*: Girtin's choice of viewpoint, and fondness for sweeping vistas is again evident. There is some confusion as to how many sets of etchings Girtin himself coloured with grey wash as a guide for the aquatinters.

Thomas Girtin 1775–1802

84 *Bridgnorth*

Medium; 623×946mm
Signed and dated: *Girtin 1802*
1849-6-9-75 (L.B. 56) Presented by Chambers Hall *Plate 64*

This is one of Girtin's latest and most monumental works, and the most ambitious of his surviving watercolours. In it he attained a grandeur and force previously unknown in the medium. Though it seems not to have been publicly exhibited, it is one of the first indications of the new status of watercolour in the early years of the nineteenth century as a rival to painting in oil.

In this watercolour the influence of Rembrandt's landscapes is evident, and in particular that of *The Mill*, which had been exhibited in London in 1799. The impact of this painting on Girtin, as on Turner and Cotman (see no. 113) appears to have been very considerable. It supplied the compositional motif of a building as a vertical accent on rising ground above a winding river, and suggested a range of sombre tones that accorded with Burke's view of 'sad and fuscous colours, as black or

45

brown, or deep purple' as expressive of the Sublime. In his *Backgrounds* lecture of 1811, Turner noted that 'Rembrandt depended upon his chiaroscuro, his bursts of light and darkness to be *felt*'.

Bridgnorth is compositionally the closest parallel to *The Mill* in Girtin's work. Although superficially a topographical subject (a pencil drawing, also in the British Museum, 1850-5-13-10, used as the basis for this watercolour is a fairly straightforward study), the whole design is imbued with a mysterious, brooding quality of dramatic power. A comparison with Cotman's earlier treatment of the subject (no. 113) emphasises the different nature of Girtin's approach. Cotman, even at this early stage of his development, seized on the decorative pattern of the silhouette. Girtin, at the end of his life (he was only twenty-seven when he died later in the year), seems to show an even greater concern than previously with the choice of shapes and perspective. The jagged silhouette of the sky-line all but dominates the composition, but he further dramatises the design by concentrating his attention on the dark, lumpish and foreshortened form of the toll-house, which completely overshadows the foreground. Any remotely 'picturesque' content has been subsumed into a more austere and haunting image. Inevitably, perhaps, there is an element of melodrama which lessens the impact of the work but it shows more clearly than any other surviving example by Girtin the expressive power which he thought the medium of watercolour might be able to sustain, and of which, after his death, Turner was to become the greatest exponent.

Joseph Mallord William Turner 1775–1851

85 *The Interior of Westminster Abbey, with the Entrance to Bishop Islip's Chapel*

Pencil and watercolour; 546×398mm
Inscribed: WILLIAM TURNER NATUS 1775
1958-7-12-402 Lloyd Bequest *Plate 66*

Turner's reputation was initially as a painter of topographical and antiquarian watercolours. Here, as so often, he exploited an existing taste rather than creating a new one; but it is characteristic of him that he should have exploited it so fully and vigorously. His early training as an architectural draughtsman under Thomas Malton, whose influence was to remain with him until the 1830s, played an important part in his development. By 1796, the year in which this watercolour was exhibited at the Royal Academy, Turner had mastered the

genre and brought it to a degree of subtlety and technical resource unmatched by any of his contemporaries. At the same time, he had become increasingly preoccupied with effects of chiaroscuro, particularly in his oil paintings. This preoccupation is evident in the dramatic and effective use of light and shade in this watercolour. Although not conceived on the large scale of some of his other architectural subjects, there is a grandeur of scale in the treatment of the soaring Gothic interior of the Abbey. Joseph Farington's comment on Turner's 1796 Academy exhibits was that they 'are very ingenious, but it is a manner'd harmony which He obtains'.

Joseph Mallord William Turner 1775–1851

86 *A View in North Wales?*

Watercolour over pencil; 247×418mm
1958-7-12-405 Lloyd Bequest *Plate 65*

The development of Turner's art was profoundly influenced by his experience of the mountainous landscape of North Wales which he visited in 1798 and 1799. The sketchbooks kept on these tours and the large watercolour studies of views in Snowdonia (drawn on the spot and perhaps partly coloured in Wales, but worked up after his return to London) reflect Turner's growing interest in Sublime landscape. The present watercolour, the subject of which has not yet been identified, has much of the same brooding, mysterious, romantic quality that characterises the artist's larger-scale Welsh subjects. His concern with effects of weather and light is evident in his rendering of the overcast, grey and misty atmosphere so often associated with Wales. The impact of Wales on Turner is fully discussed in *Turner in Wales*, a catalogue by Andrew Wilton of an exhibition held in Llandudno and the Glyn Vivian Art Gallery and Museum, Swansea 1984.

Joseph Mallord William Turner 1775–1851

87 *On the Thames*

Watercolour with scratching out; 251×353mm
1910-2-12-285 Salting Bequest

This is one of a series of watercolours of views along the Thames probably made in 1805 or shortly after: Turner had recently taken Sion Ferry House at Isleworth, a village on the

Thames west of London, not far from Twickenham and Richmond. Although more highly finished, in style and handling they are close to the coloured studies in the *Thames from Reading to Walton* sketchbook (TB XCV), with which they share a similar palette of predominantly dark olive-green tones. During the same period, c.1805–7, Turner also made a related series of oil studies from nature, in which – as in this watercolour – he approaches closest to what Constable termed 'natural painture'. It was a period in which Turner's studio work was becoming increasingly naturalistic, reflecting something of the immediacy of response and liveliness of handling that is apparent in such studies as this. It was at exactly the same time that the young Linnell, Mulready, and W.H. Hunt were encouraged by their teacher John Varley similarly to paint from nature in the Twickenham area.

Joseph Mallord William Turner 1775–1851

88 *The Lake of Brienz*

Watercolour; 388×556mm
Signed and dated: *IMW Turner RA. PP 1809*
1958-7-12-409 Lloyd Bequest *Plate 68*

Turner embarked on his first foreign tour in the summer of 1802. His chief objective was the Alps; he had already explored the most remote and dramatic regions of Britain such as the mountainous landscape of North Wales (see no. 86), the Lake District and the romantic wilderness of the Scottish Highlands. The most important group of studies made by Turner in the Alps were those in the *Grenoble* and *St Gothard and Mount Blanc* sketchbooks (TB LXXIV and LXXV). As well as being in themselves extraordinarily dramatic and impressive, they served as a pattern-book from which patrons at home could choose subjects to be worked up into finished watercolours. Several pages, for instance, are marked with an 'F' for Walter Fawkes of Farnley Hall, Yorkshire, who by 1819 owned nineteen Swiss subjects. This view of Lake Brienz, dated 1809, which was based on drawings on p.43 of the *Grenoble* sketchbook and p.38 of the *Rhine, Strasbourg and Oxford* sketchbook (TB LXXVII), is one of the few finished Swiss watercolours of the period to have been commissioned by a patron other than Fawkes. Turner's patron in this case was Sir John Swinburne of Capheaton, Northumberland (who later commissioned no. 89c). Turner continued until at least 1824 to use his Alpine studies of 1802 as the basis of fully developed watercolours.

Joseph Mallord William Turner 1775–1851

89a *An Abbey near Coblenz*

Bodycolour on white paper prepared with a grey wash;
195×313mm
1958-7-12-412 Lloyd Bequest *Plate 67*

b *Johannisberg*

Watercolour and bodycolour on white paper prepared with a grey wash; 214×337mm
1958-7-12-418 Lloyd Bequest

c *Marxbourg*

Watercolour; 291×458mm
Signed and dated: *IMW Turner 1820* and inscribed
MARXBOURG *and* BRUGBERG *on the* RHINE
1958-7-12-422 Lloyd Bequest

In 1817, Turner was one of the many visitors to the battlefield of Waterloo and from there went for a twelve day tour along the Rhine, partly inspired, perhaps, by the third canto of Byron's *Childe Harold's Pilgrimage*, published in 1816, in which the 'majestic Rhine' is apostrophised as 'A blending of all beauties'. Besides three sketchbooks, containing about two hundred and fifty pencil studies of the dramatic scenery of the Rhine, Turner also made a group of fifty-one watercolours. There has been much discussion of whether (as Turner's early biographer Walter Thornbury believed) these were made during the tour or afterwards. Thornbury stated that Turner travelled directly from the Low Countries via Hull to Farnley Hall, 'where, even before taking off his great-coat, he produced the drawings in a slovenly roll, from his breast-pocket; and Mr Fawkes bought the lot for some £500'. Later commentators doubted this picturesque anecdote but Mary Tussey (see *Turner in Yorkshire*, catalogue of an exhibition held at York City Art Gallery, 1980, pp.64–70) has argued convincingly that he at least began to paint the distances and skies from nature and to lay in the main compositional features, subsequently adding foreground details in bodycolour, perhaps in the evening at his inn. Certainly, not all the watercolours are pedantically accurate in terms of topography – on occasion Turner subtly rearranged the elements to make a more satisfactory design. None of the Farnley series, however, should be regarded as 'finished' watercolours. They have much of the character of sketches, and indeed some of them later served as the basis for commissioned watercolours of a more conventionally 'resolved' kind (no. 89c).

No. 89a and no. 89b are from the Farnley series, which was dispersed between 1890 and 1912. A pencil study in the *Waterloo and Rhine* sketchbook (TB CLX-56 *verso*) is related to no. 89a, and another tiny sketch in the same book (70 *verso*) shows Johannisberg from much the same angle as in the watercolour. *Marxbourg* (no. 89c) is one of the finished watercolours of Rhine subjects commissioned from Turner by his long-standing patrons the Swinburnes, either Sir John or his son Edward, who must have seen the Farnley studies and chosen the subjects that they wanted.

Joseph Mallord William Turner 1775–1851

90 *Hastings from the Sea*

Watercolour; 398×591mm
Signed and dated: *IMW Turner RA 1818*
1958-7-12-419 Lloyd Bequest Plate 69

Based on two studies made *c*1815–16 (T.B. CXXXIX-22a, 23; 24a–25), this watercolour of Hastings was originally intended to be engraved as part of a proposed series to be entitled *Views at Hastings and its Vicinity*. The series was to have been a sequel to *Views in Sussex*, 1820, published by the engraver W.B. Cooke, but his failure to meet deadlines for earlier works discouraged further financial backing, and the scheme petered out. This is among the most impressive of Turner's early large-scale marine watercolours, combining carefully observed nautical detail and landscape.

It was included in Cooke's exhibition of twenty-three water-colours by Turner in 1822, when it was singled out for praise by Ackermann's *Repository of the Arts* as displaying 'great power and truth'. It subsequently belonged to Benjamin Windus, and it is shown hanging over the chimneypiece in Scarlett Davis's painting of his library, no. 169.

Joseph Mallord William Turner 1775–1851

91 *Weathercote Cave, near Ingleton*

Watercolour with scratching-out and gum arabic; 301×423mm
1910-2-12-281 Salting Bequest Plate 70

This is the watercolour made for one of the series of twenty views engraved after Turner's designs for *The History of Richmondshire*, published by Longman's between 1819 and 1823; it was engraved by Samuel Middiman in 1821 with the title *Weathercote Cave, near Ingleton, when half-filled with Water and the Entrance impassable*. Turner received the commission through the antiquarian author Dr Whitaker early in 1816; it was originally for a very much larger series, which would have comprised a *History of Yorkshire*.

Most of the watercolours were based on drawings made by Turner in the course of a tour in Yorkshire in 1816 which he undertook especially for this project. He used as his base Farnley Hall, the home of his friend and patron Walter Fawkes. The diary kept by Mrs Fawkes, and Turner's own correspondence, record the worst kind of English summer weather: 'rained all day', 'heavy rain', 'weather miserably wet'. Nevertheless Turner filled several sketchbooks with rapid studies, including a pencil drawing of Weathercote Cave, which he had visited before, probably in 1808. On this later occasion the heavy rain had half-filled the seventy-foot deep cave so that he was obliged to make his sketch from above. In the watercolour he shows the water flowing in from the right. Turner's capacity for pictorial synthesis can be seen at work in the final watercolour; he includes a distant view of Whernside, which as David Hills has pointed out (*Turner in Yorkshire*, exhibition catalogue, York, 1980, p.82) 'may be cerebrally true but is visually impossible', and a rainbow, of which there was no indication in the pencil study.

Joseph Mallord William Turner 1775–1851

92 *Saltash*

Watercolour and bodycolour: 273×408mm
Signed and dated: *J M W Turner RA 25*
1958-7-12-427 Lloyd Bequest

The most ambitious publishing project with which Turner was associated during the 1820s and 1830s was undoubtedly *Picturesque Views in England and Wales*, probably commissioned in 1824 (*Saltash*, the first of the series, is dated 1825) by the engraver and publisher Charles Heath. As originally planned, it was to have consisted of one hundred and twenty engravings after watercolours by Turner, but in fact only ninety-six appeared between 1827 and 1838 in twenty-four parts, each containing four engravings and descriptive texts. Turner himself supervised the engraving in minute detail, for he attached great importance to the prints and, indeed, regarded them as the culmination of the whole creative process. Commercially the enterprise was a failure. In January 1826 the publishers who had put up the capital went bankrupt and Heath experienced continuous difficulty in financing so ambitious a project.

In 1839, the year after the last number was published, Longman's (who had taken over responsibility for the debts incurred by Heath over the *England and Wales* series) put the entire stock of plates and unsold prints up for auction. Turner himself bought them for £3,036 probably in order to prevent the plates from being ruined by reworking.

Though from a commercial point of view the project was a failure, the watercolours, groups of which were exhibited in 1829, 1831 and 1833, and indeed the prints, were admired by critics and collectors. They do in fact constitute the most sustained expression of Turner's powers as a watercolourist. He lavished enormous care on the whole series, which reflects most aspects of his interest in landscape, both natural and man-made. Andrew Wilton has described the *England and Wales* series as 'modern "history pictures" in which the common man is the hero': human activity and the relationship of man to the landscape is indeed the most important and constant theme of the sequence. The British Museum is fortunate enough to possess, largely as a result of the Lloyd Bequest, fifteen of the watercolours. The remainder of the series is widely dispersed, including a few so far untraced.

Saltash is the only watercolour in the series to bear a date. Although it seems to have been among the first drawings made for the series it was not engraved until 1827 and was published in Part III in 1828. Turner seems to have based the view, in which Saltash itself is relegated to the background, on a pencil sketch made in 1813 (TB CXXXIII–23). The foreground, which immediately attracts the spectator's eye, is entirely taken up with anecdotal detail of the marines and their families. Ruskin, who was particularly interested in the accuracy of Turner's representation of weather effects, noted of this watercolour; 'Afternoon, very clear after rain. A few clouds still on the horizon. Dead calm'. He also praised 'the perfect truth' of Turner's depiction of calm water, as compared with Van de Velde's treatment of reflected light on the surface of the sea.

Saltash belonged to Benjamin Windus, and is partly visible at the bottom of the extreme right hand row of watercolours shown in Scarlett Davis's watercolour of Windus's library, no. 169. By 1840 Windus owned thirty-six of the *England and Wales* watercolours.

Joseph Mallord William Turner 1775–1851

93 *Winchelsea*

Watercolour and bodycolour with pencil and scratching-out; 293×425mm
1958-7-12-429 Lloyd Bequest

The composition is dominated by a regiment on the march, with a group of the camp followers in the foreground. Winchelsea itself, visible only in the middle distance, is no more than the background to this scene of human activity. Ruskin, who noted that of Turner's four engraved views of the town three included soldiers, described the sky in the present drawing as 'thunder breaking down after intense heat, with furious winds'. Eric Shanes has suggested that this may be a metaphor for war (although it should be noted that the melodramatic effect of the flash of lightning in Henshall's 1830 engraving for *England and Wales* is not present in the watercolour itself). Based on pencil studies made in 1815–16 (TB CXL-58a-59), this watercolour is datable in the mid to late 1820s. It was owned by Turner's agent Thomas Griffith and subsequently by Ruskin.

Joseph Mallord William Turner 1775–1851

94 *Caernarvon Castle*

Watercolour over pencil; 278×418mm
1958-7-12-439 Lloyd Bequest

Although Wales had inspired some of Turner's most sublime early works – he visited the country five times in eight years – he never returned after 1808. For the sixteen Welsh subjects in *Picturesque Views in England and Wales* he drew on studies chiefly made in the 1790s. He had exhibited a large watercolour of Caernarvon Castle at the Royal Academy in 1800 (TB LXX-M), a Claudian composition in which the castle was the distant focus of the design. In the watercolour here exhibited, painted *c.*1833–4, the castle has become the dominant element. The view is one familiar from the many straightforward antiquarian or topographical watercolours and engravings of the late eighteenth and early nineteenth centuries; particularly in Turner's case, the paintings of Richard Wilson in which the subject is treated with a degree of classicising idealisation that looks back to Claude's *Seaports*.

As an essay in colour, this is one of the most delicately observed and beautiful of the series; the golden evening light is touched with tones of lilac-mauve and the mood of fantasy is echoed by the motif of the girls bathing in the foreground. Comparison between this and *Lowestoff* (no. 95) demonstrates the range of Turner's imaginative reinterpretation of the topographical genre.

Joseph Mallord William Turner 1775–1851

95 *Lowestoffe*

Watercolour; 275×427mm
1958-7-12-441 Lloyd Bequest *Plate 71*

Turner's transformation of the topographical genre in his
England and Wales series is here at its most uncompromising, in
the vividness with which the dangers of the sea and the horror
of shipwreck are conveyed. As so often, he has taken a theme
conventionally treated by earlier artists – in this case, apparently,
the shipwreck paintings of Vernet and his followers – but has
transformed a theatrically, even melodramatically treated subject
into a scene of brutal realism, of which the spectator is a
participant, as if himself struggling in the sea. Ruskin praised
Turner's powerful use of grey in all its various tones to evoke
the desolate mood of the scene, 'an hour before sunrise in
winter. Violent storm with rain'; despite the presence of the
lighthouse, a ship has foundered and the scene is one of
desolation. Eric Shanes has noted (*Turner's Picturesque Views in
England and Wales 1825–1838*, 1979, no. 76) that Lowestoft was
the home of the world's first effective lifeboat, launched in
1807; it was also notorious for its 'wreckers', men who deliber-
ately lured boats onto the rocks and then claimed them as
salvage.

 Lowestoffe [sic] was completed by the end of August 1835, and
was engraved for one of the last parts of the *England and Wales*
series in 1837.

Joseph Mallord William Turner 1775–1851

96 *Marly-sur-Seine*

Watercolour and bodycolour; 286×426mm
1958-7-12-433 Lloyd Bequest

This watercolour, engraved by William Miller for the 1832
edition of *The Keepsake* (one of the illustrated annuals published
by Charles Heath to which Turner contributed six French
subjects between 1830 and 1834) is based on a panoramic
sketch, TB CCLX-58. A group of related panoramic studies of
the environs of Paris suggest that Turner may have had in
mind the views of Paris made at the very beginning of the
century by his contemporary Thomas Girtin (see no. 83). The
Turner Bequest also includes a broadly handled colour study
of the same view, which concentrates more particularly on the
relationship of sky and water and the tonal value of the avenue
of trees at the left. In the final watercolour the emphasis of the
design has changed: the spectator's eye is now directed towards
the group of fashionably dressed women in the right fore-
ground. This more light-hearted emphasis may have been
intentional, to suit the middlebrow taste of *The Keepsake's* reader-
ship. The almost *fête galant* atmosphere recalls the work of
Thomas Stothard, whose reinterpretations of Watteau were
much admired by Turner in the late 1820s. This view of Marly-
sur-Seine may also be compared with Shotter Boys's watercolour
of the *Boulevard des Italiens*, no. 167, painted in the following
year. In both drawings liberal use is made of the comparatively
recently introduced emerald green pigment for the foreground
accents.

Joseph Mallord William Turner 1775–1851

97 *Lake Nemi*

Watercolour with scraping out; 347×515mm
1958-7-12-444 Lloyd Bequest *Plate 72*

In its golden tonality and elaborate technique (the extensive
scratching-out of the surface to give an overall effect of scattered
highlights may reflect the influence of Constable), this is a
characteristic example of Turner's highly finished watercolour
style of the very late 1830s; *Lake Nemi* was engraved for
Finden's *Royal Gallery of British Art* in 1842. Both in choice of
subject and in composition Turner seems to be consciously
emulating earlier landscape artists whom he particularly ad-
mired – notably Claude, Richard Wilson and J.R. Cozens, all of
whom had painted Lake Nemi and its environs. Instead of
classical staffage, however, he introduces an element of con-
temporary genre: the *contadine* figures could have come out of
a painting by Eastlake.

Joseph Mallord William Turner 1775–1851

98 *Venice: the Grand Canal, looking towards the Dogana*

Watercolour with pen and red ink; 221×320mm
1958-7-12-443 Lloyd Bequest *Plate 73*

Turner visited Venice for the first time in 1819. His second
visit was probably in 1833 (not 1835 as was formerly thought)
and his third and last in 1840. The Turner Bequest includes a
large number of watercolours of Venetian subjects connected
with the artist's two last visits, but there are also some related
sheets including the present example, which probably (thanks

perhaps to his agent, Thomas Griffith) became separated from those in the Bequest during Turner's lifetime. The problem of dating the Venetian watercolours is not yet entirely solved, but they can be grouped into sequences that seem to belong together and to have been executed at the same time. Some groups can be distinguished by stylistic differences, and others classified by size or type of paper. In some, the most evanescent impressions are conveyed by vaporous washes; in others, as the present example, the architecture is defined and emphasised by pen and ink; in others again, there is dramatic use of bodycolour on brown or grey paper. They include some of the most astonishing watercolour studies ever painted, and although the city inspired a group of magical oil paintings, it is surprising that Turner produced no finished watercolours of Venice. Turner's primary concern was not with the detailed representation of the architecture of Venice (here, of course, he differs fundamentally from his predecessor Canaletto and his contemporary Ruskin) but with the attempt to capture his impressiosn of its atmospheric qualities.

Turner's viewpoint is probably from the steps of Sta Maria della Salute, looking down the Grand Canal, with the Dogana on the right and the Campanile of S. Marco on the left. Its style and handling suggest that perhaps it was a study made on the spot.

Joseph Mallord William Turner 1775–1851

99 *Bellinzona*

Watercolour and pencil; 228×287mm
1910-2-12-288 Salting Bequest *Plate 74*

Turner visited Bellinzona – the capital of the Italian-speaking Swiss canton of the Ticino – several times during the early 1840s; this watercolour probably came from a sketchbook used in 1842 or 1843. As Ruskin noted, Turner was fascinated with the three castles set on hills above the town which give Bellinzona such a striking appearance. The fortresses were maintained in working order until the mid-nineteenth century because of the town's strategic position at the foot of the St Gothard and the San Bernardino Pass. In technique, Turner's watercolours of Bellinzona anticipate those he made on his last tour in Germany and Switzerland during 1844.

Joseph Mallord William Turner 1775–1851

100 *Zürich*

Watercolour and scratching out; 300×456mm
1958-7-12-445 Lloyd Bequest

One of two finished views of Zurich that Turner painted in the 1840s. They are the culmination of his lifelong interest in urban landscape, which for him expressed sublime grandeur as much as the wildest Alpine scenery. From his earliest period as a topographical artist he had always been aware of the social, economic and historical associations of the places he depicted, an awareness which revealed itself at its most comprehensive in the *England and Wales* series (see nos 92–95).

Turner visited Switzerland every year from 1841 to 1844; the fruit of these four journeys, in addition to a mass of colour studies, were twenty-six finished watercolours of supreme beauty. Some of his contemporaries were baffled by them, but Ruskin believed that they were Turner's greatest achievement, 'not to be described by any words . . . presenting records of lake effect on a grander scale, and of more imaginative character, than any other of his works'. H.A.J. Munro of Novar, in whose company Turner had visited Switzerland in 1836 and rediscovered his enthusiasm for Alpine subjects, owned fourteen, including this watercolour which was much coveted by Ruskin.

Joseph Mallord William Turner 1775–1851

101 *Essays in Colour to try his Palette*

Watercolour; 477×348mm
1939-12-9-1 Presented by Mrs A. J. Finberg *Plate 66*

A sheet presented to the Museum by the widow of A. J. Finberg (1866–1939), the distinguished Turner scholar, whose *Inventory of the Turner Bequest*, 2 vols., 1909, was his most notable achievement.

Turner seems to have used this sheet of paper for two different purposes: firstly, perhaps, as a 'colour-beginning' and then, apparently setting aside whatever idea he had in mind, as a way of trying out various colours. A note by Finberg is on the *verso* of the mount: 'He is not playing with colours timidly, as though he were afraid of them. He handles them like the master he was. You feel that he can do what he likes with them. He sees all the time beyond his preliminary touches. What they are going to blossom into is so vividly present in his mind that even these slight washes seem to contain a premonition of what they were intended to develop into'.

John Constable 1776–1837

102 *Study of Clouds and Trees*

Pencil and watercolour; 170×254mm
1888-2-15-57 (L.B. 28b) Presented by Miss Isabel Constable

In October 1821 Constable wrote to his friend Archdeacon Fisher: 'I have not been Idle and have made more particular and general study than I have ever done in one summer ... I have done a good deal of skying – I am determined to conquer all difficulties and that most arduous one among the rest ... That landscape painter who does not make his skies a very material part of his composition – neglects to avail himself of one of his greatest aids ... It will be difficult to name a class of Landscape, in which the sky is not the key note, the standard of Scale, and the chief organ of sentiment'. This watercolour (although unlike other examples it is not inscribed with a date or details of weather conditions) came from a sketchbook watermarked 1819 but used by Constable in 1821 and 1823; comparison with other similar studies suggests that this was made in 1821 in Hampstead, where the family had taken a house for the summer. Over summary pencilled underdrawing, Constable has rapidly swept on wet washes of colour, using the white paper to suggest delicate areas of cloud. The sky studies made in 1821 are, as Graham Reynolds has pointed out, characterised by the presence of foliage or a suggestion of buildings at the bottom, while those made in successive years usually exclude any extraneous detail. Constable's intentions in making such sketches seem to have been twofold: as his letter to Fisher shows, a significant concern was to enrich the effects of the skies in his landscape compositions (although there is no example of the direct transfer of such a study to a more complete painting, they provided him with a repertoire of appropriate sky types); he also had a serious interest in such natural phenomena for their own sake.

John Constable 1776–1837

103 *Study for 'The Leaping Horse'*

Pencil and grey wash; 203×302mm
1888-2-15-71 (L.B. 10(b)) Presented by Miss Isabel Constable

One of two studies in the British Museum for Constable's sixth and last large-scale painting of scenes on the River Stour, exhibited in 1825 and now in the possession of the Royal Academy. The genesis of the painting was more than usually complex, and it is not easy precisely to follow the development of the subject; certainly few of his large canvases show more signs of having been altered and reworked. His correspondence with his friend Archdeacon Fisher between November 1824 and September 1825 is full of references to the progress of the painting and shows that he had embarked on extensive repainting even after the picture had returned from the Academy. According to the first edition of his *Life* of Constable, 1843, C.R. Leslie believed that the artist was at one stage working simultaneously on two alternative versions of the subject, one of which 'was afterwards turned into a sketch' (presumably the full-scale sketch for *The Leaping Horse* now in the Victoria and Albert Museum).

The Leaping Horse is the only one of Constable's large scale paintings for which (in addition to the full-scale oil sketch) compositional studies of this kind are known. The drawing exhibited here was probably made towards the end of 1824 or very early in 1825, when he was formulating his ideas for the painting; unlike the other study in the Museum (not exhibited), it shows the motif of the horse jumping over one of the barriers placed along the tow-path to prevent cattle straying, which became the central dramatic emphasis of the finished picture.

John Constable 1776–1837

104 *London from Hampstead, with a double Rainbow*

Watercolour with scraping out; 197×324mm
Inscribed *verso: between 6 & 7 oclock Evening June 1831*. There is also a diagrammatic sketch showing the outline of the city with lines converging radially on St Paul's and a study of a cloud with beams of light radiating from it.
1888-2-15-55 (L.B. 32b) *Plate 75*

Constable's biographer, C.R. Leslie recalled that 'he pointed out to me an appearance of the sun's rays, which few artists have perhaps noticed ... When the spectator stands with his back to the sun, the rays may be sometimes seen *converging* in perspective towards the opposite horizon. Since he drew my attention to such effects, I have noticed ... the lines of the rays diminishing in perspective through a rainbow' (see Ian Fleming-Williams, *Constable Landscape Watercolours and Drawings*, 1976, p.100). This watercolour, which must have been painted from a window of the house in Well Walk into which he moved in 1827, dramatically illustrates this observation. 'It is to my wife's heart's content ... our little drawing room commands a view unequalled in Europe ... the *dome* of *St Paul's* in the air, realizes Michael Angelo's idea on seeing that of the Pantheon – "I will build such a thing in the sky"'.

John Constable 1776–1837

105 *A Farmhouse near the Water's Edge*

Pen, brown and grey ink and watercolour with scratching out;
145×196mm
1888-2-15-33 Presented by Miss Isabel Constable *Plate 76*

Although this watercolour is a finished work (perhaps identical with one of those exhibited at the Royal Academy in 1832 or 1833) it also forms part of a sequence begun in 1819 with *The White Horse* (Frick Collection, New York) and continued into the 1830s with three oil sketches which (to judge from references in Constable's correspondence) were perhaps studies for a larger picture suitable for exhibition. The farmhouse that forms the central motif in these later sketches and the present watercolour is Willy Lott's house on the Stour which appears on the left in *The White Horse*. In 1829 financial difficulties compelled Constable's friend Archdeacon Fisher to sell some of his pictures back to Constable. These included *The White Horse*, and Graham Reynolds has suggested that its repossession may have stimulated Constable to take up the theme again: a suggestion borne out by a pen and ink drawing, dated 1829 (B.M. 1971-1-23-1), which is essentially a repetition of the left-hand side of *The White Horse* and seems to have been the point of departure for Constable's later treatment of the subject.

This long-drawn-out sequence of variations on the same motif illustrates the complex nature of Constable's working procedure and also his tendency, in later years, to be obsessed with certain themes that had occupied him in youth. One such motif was Willy Lott's house, which developed into a symbol of an idealised way of life that had become increasingly remote and which he came to treat with an increasing degree of abstraction.

The surfaces of Constable's late paintings are made up of thick layers of rough impasto: as he himself said, he found it impossible to stop 'oiling out, making out, polishing, scraping, &c'. For his critics, the encrusted finish was as if the pictures 'had been powdered over with the dredging box or under an accidental shower of white lead'. Many of his later watercolours have the same heavily textured and highly wrought surface, but the similarly restless effect is achieved not so much by superimposing layers of pigment as by scratching through the pigment to reveal the white paper.

John Constable 1776–1837

106a *Cowdray House: the Ruins*

Pencil and watercolour; 267×274mm (the width includes a strip added on the right)
Inscribed: *Sept 14 1834* and on the *verso Internal of Cowdray – the Oriel Window, Mowbray Castle Septr 14 1834* and *Cowdray – Sepr 14 – 1834*
1888-2-15-31 (L.B. 24) Presented by Miss Isabel Constable
 Plate 77

b *Tillington Church*

Pencil and watercolour; 232×264mm (the width includes a strip added at the right)
Inscribed: *Tillington Sepr 17 1834*
1888-2-15-49 (L.B. 23b) Presented by Miss Isabel Constable
 Plate 78

In September 1834 Constabel was invited to stay at Petworth by Lord Egremont: C.R. Leslie, his closest friend at this period, was a fellow-guest and recalled their visit in his *Life* of the artist. 'Lord Egremont . . . ordered one of his carriages to be ready every day, to enable Constable to see as much of the neighbourhood as possible. He passed a day in company with Mr and Mrs Phillips [Thomas Phillips RA] and myself, among the beautiful ruins of Cowdry [sic] Castle, of which he made several very fine sketches . . . While at Petworth . . . he filled a large book with sketches in pencil and watercolours, some of which he finished very highly'. The two watercolours exhibited here, both from this sketchbook, form an instructive contrast with no. 105 – a heavily worked studio composition, which Constable executed from imagination. In his last decade he rarely sketched from nature but when he did so it was in a fresh, colourful, almost relaxed, manner, often of subjects he had never treated before. Neither of these watercolours could be mistaken for works of the artist's early period – the forms (except for Tillington Church tower) are too impressionistically rendered – but there is in them none of the tension and melancholy that characterise his attempts towards the end of his life to express the ultimate mystery that resided for him in themes long remembered and pondered over, like Salisbury Cathedral, Stonehenge or the Stour Valley.

John Constable 1776–1837

107 *Folkestone Harbour, with a Rainbow*
Watercolour; 127×210mm
1888-2-15-37 (L.B. 18b) Presented by Miss Isabel Constable
 Plate 79

108 *Littlehampton: stormy day*

Watercolour with scratching out; 113×185mm
Inscribed: *Little Hampton July 8 1835*
1888-2-15-36 (L.B. 18a) Presented by Miss Isabel Constable
Plate 80

On 7 July 1835 the artist and his two eldest children arrived to stay with his patron and namesake, George Constable of Arundel. His drawings record various excursions made in the neighbourhood in the course of the next two weeks, some of them slight and sketchy and others, including this view at Littlehampton, much more elaborately worked. The inscription implies that this was drawn on the spot, but the degree of scratching-out and the generally finished appearance suggest that it was completed in the studio. In choice of motif, scale and to some extent technique, this watercolour and the one of Folkestone Harbour (no. 107) recall Turner's *Southern Coast* series of the mid-1820s.

No. 107, previously thought to date from 1835, has recently been re-dated to October 1833, when Constable stayed in Folkestone for about two weeks to be with his eldest son John Charles, a pupil at a boarding-school in the town, who had injured himself while sleepwalking.

John Constable 1776–1837

109 *Stonehenge*

Watercolour over black chalk, squared for transfer;
168×250mm
1888-2-15-38 (L.B. 22a) Presented by Miss Isabel Constable
Plate 81

In his later years Constable became increasingly obsessed with the idea of the past, which he found awe-inspiring and melancholy. The last works that he exhibited in his lifetime (at the Royal Academy in 1836, the year before his death) had for their theme the passage of time; one was *The Cenotaph* (National Gallery), a memorial both to Reynolds and, for Constable, to Sir George Beaumont, the patron who had erected it; the other a watercolour of *Stonehenge* (Victoria and Albert Museum), for which this drawing is a preparatory study. On his only recorded visit to Stonehenge, in July 1820, he made a sketch which he used in 1835 as the basis for the finished watercolour. The present intermediate study shows Constable in the process of transforming his original straightforward record into the dramatic watercolour exhibited in 1836 with a text reflecting Constable's consciousness of the phenomenon of time: 'The mysterious monument . . ., standing remote on a bare and boundless heath, as much unconnected with the events of the past as it is with the uses of the present, carries you back beyond all historical records into the obscurity of a totally unknown period'. As in many of his late works, he included a double rainbow – a symbol of the Resurrection – which in its transience contrasts with the permanence of the stones.

John Varley 1778–1842

110 *Hackney Church*

Watercolour with pen and brown wash; 274×380mm
Signed and dated: *J. Varley 1830* and inscribed by the artist on a separate piece of paper attached to the mount *Hackney Church, a Study from Nature, J. Varley, July 21st, 1830.*
1958-7-12-448 Lloyd Bequest
Plate 83

Varley was an influential figure for the generation of watercolourists born in the 1780s and 1790s. In 1804, when he became a founder-member of the Society of Painters in Water-Colours to whose annual exhibitions he was a profuse contributor, he was already a well-established teacher, both of aspiring professionals and of amateurs. He encouraged his pupils – who included Cox, W.H. Hunt and Linnell – to adopt a naturalistic approach to landscape, with an emphasis on sketching from nature. While many of his own watercolours relied on the rather schematised, ideal compositions which he popularised in teaching manuals published between 1815 and 1821 (notably a *Treatise on the Principles of Landscape*, 1816) the more informal side of his work is characterised by lively, unaffected topographical studies such as the present example.

According to Varley's own inscription, this drawing was made from nature; even so, he achieved a carefully balanced composition, with trees framing the design on left and right, and a recession of planes marked by carefully placed verticals – the lamp-post, and church tower with its weathervane, another tree beyond – reminiscent of an earlier style of urban landscape associated with artists like Sandby or Malton. In spite of these elements of contrivance, the luminously handled washes and subtle evocation of light, shade and movement give this watercolour an appearance of spontaneity.

Varley, who was born in a house adjoining the churchyard, shows the sixteenth-century tower of the parish church of St Augustine. This tower and the funerary monument on the left in the drawing were the only features to survive the demoliton of the original church in 1798, an event which Varley recorded in sketches used much later, in 1826, as the basis of two

finished watercolours (Rose Lipman Library, Hackney). The present work was probably exhibited by Varley at the Old Water-Colour Society in 1831 as *Sketch of the Old Tower at Hackney.*

Cornelius Varley 1781–1873

111 *Lord Rous's Park*

Watercolour with touches of white bodycolour over pencil; 264×373mm
Signed with the artist's initials and dated *1801*, inscribed *Lord Rouses* [sic] *park.*
1973-4-14-15 *Plate 82*

The younger brother of John Varley, Cornelius was brought up by an uncle who made watches and designed scientific apparatus; most of his own career was devoted to instrument making. The rediscovery of a large number of watercolours and drawings by him, dating mostly from the years 1800 to 1825, revealed him as a landscape artist of considerable talent, and on the whole a more interesting one than his brother. No doubt because he was not a full-time professional artist he never relied on conventional formulae and his sketching style is marked by an unusual directness.

This watercolour, dating from Varley's visit to Norfolk and Suffolk in 1801, was made in the park at Henham Hall, the seat of the Lords Rous (later Earls of Stradbroke). It predates his invention, in 1809, of a form of *camera lucida*, registered in 1811 as the Patent Graphic Telescope, 'combining one or two reflecting surfaces with a simple kind of telescope that inverts the object . . . and apparently projecting the said image flat on a table, so that it may be easily traced on paper . . .'

William Havell 1782–1857

112 *Windermere*

Watercolour; 248×340mm
1859-5-28-140 (L.B.1)

Havell was a founder-member in 1804 of the Society of Painters in Water-Colours and initially one of their most popular exhibitors. It was probably in emulation of his rival John Glover, who according to the diarist Joseph Farington had had 'Great success . . . in selling his drawings of the Lakes', that Havell in 1807 made his first visit to the Lake District. With its rich

colouring and classicised topography, the present watercolour, which was exhibited in 1811, is a characteristic example of a type of landscape associated with the early years of the Society, which aspired to imitate the mellow golden tones of Old Master paintings (or, rather, of the discoloured varnish on them). Havell's friend Reinagle was so fond of this effect that he once postponed a sketching tour until the autumn, 'the country being before that time *too green* for colouring'. Writing in 1831, W. H. Pyne recalled that Havell's Lake District views 'suffered nothing in comparison of effect with paintings in oil'. It is significant that Havell was prominent in the group of artists who in 1812 dissolved the Society and founded a new Society of Painters in Oils and Water-Colours.

John Sell Cotman 1782–1842

113 *Bridgnorth, Shropshire*

Watercolour over pencil; 160×283mm
Signed: *Cotman 1800*
1902-5-14-8

Cotman visited Bridgnorth on the way back from his first visit to Wales in 1800, and dated this watercolour in the same year. It is small and slight enough to have been drawn, though perhaps not coloured, on the spot. The bold handling of the work and the management of light and shade recall Girtin, but the latter's rendering of the same subject (no. 84), seen from the other side of the bridge, was executed a year or two later. Seen in monochrome reproduction, the two works are not dissimilar, but the great disparity in size, coupled with the dark indigo colouring and brooding Rembrandtesque grandeur of Girtin's watercolour makes Cotman's *Bridgnorth* seem puny by comparison. However, it should be noted that this watercolour has lost its indigoes through fading, with the result that the remaining pinkish-brown tones leave it a ghost of its original self.

John Sell Cotman 1782–1842

114 *St Mary Redcliffe, Bristol*

Watercolour over pencil; 380×535mm
1859-5-28-118 (L.B. 9) *Plate 84*

Stylistically close to *Bridgnorth* (no. 113) but more sublime in character and better preserved, *St Mary Redcliffe, Bristol* consti-

tutes Cotman's principal tribute to Rembrandt's *Mill*. A dominant motif – here the tower of a fourteenth-century church (which had lost most of its spire in 1445) – stands on rising ground, its rugged form silhouetted against a patch of light in the sky. This gleam of light is reflected in the murky water in the foreground, a foreground otherwise dark like the sky at the top of the composition. Except for a few crisp touches on the skyline the lighted areas blend smoothly into the dark, as they do in Rembrandt's picture, and Cotman ingeniously accounts for the indistinctness of the scene not only by the subdued level of light, which is perhaps intended to represent dawn, but also by the smoke of Bristol, an industrial city. This is a finished watercolour based on sketches made during a visit in 1800 or 1801. It was probably painted a year or so later and may have been commissioned by one of the artist's chief patrons, the Yarmouth banker Dawson Turner, whom he knew well by 1804 and who certainly owned it later.

There are other Dutch influences in the composition, not to mention those of Girtin and Turner, but *St Mary Redcliffe, Bristol* is unmistakably Cotman's own. Touches or areas of reflected white light standing out sharply against a dark or coloured background, seen here in the river bend on the left, recur throughout his work irrespective of the other tricks of style he adopted at different times. At this stage of his career, just before the Greta period, he sought picturesque effects in scenes with emphatic contrasts of light and shade, sometimes, as here, choosing industrial landscapes.

designs from poetick passages'. Although the Sketching Society was small, met irregularly and was continually being dissolved and re-formed, it included many of the leading early nineteenth-century practitioners of watercolour. It provided the only opportunity for systematic discussion of the theory of landscape (a branch of art not then taught at the Royal Academy Schools), and its importance in Cotman's development is even now not always fully appreciated. Until his departure for Paris in November 1801, the leading figure was Girtin from whom Cotman's style was derived, in so far as it had any single outside source. It was at meetings of the Society that Cotman seems to have evolved the pattern-making style on which his twentieth-century reputation has been chiefly based. In this *Ossianic Scene – Moonlight*, dated 1803, with its boldly silhouetted shapes in white and grey used equally to represent solid forms and wraiths of mist and cloud, the style is already adumbrated, if not fully developed; what is still lacking is the delicate geometry and the pure transparent colouring of Cotman's Greta period.

The subject of the drawing, in contrast to its style, shows the characteristic features of late eighteenth-century Romanticism: the Ossianic theme is interpreted by the desolate, mountainous terrain, the primitive stone cross, the moonlight and mist and the ghostly figures inspired by the witches in *Macbeth*. It is possible to see parallels with Fuseli and Alexander Runciman who epitomised that movement in figure drawing, though the simplification of the forms and the frozen movement of the figures look forward to Cotman's emerging landscape style.

John Sell Cotman 1782–1842

115 *An Ossianic Scene – Moonlight*

Grey wash over pencil; 212×314mm
Signed: *J. S. Cotman* and inscribed and dated on the *verso* (apparently not in Cotman's hand) *The moon looks [ab]road from her clo[ud.] The grey-skirted mist is near; the dwelling of the g[ho]sts! – Ossian's poems Vol. 2, 65* The beginning of the inscription as recorded by James Reeve *Wednesday, March 23rd, 1803. Subject* – and the end *J. S. Cotman, Prest- J. Varley, J. Webster, Neil, Hayward, P. S. Munn: Visitor, W. Munn* are no longer visible.
1902-5-14-39

The particulars noted on the *verso* show that this drawing was executed at a meeting of the Sketching Society, when Cotman was presiding and set the subject. The Society's purpose, as recorded by Louis Francia on its foundation in 1799, was to establish 'a school of Historic Landscape, the subjects being

John Sell Cotman 1782–1842

116 *Gormire Lake, Yorkshire*

Watercolour; 372×546mm
1958-7-12-329 Lloyd Bequest *Plate 85*

Three months after drawing the *Ossianic Scene – Moonlight*, Cotman set off with his friend and fellow artist Paul Sandby Munn, on his first visit to Yorkshire. Their goal was Brandsby Hall, north of York, the home of the Cholmeley family to whom Cotman had been given an introduction by an earlier patron, Mrs Cholmeley's brother, Sir Henry Englefield. They arrived at Brandsby on 7 July 1803 and spent the rest of the summer exploring the North Riding.

Cotman's preoccupation in 1803 with the remains of the great ruined abbeys of the region, especially Rievaulx, Fountains, Byland and Kirkham, was only to be expected. He drew all of them and later used some of these sketches as the basis

for finished watercolours. The grandeur of the Yorkshire landscape impressed him, although his eventual taste was for less sublime subjects. The elaborate watercolour of *Gormire Lake* exhibited here, which he may have painted in the following year, seems to have been a deliberate challenge to his contemporaries: except in its handling and the use of light, it shows him in a transitory and unfamiliar aspect, and in composition, mood, colouring and the use of figures it offers a direct parallel with Turner's views of Wales and the Lake District. For more immediately recognisable works connected with his first Yorkshire tour, one has to look to a dated watercolour sketch of Rievaulx Abbey (private collection) and some of the pencil drawings of trees in the Museum's collection. These show the beginnings of that single-minded concentration on an isolated motif, undeflected by outside considerations and rendered with the utmost economy of means, that he was to develop fully in 1805.

John Sell Cotman 1782–1842

117 *Croyland Abbey, Lincolnshire*

Watercolour; 299×544mm
1859-5-28-118 (L.B. 8) *Plate 86*

Before going to Yorkshire in September 1804, Cotman spent some weeks in Suffolk with his patron Dawson Turner, and then went on to Croyland in Lincolnshire, which he reached in mid-August. From there he wrote enthusiastically to Dawson Turner: 'Croyland is most delicious . . . I feel my pen incapable of describing it 'tis so magnificent, 'tis most magnificent – the old part is full of Nature – the Door, the window in short, the whole is wonderful – there is not one upright line in the Composition therefore let not the Botanists criticise when they come to see it & they find me out of the perpendicular'. Two pencil drawings, three watercolours and an etching of the abbey by Cotman are known; he exhibited the subject twice at the Royal Academy in 1805 and three times at the Norwich Society, the first in 1807. The present watercolour is the grandest of them all and is generally identified as that exhibited in Norwich in 1807. It still retains the breadth, the atmosphere and the dramatic chiaroscuro of earlier works like *St Mary Redcliffe, Bristol* and *Gormire Lake* (nos 114, 116). The composition of tall ruins set back in space, silhouetted against a background of hills and a stormy sky of rolling clouds – characteristics inconceivable without the example of Turner – is perhaps one of Cotman's last exercises in the type of sublime landscape initiated in English art by J.R. Cozens and brought to a climax by Turner and Girtin around 1800.

What is new for Cotman and a reflection of his Yorkshire experiments is the dark slate-blue colouring, unmixed with neutral browns in the shadows, and the bold simplification of the flattened forms.

John Sell Cotman 1782–1842

118 *The Drop Gate, Duncombe Park*

Pencil and watercolour; 330×230mm
1902-5-14-14 *Plate 87*

Like no. 119, this watercolour has been identified as a view in Duncombe Park, though without any compelling reason: they are both very similar in style and must be from the same period, the summer of 1805 when Cotman was staying in Yorkshire not far from Duncombe. *The Drop Gate*, which has become one of Cotman's most famous works, shows his pattern-making style at its purest. No previous British artist – though precedents are not lacking in seventeenth-century European art – had made a complete composition from so humble a motif seen from such a close viewpoint. The relationship between recession in depth and surface design is very subtle. What happens beyond the river bank at the top left? Is the view blocked by some object or are we meant to see a sharply foreshortened field stretching back into the distance? Without the tree on the right and the slight convergence of the horizontal rails of the two parts of the gate, the large beam would appear strictly parallel to the picture surface and almost parallel to the line of the stream. Drop-gates were pieces of fencing without hinges at the side which were hung over streams to prevent cattle from straying; a similar wooden fence seems to continue beyond the tree. Yet Cotman shows no interest in the function of this primitive rustic device and concentrates only on its pictorial possibilities. The repeated uprights make for a unified effect, while all the strips of wood are subtly differentiated in shape in accordance with the classical formula for beauty: 'unity in variety'. The play of light on the gate is no less beautiful: the wood is paler in tone than the bank and the water behind it, and Cotman has subtly varied the strength of the light on the surface from sunshine to deep shadow. His effects, indeed, throughout the composition are of the most refined and carefully calculated quality.

John Sell Cotman 1782–1842

119 *Duncombe Park, Yorkshire* (?)

Pencil and watercolour; 324×228mm
1902-5-14-13 *Plate 88*

Cotman's stay in and near Rokeby Hall on the Yorkshire-Durham border began on 31 July 1805 and lasted barely five weeks. His hosts, the Morritts, were richer and more cultivated than the Cholmeleys of Brandsby (John Morritt was a classical scholar, had made the Grand Tour and was a collector of pictures, among them the 'Rokeby Venus' by Velazquez, now in the National Gallery), but Cotman's relations with them were never as close. Cotman particularly admired the park at Rokeby, which Sir Walter Scott (whose long narrative poem *Rokeby* appeared in 1813) considered 'One of the most enviable places he had ever seen'. The wooded slopes with their winding paths and hidden dells threaded through by the River Greta inspired some of the artist's finest and most characteristic watercolours. It is clear, however, that Cotman's 'pattern-making' style, of which the Rokeby drawings are the best-known examples, was not initiated nor even perfected beside the Greta. Its technical beginnings go back to Sketching Society drawings of 1803 (no. 115) and it is already adumbrated in sketches and watercolours made during Cotman's first tour in Yorkshire later in the same year. Whether or not the traditional identification of the present watercolour as a view in Duncombe Park is correct, Duncombe is not far from Brandsby Hall, and the drawing is very close stylistically both to one of a group of trees in the Ashmolean Museum dated 16 July 1805, when Cotman was staying at Brandsby, and to several watercolours of scenes on or near the Greta which must date from his immediately subsequent visit to Rokeby.

Cotman's 'pattern-making' style is characterised by the reduction of natural forms to simple, flat shapes arranged in planes as far as possible parallel to the picture surface; the representation of these shapes by transparent washes, defining the boundaries of the form by their crisp edges, rather than shading or outlines; the device of placing a light form in front of a darker one, so that the effect of recession is minimised, though not denied (hence the modern term 'pattern-making'); the use of pure, translucent colours, without monochrome underpainting; and the avoidance of any effect of movement. The result implies a rejection of illusionism, and of the traditional conception of landscape painting as a reconstruction of imaginary space; in favour of the imposition on nature of a semi-abstract design.

In his Greta watercolours and others in the same style, Cotman was obsessed by the aim of translating nature into art.

With few exceptions (such as *The Ploughed Field* in Leeds), these watercolours are without figures and reflect no interest in literature or history or even in topography; the introduction of classical allusions is for formal purposes only. In contrast to all other British landscapists of the late eighteenth and early nineteenth-centuries, Turner in particular, Cotman is not an 'associationist'. His whole-hearted desire to render his own personal sensations, and to follow the dictates of his own imaginative life, has no parallel in English landscape before Samuel Palmer at Shoreham; and the shock of having to consider the demands of a patron as Cotman had to do from 1812 onwards when he began working almost exclusively for Dawson Turner, must have been as great as that which Palmer experienced when he came under the cold eye of his father-in-law, Linnell. There is a fundamental difference, however, between Cotman and Palmer in that the visionary quality of Palmer's Shoreham period is due to a youthful romantic intensity which would be bound to diminish as he grew older, whereas Cotman's proceeded from an intellectual reassessment of the nature of landscape art.

John Sell Cotman 1782–1842

120a *Trees in Duncombe Park, Yorkshire*

Pencil; 206×131mm
1902-5-14-256

b *Trees in Duncombe Park, Yorkshire*

Etching; 216×145mm
Signed and dated in the plate: *J S Cotman Del et Sc Nov 19th 1810*
(Popham 5; probably first state)
1902-5-14-257

The contemporary indifference to Cotman's Yorkshire watercolours, characterised as they are by delicate observation of isolated natural motifs, was extended to his first volume of prints, *Miscellaneous Etchings*, published in 1811. Although Francis Cholmeley's sisters praised 'the trees at Duncombe Park . . . as most like Rembrandts', he himself reported to Cotman a bookseller's comment: 'He said his subscribers did not like the view in Duncombe Park, because it might be *anywhere*. Two-thirds of mankind, you know, mind more about what is represented than *how* it is done' – a criticism which helps to explain the lack of interest in his non-topographical watercolours.

John Sell Cotman 1782–1842

121 *Greta Bridge*

Watercolour over pencil; 227×329mm
1902-5-14-17

Greta Bridge is one of the best-known of all English watercolours; such over-familiar images can be difficult to judge without preconceived ideas.

The bridge, which is the focus of Cotman's design, was built by John Carr of York in 1773. It spans the River Greta at the south gates of Rokeby Park, where Cotman stayed for three weeks in 1805 (see no. 119). When his friend Francis Cholmeley left to go to Northumberland, Cotman went to stay at an inn near Greta Bridge. While there has been disagreement as to whether watercolours like nos 118 and 122 were painted on the spot, there can be no doubt that *Greta Bridge* was developed from a pencil sketch made in 1805, now also in the British Museum (1902-5-14-76); Adèle Holcombe (*John Sell Cotman*, 1978, p.20) has dated the present watercolour 1805, and Miklos Rajnai (*John Sell Cotman*, exhibition catalogue, 1982, p.91) *c*.1807. Although the sketch anticipates the general structure of the watercolour, it is still a straightforward account of a picturesque subject, with none of the austerity and beautiful resolution of the final design. The effect of the composition is produced by the contrast between, on the one hand, the geometric forms of the foursquare house and the ovoid shape created by the arch of the bridge and its reflection, and on the other the apparently random (but in fact carefully calculated) patterns made by the river banks and the foreground boulders.

A later version painted in 1810, five years after Cotman's last visit to Yorkshire and now in the Castle Museum, Norwich (Colman Bequest) is an even more carefully calculated essay in picture making, darker in tone and less lyrical in mood and handling. The differences between the two versions were acutely analysed by Lemaitre: *'la différence de tonalité entre les deux œuvres prouve que son art est, pour Cotman, une recherche expérimentale des différents types possibles de l'expression de l'imagination formelle et picturale'* (*Le Paysage Anglais à l'aquarelle 1760–1851*, 1955, p.287).

John Sell Cotman 1782–1842

122 *The Scotchman's Stone on the Greta, Yorkshire*

Watercolour over pencil; 267×394mm
1902-5-14-12 *Plate 89*

The Scotchman's Stone is a rock in the river above Greta Bridge and Cotman refers, in a letter written in late August 1805, to having 'coloured a sketch of it'. Cotman was certainly familiar with the traditional procedure then practised by almost all landscape watercolourists, of making pencil sketches on the spot and working them up into finished watercolours in the studio, in some cases perhaps even as much as two or three years after the pencil drawings were made. At the same time some artists, Cotman included, were beginning to use colour in their original sketches. Cotman wrote to Dawson Turner from Yorkshire in 1805 that his 'chief study has been colouring from Nature', adding that many of his works were 'close copies of that ficle [sic] Dame', which might suggest that he found the process unfamiliar and somewhat difficult. The problem is to distinguish, in terms of the period, between a coloured sketch and a finished watercolour. This ambiguity arises particularly in connection with some of Cotman's most famous works, such as the present drawing and *The Drop Gate, Duncombe Park* (no. 118). The artist's biographer Sydney Kitson writing in 1937 assumed that they were outdoor studies for fully worked-up exhibition-pieces which have subsequently disappeared. More recently (1979 and 1982), Rajnai has argued that the designs are too subtle and the colours too arbitrary for this to be the case, and that these drawings are in fact those executed in the studio and exhibited. What is interesting is that there should be this ambiguity. Cotman, like Constable in the medium of oil paint at the same time, was narrowing the gap between sketch and finished picture, imbuing the latter with much of the freshness of an on-the spot study and, still more important, imposing on the former some of the contrivances of picture making.

John Sell Cotman 1782–1842

123 *Durham Cathedral*

Watercolour over pencil; 436×330mm
1859-5-28-119 (L.B. 1) *Plate 87*

In September 1805, after staying for three weeks at Rokeby and a fortnight at Greta Bridge, Cotman went on to Durham where he seems to have spent about a week. Mrs Cholmeley had urged him to 'storm Durham', a plea which he was inclined to resist: as he wrote to her son on 29 August 1805 '. . . but seriously what have I to do with Durham? Am I to place it on my studies of trees like a Rookery. No and besides I have no time for Durham I want to get to Ray Wood'. In spite of his initial reluctance Cotman was sufficiently impressed by the

cathedral and its setting – 'magnificent tho not so fine as York' – to make at least five views, of which this is the finest, showing the cathedral perched almost like the artist's 'rookery' high above the trees. It is probably the work exhibited by Cotman at the Royal Academy in 1806 and at the Norwich Society in 1807, and subsequently belonged to his patron, the banker Dawson Turner, whose enthusiasm for the medieval would have given the subject a particular appeal.

Together with no. 126, this was among the earliest drawings by Cotman to enter a public collection, the two having been acquired on behalf of the Museum at Dawson Turner's sale in 1859.

John Sell Cotman 1782–1842

124 *Interior of Norwich Cathedral; Stone Screen*

Pencil and watercolour; 360×272mm
1902-5-14-18

One of a group of drawings and watercolours of the Cathedral made shortly after Cotman returned to Norwich in 1806. Disappointed by his lack of public success in London, which had culminated in his rejection by the newly-formed Society of Painters in Water-Colours, he remained in provincial isolation in Norfolk for the next twenty-seven years. Cotman had always drawn ruined abbeys and castles and other picturesque architectural subjects (see nos 114, 117), but from c.1806 the nature of his interest in them changes as he came increasingly to concentrate on the details – the decorative carving of medieval church doorways, for example. He was encouraged – or even bullied – to concentrate on antiquarian draughtsmanship by his patron, the Yarmouth banker, Dawson Turner. Although often represented as a period of decline in Cotman's life, in which he was forced to turn out hack work, closer examination reveals that the drawings (and indeed the etchings) have undeniable quality.

In its concentration on the shapes and patterns of architectural form and decoration, a study like this might fairly be compared with such Yorkshire subjects as *The Drop Gate*: here the delicate tracery of the screen and the resultant areas of light and shade have taken the place of the wooden gate; and the simpler geometric shapes of the stone paving and the wooden screen, of the river bank. Cotman's appreciation of tonal values and textures, and his concentration on isolated motifs, which developed in the period 1803–5, enabled him to transform an antiquarian record into a refined and subtle work of art.

John Sell Cotman 1782–1842

125 *A Centaur Fighting a Lapith*

Pencil and grey wash; 329×222mm
1902-5-14-41

The inspiration of this drawing seems to have been one of the metopes from the Parthenon frieze (probably XXXI), which Cotman may have seen in 1807 when Lord Elgin put the marbles on exhibition in London. Cotman's imaginative adaptation of an Antique motif and his setting of it in a Dughet-like landscape, recall his earlier association with the Sketching Society (see no. 115), whose members aimed to make landscape no less significant than history painting by treating literary or historical themes in terms of landscape. They may have been following the principles of *paysage historique* (or *paysage composé*) propounded at the very end of the eighteenth century by the French painter and theorist Pierre-Henri de Valenciennes. He argued that landscape could be raised to the level of history painting by ennobling and idealising nature to create a setting appropriate in mood for the elevated actions of the figures.

John Sell Cotman 1782–1842

126 *Composition: A Sarcophagus in a Pleasure-Ground*

Watercolour over pencil; 330×216mm
1859-5-28-121 (L.B.2) *Plate 88*

This is one of a group of studies of Antique sculpture probably (to judge from an inscription on one) inspired by the statuary placed in the grounds of Castle Howard in Yorkshire, which Cotman visited in 1803 and 1805. This watercolour of c.1806, derived from a preliminary pencil study datable c.1803–4, reflects the romantic classicism and the essentially aesthetic response to the Antique that was a feature of Cotman's work.

John Sell Cotman 1782–1842

127 *Mousehold Heath*

Pencil and watercolour; 299×436mm
1902-5-14-20

This is one of two watercolours of similar size showing the same scene, a favourite sketching ground for Norwich School artists (the other is in the Colman Bequest, Castle Museum, Norwich).

A preparatory drawing in the British Museum (1902-5-14-221) is dated 10 April 1810, and this watercolour may have been one of the two *Views on Mousehold Heath* included in the Norwich Society of Artists exhibition in the same year. Cotman's attachment to the Heath was life-long. In November 1841 he wrote to Dawson Turner recalling his last day in Norfolk that autumn: 'I galloped over Mousehold Heath on that day, for my time was short, through a heavy hail-storm, to dine with my Father – but was obliged to stop and sketch a magnificent scene . . . Oh! rare and beautiful Norfolk'.

By this stage in Cotman's development, delicate detail has been largely suppressed, and his treatment of forms is much bolder. In its rich colouring this drawing anticipates Cotman's style of the 1820s. The panoramic vista is made even more striking by the pattern created by the paths on the surface of the undulating heath. Compositionally, there seems to be an echo of Gaspard Dughet (whose paintings Cotman admired), in the introduction of a reclining figure in the left foreground and in the general structure of the design. Cotman had at this stage little interest in Dughet's classical subject matter, but seized on his feeling for mass and his reliance on a compact yet fluid pictorial architecture.

This was among the drawings that Cotman seems to have been unable to sell; one of his sons later pledged it to a Norwich pawnbroker, and when auctioned in 1862 it failed to reach its reserve price of £10, being withdrawn at £5.15s.

John Sell Cotman 1782–1842

128 *The Dismasted Brig*

Pencil and watercolour; 201×310mm
1902-5-14-32

129 *Yarmouth River*

Watercolour; 239×340
1859-5-28-116 (L.B. 3) *Plate 90*

Just as Cotman brought an idiosyncratic approach to architectural subjects (no. 123), so his seascapes are marked by an equally distinctive character. *The Dismasted Brig*, one of the artist's most celebrated watercolours, has been variously dated; by Sydney Kitson *c*.1824–5 and by Miklos Rajnai *c*.1808. It could be argued, however, that both this watercolour and that of Yarmouth River may well date from soon after Cotman's move in 1812 from Norwich to Yarmouth, which was the home of his principal patron, the banker Dawson Turner. Cotman

acted as drawing master to Turner's wife and six daughters, and increasingly found himself involved with Turner's antiquarian publications so that he was devoting most of his energies to architectural etching. A letter from the artist to his Yorkshire friend Francis Cholmeley, 13 April 1812, describes his new house in Yarmouth, and his fascination with the sea: '. . . My small garden leads me on to the road . . . Then, a green meadow, then the view along the banks of which, directly before my house, lies the condemned vessels of every nation, rigged and unrigged in the most picturesque manner possible . . . From my house we reach the sea in about ¾ of a mile, on which rides at time[s] the Navey dimly moved in view. Today at sea a frigate and open brigg c[a]me to anchor. In short I have nev[er] saw so animated a picture as this spot affor[ds], it is always changing, always new' (quoted in *John Sell Cotman, 1782–1842*, exhibition catalogue, 1982, p.107).

John Sell Cotman 1782–1842

130 *Fire at a Vinegar Works on the River Wensum*

Pencil with coloured chalk and touches of bodycolour on grey paper; 229×327mm
1905-5-20-2 Presented by Henry Joseph Pfungst *Plate 91*

One of two studies in the British Museum recording the destruction by fire of Squire, Hill & Co's Vinegar Works on the banks of the River Wensum in October 1829. The flames irradiate the chimneys of the factory, and the sparks cascade across the river. The effect of the fire is conveyed by treating the rest of the subject in monochrome.

John Sell Cotman 1782–1842

131 *A Mountain Tarn*

Watercolour; 180×265mm
1902-5-14-28 *Plate 93*

In the mid-1830s Cotman experimented with watercolour combined with a thickening agent (perhaps derived from flour paste or size) which gave the medium some of the qualities of oil-paint. Not only was the depth of colour intensified, but the pigment had a texture that enabled it to be to some extent manipulated. The present drawing is one of a group of Welsh subjects presumably based on impressions and recollections of his sketching tours in Wales in 1800 and 1802.

John Sell Cotman 1782–1842

132 *Postwick Grove*

Watercolour and black chalk; 210×290mm
1902-5-14-29

Executed (like the preceding watercolour) in the opaque medium which Cotman used in the 1830s, this is one of a number of nearly monochrome landscapes: a striking contrast with no. 131. In its inky, soft black tonality, and concentration on simple, abstracted forms it is perhaps not too fanciful to regard these drawings, as Miklos Rajnai has suggested, as Cotman's version of Alexander Cozens's 'blot' drawings – mysterious evocations of landscape, rather than direct representations.

John Sell Cotman 1782–1842

133 *Boys Fishing*

Black chalk and grey wash with some watercolour and bodycolour on blue paper; 278×375mm
1902-5-14-58 *Plate 92*

This drawing is related to a painting exhibited by Cotman in Norwich in 1839 with the title *Henley-on-Thames: Boys Fishing*. With its faintly elegiac quality and almost monochrome tonality, relieved by touches of colour, it is among the most beautiful of Cotman's late drawings. The similarity of motif suggests that Cotman may have known Constable's painting *Stratford Mill*, exhibited at the Royal Academy in 1820, or the mezzotint of it published as *The Young Waltonians*.

John Sell Cotman 1782–1842

134 *Hollow Way at Blofield*

Black chalk heightened with white on blue paper; 231×336mm
1902-5-14-116

Cotman's last visit to Norfolk took place in the autumn of 1841. 'The Principal of King's College, London [where Cotman was drawing master] has given me a holiday of a fortnight, but I shall stretch it to three weeks or nearly so'; in fact, he remained in his native county for almost two months, a period which saw his last great burst of creative energy. The group of drawings on coloured paper inspired by this visit to Norfolk are the final phase of Cotman's work; in place of the brilliant colour and thickly applied pigments of the late watercolours (see no. 131), he turned to the monochrome medium of black chalk, softening his previously emphatic outlines in a new and distinctive way, which in mood recall some of Gainsborough's late drawings.

George Robert Lewis 1782–1871

135 *The Valley of the Rocks, Lynton*

Watercolour over pencil; 332×495mm
Signed: *G. R. Lewis*
1883-10-13-36 (L.B. 7) *Plate 94*

Little is known about George Robert Lewis, the uncle of J. F. Lewis. Although he seldom exhibited his works, his few surviving paintings (in particular, the two harvest scenes of *c*.1815 now in the Tate Gallery) and watercolours reveal him as an artist deserving wider recognition. He was a friend of Linnell, whom he accompanied on a sketching tour of Wales in 1813, and with whom he shared an interest in the prosaic, unpicturesque aspects of landscape; it was in keeping with this taste that both artists made watercolour studies of labourers at work and other everyday subjects. The present watercolour is not dated, but was probably made in the 1820s or 1830s. It is in some ways an anticipation of Pre-Raphaelite landscape. But while the theme of manual labour played an important part in the work of artists like Henry Wallis, John Brett and Ford Madox Brown, G.R. Lewis's stonebreaker is no more than a diminutive figure in the rocky landscape.

David Cox 1783–1859

136 *A Cornfield*

Watercolour; 200×305mm
Signed and dated: *D. Cox 1814*
1915-3-13-76 Sale Bequest *Plate 96*

Dating from the year in which Cox published his *Treatise on Landscape Painting*, this watercolour shows how Cox absorbed the example of John Varley and, in particular, his contemporary De Wint, who specialised in harvesting scenes of exactly this type. At this stage in his career, Cox is still applying watercolour in broad, rich washes and has not yet developed the distinctive technique of animating the surface of his work with repeated small strokes of the brush.

David Cox 1783–1859

137 *The Brocas, Eton*

Watercolour; 216×336mm
1900-8-24-492 (L.B. o) Vaughan Bequest

Cox's early watercolours included numerous Thames-side views in the style of John Varley, who exercised a considerable influence on many of the watercolourists who came to maturity in the early years of the nineteenth century. This example, however, in which Cox's brilliant, limpid manipulation of watercolour transforms Varley's formularised composition into something altogether more forceful, suggests a date in the early 1820s.

David Cox 1783–1859

138a *Early Summer; in the Meadows*

Watercolour; 188×292mm
1878-12-28-74 (L.B.22) Henderson Bequest

b *Ulverston Sands*

Watercolour; 258×368mm
1915-3-13-13

Probably dating from the late 1820s or early 1830s it has been suggested that 138a is perhaps a view in the meadows near Battersea. The low-lying land, the open sky and the receding group of figures, are all elements recurring in Cox's landscapes throughout his life. Despite this element of repetition (and Cox often made several versions of his compositions), he was able to maintain an apparent spontaneity and freshness of effect.

Cox visited the North-West of England on sketching tours in the mid-1830s and exhibited views of the coast near Lancaster at the Old Water-Colour Society in the late 1830s and early 1840s. Ulverston Sands, at the outlet of the River Leven on the Furness peninsula of Morecambe Bay, was a subject he painted on several occasions. By the late 1830s, the probable date for 138b, Cox's style had become extremely free and fluent, and he was a master at achieving atmospheric effects, attaching great importance to the depiction of the sky.

David Cox 1783–1859

139 *Snowdon*

Watercolour with scratching out; 264×368mm
Signed: *David Cox*
1878-12-28-64 (L.B. 1) Henderson Bequest *Plate 98*

A late example of Cox's Welsh views; here, although executed on a comparatively small scale, he evokes the sombre and almost threatening grandeur of Snowdon. The granular texture and irregularity of the paper enhances the effect of Cox's sponged and scraped areas of steel grey and green: a Sublime interpretation of the landscape that is in a direct line of descent from Turner's 1798–9 Welsh studies (see no. 86).

David Cox 1783–1859

140 *Beeston Castle*

Watercolour and bodycolour with scratching out; 604×859mm
Signed and dated: *David Cox 1849*
1915-3-18-22 Sale Bequest *Plate 99*

Dating from the last decade of Cox's life, this watercolour is one of a number of such late works depicting the elemental forces of nature. The vast, rain-swept landscape, its scale enhanced by indistinctness, reflects a Burkean notion of the Sublime. Cox was clearly aware of Burke's observation that 'the idea of a bull is therefore great, and it has frequently a place in sublime descriptions, and elevating compositions', the bellowing and the storm 'awaken a great and aweful sensation in the mind'. In a similar watercolour of 1853, *The Challenge* (Ashmolean Museum, Oxford), two bulls confront one another across a ravine; here, Cox concentrates on one bull in the foreground of the composition, suggesting the conflict of the lone creature against the threatening powers of nature. The subject also recalls James Ward's celebrated painting, *Gordale Scar* (Tate Gallery), 1811–15, an essay in the 'terrific' sublime.

Samuel Prout 1783–1852

141 *The Church of St Lô, Normandy*

Watercolour with pen and brown ink; 355×236mm
1900-8-24-530 (L.B. 1) Vaughan Bequest

In the first half of the nineteenth century Prout was one of the most popular exponents of picturesque architectural topography. His views of the quaint aspects of foreign medieval cities were widely reproduced as engravings and lithographs and appealed to a new middle-class public, who, if they themselves had not yet begun to travel in Europe, vicariously enjoyed the experience in the form of illustrated travelogues or – as they were then known – 'picturesque annuals'. As a boy, Ruskin had been a pupil of Prout, and never ceased to express admiration for his work, praising his calligraphic outline (which, incidentally, seems in fact to go back to Canaletto via his English imitators). Prout's favourite compositional device, as in the present drawing, was a corner or fragment of a building seen close up and enlivened by a busy foreground scene. A semi-invalid, most of his foreign travel took place in the 1820s and provided the material for subsequent watercolours. His work can be difficult to date, for he settled into a consistent style and was in the habit of repeating earlier compositions. His influence was disseminated by means of drawing manuals, including *A Series of Easy Lessons in Landscape Drawing*, 1820 and *Prout's Microcosm: The Artistic Sketchbook of Groups of Figures, Shipping and other Picturesque Objects*, 1841, which gave amateurs instructions on how to arrive at suitably picturesque compositions.

Peter De Wint 1784–1849

142 *Harvesting*

Watercolour over pencil; 130×578mm
1910-2-12-247 Salting Bequest

Undeterred by the disparaging opinion of Thomas Uwins, a fellow member of the Society of Painters in Water-Colours, that 'hay-making, reaping etc, are general, and known to everybody, and this is against it as an exhibition scene', De Wint exhibited numerous subjects of this kind, which are now regarded as some of his most attractive works. Despite his success as a watercolourist – 'so congenial indeed to the collectors . . . that not only his larger works, but every scrap from his pencil is sought with avidity' as an article in the *Library of the Fine Arts* noted in 1831 – De Wint found difficulty in selling his oil paintings. These included *A Cornfield*, 1815 (Victoria and Albert Museum), which is one of the most remarkable observations of the English countryside hitherto painted. His taste for broad stretches of open landscape and his palette of rich gold and earth tones were ideally suited to such subjects.

Peter De Wint 1784–1849

143 *The Village Pond*

Watercolour; 367×502mm
1910-2-12-245 Salting Bequest

Although Ruskin noted during the artist's lifetime that 'De Wint despises all rules of [classical] composition, hates old masters and humbug, synonymous terms with him', there are in fact a number of watercolours which reflect an awareness of seventeenth-century landscape painting: here he seems to be echoing a compositional formula popularised by Gaspard Dughet.

Peter De Wint 1784–1849

144 *A Panoramic Landscape with a Donkey in the foreground*

Watercolour with pen and brown ink; 300×474mm
1892-7-14-447 (L.B. 9) *Plate 100*

The influence of Girtin is still apparent in this panoramic sketch which is perhaps datable before c.1820; the rather coarse, granular, buff-coloured paper resembles that used by Girtin in his own early work and also suggests an early date. De Wint was skilful at using the roughness of the paper to give luminosity to his washes. It was perhaps this sort of study that the poet John Clare was referring to in 1829, when he wrote to ask De Wint for 'a bit of your genius to hang up in a frame in my Cottage. What I mean is one of those scraps which you consider nothing after having used them that lye littering about your study for nothing would appear so valuable to me as one of those rough sketches taken in the fields that breathes with the living freshness of open air . . . where the blending & harmony of earth air & sky are in such a happy unison of greens & greys that a flat bit of scenery on a few inches of paper appear so many miles'.

Peter De Wint 1784–1849

145 *Lancaster*

Watercolour over black chalk and pencil; 267×446mm
1915-3-13-26 Sale Bequest *Plate 97*

The extent of Girtin's influence on De Wint is evident in this panoramic view of Lancaster. At the age of eighteen De Wint had been introduced by John Varley to Dr Monro, whose collection of watercolours, including a notable group by Girtin, he was able to study. Girtin's work was probably the strongest influence on the generation of watercolourists who came to maturity in the first decade of the nineteenth century. They included Varley, Cotman, Cox and De Wint, the last being perhaps Girtin's closest follower. In this drawing, the foreground roofscape was evidently inspired by such drawings by Girtin as the studies of London, drawn from a similarly high vantage point, nos 82a–f. However, De Wint's application of paint, washes of loose flowing colour in warm tones of purplish brown and olive green, is quite unlike Girtin.

De Wint exhibited three views of Lancaster at the Old Water-Colour Society between 1826 and 1834: this sketch probably dates from the same period.

Peter De Wint 1784–1849

146 *Lincoln*

Watercolour; 670×1113mm
1958-7-12-341 Lloyd Bequest *Plate 101*

After his marriage in 1810 to the sister of the history painter William Hilton, De Wint became a frequent visitor to Lincoln, where his wife's family lived. This watercolour is one of his largest and most monumental views of the city, and was doubtless conceived as an exhibition piece. Between 1807 and his death in 1849 he exhibited 326 works, but since he never signed or dated his watercolours it is impossible to do more than distinguish groups of stylistically related drawings. Elaborately finished works of this kind probably date from the 1830s. They reflect the influence of De Wint's contemporaries, including Turner (whose *England and Wales* series affords an interesting comparison) and Prout. Apart from Turner, De Wint was one of the few artists of his generation who mastered both the challenge of the large scale exhibition piece and the informal sketch.

William Collins 1788–1847

147 *A Cottage at Shedfield, Hampshire*

Watercolour and ink over pencil, with scratching out, on buff paper heightened with white; 175×250mm
1847-5-29-2 (L.B. 7) *Plate 102*

Collins was a life-long friend of Linnell, and his memoirs show that as a young man they shared many of the same ideas about the study of landscape. 'I think him [Linnell] right in . . . insisting upon the necessity of making studies – without much reference to form – of the way in which colours come against each other'. This sketch of an old cottage is close in style to studies of the same kind made by Linnell *c*.1811–15.

George Scharf 1788–1860

148a *The Strand from the Corner of Villiers Street*

Watercolour over pencil, with black ink; 218×372mm
(the sheet made up by about 35mm on either side and 5mm at the top)
Signed and dated: *G Scharf del. Sept.*br *1824*
1862-6-14-19

b *Allen's Colourman's Shop, St Martin's Lane*

Watercolour over pencil; 138×227mm
Signed and dated: *In S*t*. Martins Lane G Scharf del. 1829*
1862-6-14-119 *Plate 104*

c *The Laying of the Water-Main in Tottenham Court Road*

Watercolour over pencil with scratching-out; 250×443mm
Signed and dated: *G Scharf del 1834. Tottenham C*t*. Road*
1862-6-14-308 *Plate 105*

Scharf was born in Bavaria and spent the early part of his career as a miniature painter, specialising during the Napoleonic Wars in portraying the officers of the contending armies. He served in the British Army at Waterloo and in 1816 settled in London. He had studied the new art of lithography before leaving his home-country and became well-known for precise illustrations of scientific and antiquarian subjects and for his views of London. In 1862 the British Museum purchased from his widow and their son, Sir George Scharf (1820–95), the first Director of the National Portrait Gallery, the huge collection of studies of London life and topography from which the present drawings are taken. Scharf's detailed observation in these

studies is that of a foreigner to whom everything is slightly un-familiar: it bears out the truth of Madame de Staël's saying: *'les étrangers sont une posterité contemporaine'*.

In no. 148a the row of small shops, one of which is on fire, at the west end of the Strand was to be replaced in 1830–2 by Nash's neo-classical 'Metropolitan Improvements'. The Colour-man (no. 148b) was a retailer of paints and artists' supplies. Since the mid-seventeenth century painters in oil had been able to buy their colours ready-prepared, but until about 1780 watercolourists had had to grind and wash their own pigments before blending them with gum arabic. The convenience of portable 'water colours in Cakes', developed most successfully by Thomas and William Reeves, had made the medium con-veniently available to thousands of amateurs as well as increasing its use among professional artists and leading to the develop-ment of watercolour as an artistic medium in its own right.

The laying of the water-main in Tottenham Court Road in 1834 (no. 148c) was part of a large-scale programme of im-proving the sanitation of the rapidly expanding city. Scharf has moved away from the minute recording of detail which was his major concern in the view of the Strand ten years earlier, using a broader style in an attempt to convey the smoky atmosphere and scratching the surface of the paper to indicate the sparks flying from the cauldron. The tradition of genre studies of working-class life is combined with a fascination with techno-logical developments of the day; the spellbound onlookers share what must have been the feeling of the average Londoner and, no doubt, of Scharf himself.

John Martin 1789–1854

149 *Proposed Triumphal Arch across the new Road from Portland Place to Regents Park*

Pen, brown ink and brown wash over pencil; 345×495mm
Signed and dated: *John Martin 1820*
1867-3-9-1706 (L.B. 5)

Martin made his name as a painter of a series of highly coloured canvases usually showing melodramatic scenes from the Bible such as *Joshua Commanding the Sun to stand still*, *The Fall of Babylon* and *Pandemonium*. These pictures, which were crowded with figures and illuminated by dramatic lighting effects, delighted the public but pleased the critics less. Ruskin condemned them for being 'as much makeable to order as a tea-tray or a coal-scuttle'.

The obsession with visionary architecture suggests that Martin

was a frustrated architect. The present drawing, dated 1820, is a design for a national monument to commemorate the victory of Waterloo. It took the form of a triumphal arch over the New Road (now the Marylebone Road) which would continue the line of Portland Place and provide 'a noble and ample access to London' from the north – an access which would in practice have been limited to pedestrians. The bridge supports a squat column decorated with the simulated barrels of cannon and surmounted by a statue of the Duke of Wellington. The view is looking east, towards the Church of Holy Trinity, at the corner of Albany Street.

William Henry Hunt 1790–1864

150 *Bushey Churchyard*

Pen and ink with watercolour; 320×415mm
1921-7-14-14 *Plate 107*

A protégé of the collector and physician Dr Monro, Hunt was a frequent guest at Merry Hill, his country house near Bushey in Hertfordshire. He was a cripple, so Monro had him 'trundled on a sort of barrow with a hood over it, which was drawn by a man or a donkey while he made sketches'. A number of views in the neighbourhood of Bushey survive, but this example is of particular interest, since it shows the churchyard where two of Monro's other protégés and friends, Thomas Hearne (1744–1817) and Henry Edridge (1769–1821) (see nos 45–7 and 71), were buried. Their tombs are shown, together with that of Henry Monro (1791–1814), the doctor's second son, a promising artist who died at the early age of twenty-three. At the extreme right is Dr Monro himself, on horseback. This is a replica, executed c.1822, of the original watercolour made for Dr Monro and now in the Yale Center for British Art. The vigorous, wiry pen outlines drawn in brown ink recall Hunt's early practice in 1806–11, when he was still a pupil of John Varley, of copying drawings by Canaletto in Dr Monro's collection.

William Henry Hunt 1790–1864

151 *A Village in a Valley*

Watercolour; 267×375mm
Signed: W. HUNT
1958-7-12-352 Lloyd Bequest *Plate 106*

In 1806 Hunt had the good fortune to become a pupil of John Varley, in whose studio he met the slightly older Mulready and also John Linnell, with whom he went on sketching expeditions. Hunt's early work reflects something of the same approach to landscape as Linnell's, though without his obsessive intensity. The style of this watercolour by Hunt suggests a fairly early date, and possibly also some knowledge of the work of John Varley's younger brother Cornelius.

Hunt's development from such broadly handled landscapes in pure watercolour to the minutely worked, richly-textured and highly-coloured stippled works of the 1830s onwards reflects the change of taste in the first twenty years of the nineteenth century when watercolours became increasingly acceptable to the middle-classes as substitutes for oil paintings.

William Henry Hunt 1790–1864

152 *Plucking the Fowl*

Watercolour with scratching out; 346×362mm
Signed and dated: HUNT 1832
1958-7-12-353 Lloyd Bequest *Plate 108*

In the late 1820s Hunt largely gave up making topographical views and turned to still-life subjects and rustic genre (in which he was able to combine elements of portraiture, landscape and still-life), developing a distinctive technique of minutely applied touches of colour, quite the reverse of his early style in which translucent washes were subordinated to a firm outline. The present watercolour, exhibited in 1833, is a direct and un-sentimental example from Hunt's middle period: he was later to adopt a rather archly sentimental or humorously anecdotal manner.

Hunt's watercolours were much admired by Ruskin and the Pre-Raphaelites, who approved of his concern for careful observation of natural detail, his sense of colour and his technique. Ruskin's detailed account of prismatic colouring in his influential book *The Elements of Drawing*, 1857, was largely based on his careful analysis of Hunt's practice: '. . . it had its origin and authority in the care with which he followed the varieties of colour in the shadow, no less than in the lights . . . if all accidents of local colour, and all differences of line between direct and reflected light are to be rendered with absolute purity . . . only interlaced touches of pure tints on the paper will attain the required effect'. Hunt's mastery of textural effects and the play of light is admirably demonstrated in the present watercolour.

In his Preface to the exibition of the works of Prout and Hunt held at the Fine Art Society in 1879–80 Ruskin noted the

John Martin *Proposed Triumphal arch across the new road from Portland Place to Regents Park* (no.149)

reasons for the appeal of Hunt's works: '[they] were made for [the] . . . middle classes, exclusively; . . . The great people always bought Canaletto, not Prout, and Van Huysum, not Hunt. There was indeed no quality in the bright little watercolours which could look other than pert in ghostly corridors, and petty in halls of state; but they gave an unquestionable tone of liberal mindedness to a suburban villa, and were the cheerfullest possible decorations for a moderate-sized breakfast parlour opening on a nicely-mown lawn'.

John Linnell 1792–1882

153 *The Valley of the River Lea, Hertfordshire*

Watercolour and black chalk heightened with white on blue
paper; 340×540mm
Signed and dated: *River Lea. J. Linnell 1814* and inscribed,
perhaps with colour notes, in a form of shorthand or cipher.
1980-1-26-116 *Plate 103*

Linnell's journals record visits to the River Lea in 1814 in
connection with a commission he had received for illustrations
to a new edition of Izaak Walton's *Cmpleat Angler*; this drawing
is one of a number of studies made on blue paper in that year.
 His master, John Varley, had encouraged him to sketch
small picturesque subjects from nature such as gnarled trees,
broken fences and old cottages, but in this group of Hertford-
shire drawings he has abandoned his earlier conventional notions
of pictorial composition and picturesque motifs in favour of
the faithful representation of broad stretches of open and
often featureless countryside. Samuel Palmer was later to recall
the advice of Mulready (a fellow-pupil with Linnell of John
Varley) 'to copy objects which were not beautiful, to cut away
the adventitious aid of association'. In fact, Linnell's obsessive
concentration on transcribing exactly what he saw has resulted
in a strikingly original image.

Clarkson Stanfield 1793–1867

154 *A Windmill near Fécamp, Normandy*

Watercolour with scratching out; 194×257mm
1900-8-24-583 (L.B. 7) Vaughan Bequest *Plate 110*

Stanfield's indebtedness to Bonington can be seen in the choice
of subject and handling of this watercolour. It may have been
intended for engraving in Charles Heath's *Picturesque Annual*
for 1834, in which there is a view of the shore at Fécamp.
Stanfield had visited the area in 1832 during his tour along the
north coast of France, to gather material for the *Picturesque
Annual*.

Clarkson Stanfield 1793–1867

155 *The Dogana and the Church of the Salute, Venice*

Watercolour and bodycolour with scratching out; 220×315mm
1900-8-24-537 (L.B. 5) Vaughan Bequest

Stanfield's reputation was chiefly as a marine painter, and
many of his contemporaries regarded him as the equal of
Turner. With hindsight, this opinion is over-generous; an
element of melodrama (he first achieved success as a scene-
painter) is never far away, but Stanfield was undoubtedly one
of the most accomplished painters of the period. A review in
The Times in 1870 of a retrospective exhibition of his work
noted 'his unerring sense of the agreeable and picturesque',
qualities which help to explain his success.
 During the 1830s, Stanfield was one of the foremost con-
tributors to the various illustrated travel books that had become
so popular; Charles Heath's *Picturesque Annuals* for 1832, 1833
and 1834 were all solely illustrated by engravings after Stanfield.
This watercolour – one of his liveliest and most accomplished –
was based on sketches made during a visit to Venice in 1830,
and was engraved by Edward Goodall for the *Picturesque Annual*
of 1832. 'The time chosen by the artist is during a storm . . .
Woe betide the Gondoliers that have not time to get home
before the riot commences! . . . All Venice is in an uproar!'
(p.169).

Clarkson Stanfield 1793–1867

156 *The Pic du Midi d'Ossau, Basses Pyrenees*

Pencil, black chalk and watercolour heightened with white;
478×337mm
Signed with the artist's monogram and inscribed; *Pic du Midi
d'Ossau. Saturday Nov'. 8th 1851. Basses Pyrenees.*
1981-3-28-6

Stanfield used this study, made during a sketching tour in the
Pyrenees and northern Spain in 1851, as the basis for a large
painting commissioned in 1852 by the collector Elhanan Bick-
nell, a notable patron of Turner, among other contemporary
artists. It was completed in 1854 and exhibited at the Royal
Academy in the same year, and is now in the collection of The
Royal Holloway College.

David Roberts 1796–1864

157 *The Interior of the Church of San Miguel, Xeres*

Watercolour and bodycolour; 355×262mm
Signed and dated: *D. Roberts 1834*
1900-8-24-532 (L.B. 3) Vaughan Bequest *Plate 109*

158 *Burgos Cathedral*

Watercolour; 393×259mm
Signed and dated: *D. Roberts 1836*
1900-8-24-533 (L.B. 4) Vaughan Bequest

David Roberts, together with Samuel Prout, James Duffield
Harding, Clarkson Stanfield and, to some extent, J. F. Lewis,
belonged to the group of artists specialising in foreign topo-
graphical views who came to prominence in the 1820s and
1830s. Originally apprenticed as a house painter in his native
Edinburgh, Roberts became a scene painter. In 1822 he moved
to London and in 1830 was President of the Society of British
Artists. In October 1832 he left for Spain, and did not return to
England until eleven months later. This was his first long and
important journey abroad, a precursor of his tour to Egypt,
The Holy Land and Syria in 1838–39. He seems to have been
attracted to Spain by the fact that it was a country whose
architecture had until then been neglected by British painters
(it is true that Wilkie had visited Spain in 1828, but he was
chiefly interested in the depiction of Spanish *genre* and daily
life). Roberts wrote from Cordoba: 'Those who could have
appreciated the richness of its architecture have generally gone
to Italy or Greece. My portfolio is getting rich, the subjects are
not only good, but of a very novel character'. This element of
novelty seems to have been of great importance; the 1830s
were the decade of the new illustrated publications, and Roberts
was deliberately assembling material not only for worked-up
watercolours and oil paintings, but also for reproduction in the
form of steel-plate engravings and lithographs. His Spanish
works were published in the *Landscape Annuals* from 1835 and
in a separate volume, *Picturesque Sketches in Spain*, 1837.
 These two watercolours, worked up from sketches after the
artist's return to England, are fine examples of his style, com-
bining architectural precision with atmospheric sensitivity. *The
Interior of San Miguel, Xeres* (lithographed in *Picturesque Sketches
in Spain*), with its richly solemn, mysterious character, is perhaps
to some extent inspired by Bonington (for example, *The Interior
of S. Ambrogio, Milan*, 1828, Wallace Collection); while the view
of *Burgos Cathedral*, which Roberts described as 'one of the
finest in Spain', has a faint flavour of the kind of bizarre
sublime developed by John Martin. So familiar became Roberts's
Spanish views that in his celebrated guide book to Spain,
published in 1845, Richard Ford referred to one aspect of
Burgos Cathedral as 'forming a picture by Roberts'.

James Duffield Harding 1797–1863

159 *Dunstanborough Castle, Northumberland*

Watercolour and bodycolour; 220×323mm
1958-7-12-347 Lloyd Bequest *Plate 111*

Harding was chiefly important as a drawing master (the young
Ruskin was one of his pupils) and as a lithographer, by which
means he was able to popularise his method of landscape
composition. He was also among the most frequent contributors
to the *Landscape Annual*, one of the illustrated publications
which sprang up as a result of the development in the 1820s of
engraving on steel plates, a much harder material than copper,
and one that enabled an economic number of impressions to be
taken. These provided a new source of employment for water-
colourists who specialised in topographical subjects.
 Dunstanborough Castle reflects Harding's admiration for
Turner's marine watercolours. He no doubt had in mind a
series like *The Ports of England*, in particular the view of Dover
from the sea of *c.*1825. Ruskin admired 'the rich, lichenous,
and changeful warmth, and delicate weathered greys of Harding's
rock . . . the most fearless, firm, and unerring drawing, render
his wild pieces of torrent shore the finest things, next to the
work of Turner'.

Joseph Stannard 1797–1830

160 *The Beach at Mundesley, Norfolk*

Coloured chalks with touches of bodycolour over pencil and
black chalk on brown paper; 149×466mm
Signed and dated: *JStannard 182[?]*
1902-5-14-466 *Plate 112*

A comparatively little-known member of the Norwich school,
Stannard was greatly influenced by Dutch art and studied in
Holland for a year in 1821–2. Although he exhibited in London
from time to time, he was based in Norwich and his work was
almost exclusively concerned with recording the scenery of his
native area. Although uneven in quality, some of his etchings
(which reflect his admiration for Rembrandt's landscapes) and
drawings are of considerable merit. This view of the beach at
Mundesley is unusual in technique: at first sight it appears to be
a watercolour, but in fact it is largely executed in coloured
chalks.

James Prinsep 1799–1840

161 *A Monument to perpetuate the Fame of British Artists of 1828*

Watercolour; 248×205mm
Signed: *James Prinsep 5 July 1830*
1980-5-10-21

In 1826 the artist George Fennel Robson was commissioned by Mrs George Haldimand, the wife of a leading financier and sister of James Prinsep, 'to form a representative album of drawings by the best watercolour painters of the day'. When complete, in 1828, the collection amounted to one hundred drawings. It remained intact until 1980, and was the most elaborate surviving example of the then contemporary fashion among collectors at that period for compiling such albums.

James Prinsep's watercolour must have been intended as a frontispiece to the album, since all the artists recorded on the column were represented in the collection. Together with Turner, Cox and De Wint are the names of those whose reputations have faded into near-obscurity – for example, Charles Wild (1781–1835) and Samuel Austin (1796–1834). Yet Cotman, who had left London in 1806 to take up a frustrating provincial career as a drawing-master, and whose work is generally thought to have been ignored during the 1820s, has achieved a place on the column.

Edward Calvert 1799–1883

162 *A Primitive City*

Watercolour with pen and ink; 68×102mm
Signed and dated: EDWARD CALVERT 1822
1947-2-17-1 Presented by the National Art—Collections Fund *Plate 123*

Almost all of Calvert's surviving works are from the latter part of his career. His smallish idyllic landscapes with figures, vaguely classical or pastoral in feeling, light in tone and executed on paper in oil paint so thinly diluted as to have the appearance of watercolour, are not without distinction and even beauty, of a faint and somewhat monotonous kind; but Calvert's fame as an artist rests on the group of fifteen little prints which he produced in the late 1820s and early 1830s – two lithographs, four engravings on copper and nine wood-engravings. He had been one of the group of youthful disciples, including Samuel Palmer, who gathered round William Blake in his last years, and his prints are directly inspired by Blake's wood-engravings for Thornton's *Virgil*. The *Primitive City*, which resembles them in scale, format, imagery and poetic intensity and similarly represents a vision of a pastoral Arcadia, is the only known drawing of this early phase of the artist's activity. The fact that it is dated two years before he left his native Devonshire to come to London suggests that the form, style and subject-matter of his engraved compositions were determined before he came into contact with the Blake circle. He is known to have owned a copy of Blake's *Illustrations to the Book of Job*, and it seems probable that he also possessed the *Virgil*, published in 1821.

'I have a fondness for the Earth' he wrote, 'and rather a Phrygian mode of regarding it. I feel a yearning to see the glades and the nooks receding like vistas into the gardens of Heaven'. But as with many English romantic artists – Palmer is a conspicuous example, and the Pre-Raphaelites – this mood of passionate poetic intensity was impossible to sustain for more than a few years.

James Baker Pyne 1800–1870

163 *Shipyard on an Estuary*

Watercolour and bodycolour; 277×435mm
1958-7-12-365 Lloyd Bequest *Plate 117*

A self-taught artist, having abandoned a career as a lawyer, Pyne became a successful exponent of the virtuoso techniques of watercolour practised in the 1830s and 1840s. The influence of Turner is particularly noticeable in this watercolour, in which Pyne attempts not unsuccessfully to emulate his effects of light and his panoramic compositions of the *England and Wales* series. It has been described as an Italian landscape, but to judge from the architecture and the appearance of the figures in the foreground it could equally well be an Italianised interpretation of a view on the English coast. By including a wounded man (a naval veteran?) in the foreground Pyne was perhaps influenced by Turner's preoccupation with the role of the figure in landscape, particularly in the *England and Wales* series, in which figures often indicate specific local activity.

Richard Parkes Bonington 1802–1828

164 *Rouen from the quays*

Watercolour with pen; 403×275mm
1859-7-9-3251 (L.B. 1) *Plate 114*

Born near Nottingham in 1802, Bonington died of consumption in London in 1828, a month before his twenty-sixth birthday: his short creative life was concentrated into the years between 1817 and his death. When he was fifteen, his family left England because of the collapse of the Nottingham lace trade, settling in Calais, where his father set up a new lace manufacturing business. Apart from three visits to his native country, Bonington spent the rest of his life in France, and it may be argued that he belongs essentially to that group of young French artists of the 1820s who rebelled against the neo-classical formulas of the previous generation. They had in common an enthusiasm for painting landscape, an interest in the history and architecture of France, a fascination with the Near East and a passion for poetry and for the novels of Sir Walter Scott. However, Bonington also absorbed many of the characteristics associated with English art of the period – notably, the importance attached by many of the most talented artists to watercolour as an independent medium in its own right – Turner and Constable above all, but also Cotman, Callow, Prout and Shotter Boys.

Bonington's Anglo-French formation echoed his artistic training. His first teacher was Louis Francia (1772–1839), who had spent many years in England, where he had been a member of Girtin's sketching club, and who was living in Calais when Bonington's family settled there. In 1820 Bonington entered the atelier of Baron Gros (1771–1835) in Paris, at the École des Beaux-Arts, where he remained until 1822. While a student, he went on sketching expeditions in France, being absent for two terms in 1821 when he undertook an extensive tour to Normandy with his friend Alexandre Colin (1798–1875), 'knapsack on his back over his long blouse, a flat cap on his head and a stick in his hand'. This view of Rouen Cathedral (subsequently lithographed, with slight variations, in Bonington's *Restes et Fragmens [sic] d'Architecture du Moyen Age*, 1824), one of the artist's most impressive and important early drawings, was one result of this tour. As John Ingamells has pointed out (*Richard Parkes Bonington*, 1979), the serious depiction of medieval architecture in France had only very recently begun, with the first volumes of the Baron Taylor's *Voyages Pittoresques dans l'ancienne France*, 1820–1865, a state-backed publication. It is noteworthy that English taste had already anticipated this development. Bonington was following in the footsteps of Cotman, Edridge and Prout who, anticipating the possibility of publication, had made sketching expeditions to Normandy between 1817 and 1820.

Richard Parkes Bonington 1802–1828

165 *The Château of the Duchesse de Berri*

Watercolour and bodycolour; 203×272mm
1910-2-12-223 Salting Bequest *Plate 116*

166 *Paris: The Institut seen from the quays*

Watercolour; 243×200mm
1910-2-12-224 Salting Bequest *Plate 109*

The brilliance and luminosity of watercolours such as these inspired Bonington's friends with admiration, if not envy. Delacroix – with whom Bonington shared a studio for some months in 1825–6 – wrote 'I could never weary of admiring his marvellous understanding of effects, and the facility of his execution'. No. 165, datable *c.*1825, a composition which the artist also treated as an oil-painting (Coll. Martyn Beckett, Bt) is among his most remarkable landscapes, imbued with a quality of perfect if melancholy serenity, the essence of which is the sky, reminiscent of Constable (see no. 104). Although painted on a very small scale, the panoramic effect, with the Château acting as a discreet focus of the design, is striking. It is instructive to compare the view of the *Institut*, no. 166, probably dating from the end of Bonington's life with the Parisian view by his contemporary, Thomas Shotter Boys (no. 167). Bonington has captured the essentials of the architectural detail with a beautifully nervous touch, but the composition itself could well have been suggested by the work of someone like Prout (see no. 141). Where he differs from Prout is in his concern with light and atmosphere, rather than the quaintness of architectural detail.

Thomas Shotter Boys 1803–1874

167 *The Boulevard des Italiens, Paris*

Watercolour heightened with bodycolour and gum arabic; 372×597mm
Signed: *Thos. Boys 1833*
1870-10-8-2364 (L.B.) *Plate 115*

Trained as an engraver, Boys went to Paris in about 1823 where he seems to have been able to take advantage of the dearth of French experts in this field. By 1826 he was closely associated with Bonington, whose influence is apparent in his early watercolours, but from the outset his interests were

different. Whereas Bonington displays romantic sensibility and response to the atmospheric quality of his surroundings, Boys's studies of Paris are primarily topographical. His main concern was to record the architecture and human activity he observed around him. This is particularly marked in the early 1830s. Bonington had died in 1828, and freed from his direct influence Boys's style reached maturity. This watercolour of the *Boulevard des Italiens*, dated 1833, is a splendid example of his mastery of urban topography, showing his technical virtuosity and his sense of design on a large scale. His depiction of the architecture and of the figures is equally confident: these are not mere *staffage* (as in so many late eighteenth-century urban views, see nos 50, 64) but fulfil an essential role in the composition. His success in combining architectural accuracy with human activity accounts for the great popularity of his lithographic series *London as it is*, 1842, and suggests an interesting comparison with Turner's approach to urban topography.

Matilda Heming *fl*.1804–1855

168 *A Backwater at Weymouth*

Watercolour; 157×256mm
1877-5-12-197 (L.B. 2) *Plate 113*

Mrs Heming, daughter of the engraver Wilson Lowry, appears to have been a minor artist of professional standing; she was awarded a Gold Medal by the Society of Arts in 1804 and between 1805 and 1855 exhibited landscapes, miniatures and portraits. This watercolour suggests that she had a genuine talent as a landscapist, working directly from nature in the idiom of Cristall or of such followers of John Varley as Linnell or Mulready. In its not obviously picturesque choice of subject, this drawing is unlike the kind of tasteful watercolour generally associated with 'lady painters'.

John Scarlett Davis 1804–1844

169 *The Library at Tottenham, the Seat of B.G. Windus, Esq.*

Watercolour with stopping out, heightened with gum arabic; 299×557mm
Signed and dated: *Scarlett Davis 1835*
1984-1-21-9 *Plate 118*

This picture records some of the finished watercolours by Turner in one of the most distinguished nineteenth-century collections of British drawings and watercolours. The owner was Benjamin Godfrey Windus (1790–1867), a member of a long-established family firm of coachbuilders (not, as has sometimes been implied, a self-made man). From about 1820 he began to collect watercolours by Turner, and by the late 1830s he had amassed some two hundred. He also owned an important collection of drawings by Stothard and Wilkie, and was later a patron of the Pre-Raphaelites. An obituary of his uncle, Thomas Windus, himself a collector of engraved gems, in *The Gentleman's Magazine*, April 1855, noted the 'liberality' with which the younger Windus opened his collection to the public.

Scarlett Davis had established a reputation for his interior views of art galleries – a genre ultimately derived from seventeenth-century Dutch and Flemish examples. In February 1835 he was commissioned to record the appearance of the library at Windus's house at Tottenham Green, north of London. He wrote to a friend: 'I am now engaged on a very difficult subject, the interior of the Library of Mr Windus, who has it filled with about fifty Turners . . . there are parts of some of them *wonderful*, and by G-d all other drawings look heavy and vulgar, even Callcott and Stanfield and even the immortal Alfred Vickers, J.D. Harding and J.B. Pyne'. He later recorded that Turner had seen the present drawing, 'and spoken in the highest terms of it, and . . . it now hangs in company with fifty of his best works'.

The Windus collection was particularly rich in Turner's finished watercolours, including the largest single group of the *England and Wales* series, many of which are shown in Scarlett Davis's picture. At the nearer end of the lower row on the right-hand wall is *Saltash*, 1825, now in the British Museum (see no. 92): to the left of the children, the large watercolour above the chimney-piece is *Hastings from the Sea*, 1818, also in the British Museum (see no. 90).

As can be seen, Windus's watercolours were elaborately framed in keeping with contemporary taste, and Scarlett Davis's drawing is here exhibited in what was doubtless its original frame, designed to be *en suite* with the Turners.

William Leighton Leitch 1804–1883

170 *S. Croce in Gerusalemme, Rome*

Watercolour and bodycolour over pencil: 339×227mm
1980-6-28-4 *Plate 120*

Leitch was in Italy from 1833 to 1837. As an artist he was
competent rather than inspired, but the charm of his views of
Rome lies precisely in the literalness with which they are
recorded. This view of the church of S. Croce in Gerusalemme,
on the south-eastern edge of the city just beyond the Lateran
Basilica, must have been taken from the gardens of the Villa
Wolkonsky, now the residence of the British Embassy.

John Frederick Lewis 1805–1876

171 *The Alhambra*

Watercolour and bodycolour on buff paper; 258×360mm
Inscribed: *Alhambra, Oct 5, 1832*
1885-5-9-1644 (L.B. 1) *Plate 119*

Inspired by the example of his friend David Wilkie, Lewis
travelled in Spain from 1832 to 1834, having, according to his
patron Richard Ford, 'orders for young ladies' albums and
from divers booksellers, who are illustrating Lord Byron'. The
exotic and romantic character of Spain seems to have kindled
Lewis's enthusiasm for distant places: for ten years from 1841
he lived in Cairo, and on his return to England was to cause a
sensation with his watercolours of Arab subjects.
 Lewis used the sketches made on his Spanish tour as the basis
for later watercolours as well as for two volumes of lithographs:
this view of the Alhambra was used as the background for the
Distant View of the Sierra Nevada, published in *Lewis's Sketches of
Spain and Spanish Character*, 1836. The vibrant colouring of
studies such as this astonished Cotman when he saw Lewis's
Spanish drawings in 1834: 'words cannot convey to you their
splendour, *My poor Red Blues* & Yellows for which I have been
so much abused and broken hearted about, are faded fades, to
what I there saw, Yes and aye, *Faded Jades* & trash . . .'. Lewis
was subsequently to abandon the swift and fluent use of water-
colour as seen here in favour of a microscopically elaborate and
dense technique that rivalled the brilliance of oil-paintings.
Indeed, in 1858 Lewis resigned from the Water-Colour Society:
'I felt that work was destroying me. And for what? To get by
water-colour art £500 a year, when I know that as an oil painter
I could with less labour get my thousand'.

Samuel Palmer 1805–1881

172 *1819 Sketchbook*

Twenty-nine leaves, drawn in a variety of media, including
pencil, pen and indian ink and watercolour; each leaf
approximately 112×185mm
Inscribed inside the front cover: *Samuel Palmer Jun'/Feby 1819*
and *Sketches from Nature*
1966-2-12-11(1–29)

Palmer was fourteen when he used this sketchbook; many of
the studies show the influence of contemporary drawing-
manuals, notably David Cox's *Treatise on Landscape Painting*. His
interest in the sky (see no. 174) is already apparent in this
sketchbook, which also includes a memorandum to himself
anticipating the self-admonitory notes made in his 1824 sketch-
book (no. 173): on 11 June 1819 he scribbled on the *verso* of
one watercolour sketch 'This study though the sketch is unin-
teresting was very good in nature'. This was also the first year
in which Palmer exhibited works at the Royal Academy.

Samuel Palmer 1805–1881

173 *Leaves from the 1824–1825 sketchbook*

Pencil, indian ink and touches of watercolour on some of the
pages; each leaf approximately 116×187mm
Originally inscribed inside the front cover: *Samuel Palmer 10
Broad St Bloomsbury July 15th 1824*
1964-11-4-1(2-77) *Plate 121*

This sketchbook originally contained ninety-two sheets; sixteen
have been removed, of which five are now in the Victoria and
Albert Museum. The remaining sheets were separately mounted
when acquired by the British Museum in 1964. The drawings
cover the period shortly before Palmer's first meeting with
Blake, to whom he was introduced by John Linnell in October
1824, until well into the next year. He no doubt refers to Blake
in the note on page 28 – 'Remember that most excellent
remark of Mr B's – how that a tint equivalent to a shadow is
made by the outline of many little forms in one mass near it,
such for instance as flesh etc'. The sketchbook shows clearly the
intensity of Palmer's study of landscape, and his passion at this
time for Raphael and the engravings of Dürer, Lucas Van
Leyden and other early masters. Scribbled memoranda and
sketches show Palmer inventing and developing themes that
were to preoccupy him for the following six or seven years.

Thus on page 58, envisaging pastoral subjects: 'labourers going out at sunrise, coming home to their families . . .; the horned moon rising – the harvest moon – ascending fields ripening . . . cottages and churches'. In effect, this sketchbook was a compendium of the subject matter and of the emotional attitudes of Palmer at the outset of the Shoreham period.

Samuel Palmer 1805–1881

174 *Drawing for 'The Bright Cloud'*

Black ink with scratching out; 152×151mm
1927-5-18-10

One of a group of small monochrome studies, chiefly of moonlit scenes, this dates from the latter part of Palmer's Shoreham period; it is a study, probably executed *c*.1831–2, related to the painting of the same title exhibited at the Royal Academy in 1833 or 1834 (now in the Tate Gallery). Palmer shared none of Constable's quasi-scientific interest in studying the sky, but was responsive to its pictorial possibilities. In a letter to John Linnell of 21 December 1828, he wrote: 'Nor must be forgotten the motley clouding, the fine meshes, the aërial tissues that dapple the skies of spring; nor the rolling volumes and piled mountains of light'. The final composition, *The Bright Cloud*, shows the influence of Linnell's landscapes, and in the same letter Palmer noted 'Those glorious round clouds which you paint I do think inimitably, are alone an example how the elements of nature may be transmitted into the pure Gold of Art.'

Samuel Palmer 1805–1881

175 *Tintagel Castle*

Watercolour and bodycolour over pencil and black chalk; 262×370mm
1910-7-16-17 *Plate 124*

In the summer of 1848 Samuel Palmer went on a sketching tour in Devon and Cornwall. He made a number of broadly-handled black chalk sketches of the dramatic, wind-swept coastline, and at least two watercolours of the cliffs at Tintagel surmounted by the crumbling ruins of the twelfth-century castle. The watercolour here exhibited, with its bold chalk underdrawing, seems to have served as the basis for the more highly finished watercolour now in the Ashmolean Museum, Oxford, which is probably to be identified with one exhibited in 1849. Palmer there comes close to the sublime landscape of Turner. That he knew well Turner's view of Tintagel is established by a reference to it in a letter of 1864. It was engraved in 1818 by George Cook (a friend of Palmer's father) for the series *Picturesque Views on the Southern Coast*. Palmer may even have seen the original watercolour when it was exhibited in 1822. Turner's practice of referring to local human activity may also have inspired Palmer's inclusion, in the Ashmolean version, of fragments from a shipwreck, with men hauling away a salvaged anchor.

Samuel Palmer 1805–1881

176 *A Pastoral Landscape*

Watercolour with bodycolour, pen and ink and gum arabic over black chalk; 229×353mm
Signed: S. PALMER
1958-6-12-360 Lloyd Bequest *Plate 122*

This little known watercolour must date from towards the end of Palmer's life; in mood, elaboration of technique, and richness of colour it recalls the series of eight watercolours illustrating Milton's *L'Allegro* and *Il Penseroso* which he painted in the mid-1860s. It combines the pastoral element which had been the central focus of the artist's Shoreham period with a more idealised and classical type of composition. In this he was perhaps inspired by Claude, whose painting *The Enchanted Castle*, now in the National Gallery, he described as 'that divinest of landscapes'. In this drawing and others like it Palmer sought to recapture the intense inspiration of his youth – 'Thoughts on RISING MOON, with raving-mad splendour of orange twilight-glow on landscape. I saw that at Shoreham' – while reconciling his 'visions of the soul' with a more publicly acceptable style.

Henry Bright 1814–1873

177 *Scratby near Yarmouth*

Coloured chalks on grey paper; 185×280mm
1902-5-14-3

By training a chemist, Bright came into contact with Cotman and John Berney Crome when employed as a dispenser at Norwich Hospital; in 1836 he moved to London and became a professional artist. His public style of drawing, described by Martin Hardie as 'slick and rather showy' ensured him a livelihood as a popular teacher, with scores of aristocratic pupils, apparently earning him £2,000 per annum at one stage. However, he could also work in a less formal idiom, and some of his sketches, executed with sensitivity to fleeting effects of light and shade, often in coloured chalks on toned paper, have an appeal lacking in his more bravura efforts.

William Bell Scott 1811–1890

178 *King Edward's Bay, Tynemouth*

Watercolour and bodycolour over pencil; 251×353mm
Signed: *W. B. Scott*
1954-3-2-1 Presented by J. A. Gere *Plate 126*

William Bell Scott, the younger brother of the painter David Scott, whose life he wrote, trained at the Trustees Academy in Edinburgh and moved to London in 1837. There he became associated with a group of young artists, including Dadd, Frith and Egg, known as 'The Clique'. In 1843 he was appointed Master of the newly-established Government School of Design in Newcastle. Like Dante Gabriel Rossetti, Scott was a poet as well as a painter, and his association with the Pre-Raphaelites stemmed from Rosetti's admiration for his poem *The Year of the World* (1846). They became close friends (although they later quarrelled), but until 1864, when Bell returned to live in London, the fact that he was employed in Newcastle resulted in a certain degree of artistic isolation.

Scott travelled in Germany in the 1850s and works such as this watercolour of a coast scene near Newcastle, which probably dates from the late 1850s or early 1860s, and others of desolate seashores at twilight, seem to owe some debt to German Romantic painting. Scott's method of working was different from that adopted by the Pre-Raphaelites: he did not follow their practice of painting directly from nature, but his work can be seen as in some sense a parallel to theirs.

Edward Lear 1812–1888

179 *Choropiskeros, Corfu*

Watercolour with pen and brown ink with coloured chalks; 478×349mm
Inscribed: *14 June 1856 (6)*
1929-6-11-70 Presented by Messrs Craddock and Barnard
Plate 120

Lear is best known for his *Nonsense* verses, and his illustrations to them which he produced concurrently with his life-long activity as a landscape painter. He was one of the few mid-nineteenth century practitioners of the linear technique of watercolour, which can be seen as a reversion to the 'tinted drawing' manner of a hundred years earlier. At the same time he clearly shared the contemporary view that the finished work should preserve the spontaneity and liveliness of the sketch. Lear's technique was to make a pencil drawing of the motif with written notes of colour and tone, and then to work over the outlines with pen and ink and washes of colour in the winter evenings. Much of his life was spent abroad; in the late 1850s and early 1860s he made several extended visits to Corfu, where he seems to have been particularly attracted by the quality of the light and the wild, luxuriant vegetation. This is a particularly subtle and delicate example of a characteristic composition – a complex spatial recession from a high viewpoint towards a distant ridge of mountains.

William James Müller 1812–1845

180 *Tlos, Lycia, from the North-East*

Watercolour; 354×553mm
Inscribed: *Tloss, Jan. 1, 1844*
1878-12-28-121 (L.B. 61) Bequeathed by John Henderson
Plate 125

A pupil of J. B. Pyne in his native Bristol (his father had been a Prussian refugee from the Napoleonic wars and had settled there), Müller was influenced by studying the Cotman drawings belonging to the Rev. James Bulwer to visit Norfolk for two months in 1831; in the following year he founded a Sketching Club in Bristol, inspired by that of Girtin and Cotman. Like many other topographical watercolourists of the period, Müller travelled abroad extensively, both in Europe and further afield, visiting Athens and Egypt in 1838–9. In 1843–4 he accompanied the Government Expeditionary Force, led by Sir Charles Fellows, to Lycia, and made a series of thirty-six watercolours (all in the British Museum), of which this is an example. Perhaps fortuitously, the supplies of white bodycolour

he took with him oxidised, and he abandoned its use, concentrating instead on a strikingly bold and free use of pure watercolour, in rich, earthy tones of ochre and brown, well-suited to the rugged landscape through which he was travelling.

Richard Dadd 1817–1886

181 *Port Stragglin*

Watercolour; 190×142mm
Signed: *R.ᵈ Dadd 1861* and inscribed *verso: General View of Part of Port Stragglin – The Rock & Castle of Seclusion and the Blinker Lighthouse in the Distance. not sketched from Nature. by R.ᵈ Dadd 1861 Jan.ʸ Finit* and along the top and bottom edges of the *verso: Not a bit like it. [?] . . . Style Sir [?] very; What a while you are! Of course it is!! I don't like it. No.*
1919-4-12-2 Presented by the National Art—Collections Fund in memory of Robert Ross *Plate 127*

Confined in 1844 to Bethlem Hospital, and from 1864 to Broadmoor, for the murder of his father, Dadd was allowed to continue painting. Even before his illness, he had been an imaginative artist of unusual perception. The present watercolour, perhaps the most intensely visionary that he painted, combines a delicacy of colour and a precision of drawing on a tiny scale. The towering pinnacle of rock surmounted by a castle seems to invoke Dadd's own seclusion in Bethlem, while the design is composed of many recognisable elements. The rock and the town clustered below are perhaps recollections of Dadd's travels to Greece, Egypt and the Middle East in 1842–3, and it has been suggested that the tower which he calls the Blinker Lighthouse could have been inspired by Eddystone. Dadd's own comment on the *verso* 'Not sketched from Nature' seems almost unnecessary, yet it is of interest partly for what it reveals of his state of mind and partly because it reflects the fact that by the 1860s sketching in colours from nature had become the norm.

John Ruskin 1819–1900

182 *Fribourg*

Watercolour and bodycolour with pen and ink on blue paper; 225×287mm
Signed, inscribed and dated: *Sketch for etchings of Swiss towns, 1859 Signed: (1879). J. Ruskin*
1901-5-16-4 (L.B. 2) *Plate 129*

Throughout his life Ruskin was in the habit of drawing. As a boy he had lessons from the then fashionable masters, including Copley Fielding, James Duffield Harding and Samuel Prout, whose style remained an important influence until he fell under the spell of Turner in the 1840s. Though technically an amateur, his studies of architectural details, plants, geological specimens, etc., are unsurpassed in loving delicacy of execution and exactness of observation. On 4 January 1861, George Price Boyce recorded in his diary that 'Ruskin is now hard at work mastering the manipulation of paint under old Wm. Hunt. He expects to be 8 or 10 years at this; meantime does not mean to write or lecture'. This was clearly no more than a momentary whim, though such remarks show how seriously Ruskin took his own practice of art. The drawings he made in the 1850s are among his most ambitious and original, combining Turnerian impressionism and Pre-Raphaelite detail. In 1854 he planned a history of Switzerland to be illustrated with etchings after his own drawings, and in the next few years he made many watercolours in preparation for this unfulfilled project. They included this drawing of Fribourg, one of his most remarkable landscape studies, in which he ignores all conventional ideas of composition.

Samuel Bough 1822–1878

183 *View of a Manufacturing Town*

Watercolour; 184×321mm
1886-6-7-9 (L.B.1) *Plate 128*

By the second half of the nineteenth century, the landscape created by the Industrial Revolution had ceased to seem in any way Sublime. Bough's straightforward view of a northern town, perhaps in Airedale in Yorkshire to judge from the topography and the type of industry, crowded with chimney-stacks beneath a sky black with smoke, clearly illustrates this change of approach.
A. E. Housman, writing from Oxford in 1877, gives a vivid account of a lecture by Ruskin in which he used a watercolour by Turner as the basis for his denunciation of modern progress. 'He pointed to the picture as representing Leicester when Turner had drawn it. Then he said "You if you like may go to Leicester to see what it is like now. I never shall. But I can make a pretty good guess". Then he dashed in the iron bridge on the glass of the picture. "The colour of the stream is supplied on one side by the indigo factory." Forthwith one side of the stream became indigo. "On the other side by the soap factory".

Soap dashed in. "They mix in the middle – like curds," he said, working them together with a sort of malicious deliberation. "This field, over which you see the sun setting behind the abbey is now occupied in a *proper* manner". Then there went a flame of scarlet across the picture, which developed itself into windows and roofs and red brick, and rushed up into a chimney. "The atmosphere is supplied – thus!" A puff and cloud of smoke all over Turner's sky: and then the brush thrown down, and Ruskin confronting modern civilization amidst a tempest of applause' (*The Letters of A. E. Housman*, ed. H. Maas, 1971, p.13; the watercolour of Leicester is now in the Art Institute in Chicago). Turner would not necessarily have agreed, for in spite of the unprecedented range of his art and his astonishing capacity for technical innovation, he remained in some respects a child of the eighteenth century, perhaps the last artist, in the tradition of Joseph Wright of Derby, to see in industrial change the dramatic contrast between past and present, to feel the excitement of scientific discovery and the harnessing of power to produce wealth, and able to appreciate the forbidding but picturesque grandeur of great cities wreathed in unfamiliar atmospheric effects.

William Simpson 1823–1899

184 *Summer in the Crimea*

Watercolour with touches of white bodycolour over pencil; 250×354mm
Signed: *W. Simpson 1857*
1971-5-15-10 *Plate 130*

Simpson had been trained as a lithographer, and became the first English 'war-artist' when he was sent to the Crimea by Colnaghi and Son to prepare a volume of lithographic illustrations of the campaign. This was the first of a long series of tours to distant parts of the world, many of them undertaken to report colonial wars for *The Illustrated London News*, of which he joined the permanent staff in 1866. With the development of cheap and rapid methods of reproduction, such illustrated publications became widely popular in the second half of the century.

Most of Simpson's drawings are straightforward reportage, and might be compared with a modern photo-journalist's work. This watercolour, however, is quite different in mood. The scale and juxtaposition of the component elements give it, to modern eyes, an almost surrealist quality. It was reproduced in chromolithography, with the following explanatory text:

'Flowers, around which the bright lizards play, deck the earth; the convolvuli twine around the now rusty messengers of slaughter, while in the distance, the bombardment still continues, shot and shell dealing death around; the soldier's fate suggested by the butterfly fluttering over the burning bomb'.

Richard Doyle 1824–1883

185 *Under the Dock Leaves – an Autumnal Evening's Dream*

Watercolour and bodycolour; 499×776mm
Signed with the artist's monogram and dated 1878
1886-6-19-17 (L.B. 6) *Plate 131*

A representative example of the genre of fairy painting that, together with fairy literature, became popular in the middle of the nineteenth century. To some extent, this genre was a development of a revived interest in medieval romance and folk literature, combined with sentimental whimsy. Side by side with the hard-headed economic and scientific materialism of the period went a notable degree of interest in the intangible spirit world; Dickens affirmed in *Household Words* of 1853 'In a utilitarian age, of all other times, it is a matter of grave importance that Fairy Tales should be respected'.

Dicky Doyle, whose nephew Sir Arthur Conan Doyle was to become a leading figure in the Society for Psychical Research, was one of the most successful illustrators of fairy subjects in the period. His masterpiece is probably *In Fairyland*, published in 1870, a triumph of Victorian book production, with verses by the Pre-Raphaelite poet William Allingham and thirty-six coloured wood engravings. In the 1870s Doyle made extensive use of the watercolour medium on a large scale, as in this example. He ingeniously conveys the minuteness of the fairies by his naturalistic rendering of the leaves and trees on a much larger scale.

Myles Birket Foster 1825–1899

186 *A Cottage Garden*

Watercolour over pencil; 166×244mm
Signed: *BF* (in monogram)
1948-10-9-4 Bequeathed by P.C. Manuk and Miss G.M. Coles through the National Art—Collections Fund *Plate 132*

187 *Studies of Trees – two leaves from a sketchbook*

Watercolour with scratching out; 84×145mm; 84×176mm
Inscribed: *May 186[?]*
1938-12-9-1, 2 Presented by E. Kersley

The rustic scenes of Birket Foster and his follower Helen Allingham represent the sentimental close of the picturesque movement, with its nostalgia for a supposedly happier rural past. As has been pointed out, such idyllic visions imply a certain criticism of the present age. But the converse point of view was expressed in a poem *Old Cottages* by Tom Taylor, written to accompany a series of wood-engravings after watercolours by Birket Foster published in 1863 under the title *Pictures of English Landscapes*:

THE cottage-homes of England! Yes, I know,
How picturesque their moss and weather-stain,
Their golden thatch, whose squared eves shadows throw
On white-washed wall and deep-sunk latticed pane . . .
The kindly nature that still masks decay
With flowers, and hues only less fair than flowers,
All these I know,—know, too, the plagues that prey
On those who dwell in these bepainted bowers:
The foul miasma of their crowded rooms,
Unaired, unlit, with green damps moulded o'er,
The fever that each autumn deals its dooms
From the rank ditch that stagnates by the door;
And then I wish the picturesqueness less,
And welcome the utilitarian hand
That from such foulness plucks its masquing dress,
And bids the well-aired, well-drained cottage stand,
All bare of weather-stain, right-angled true,
By sketchers shunned, but shunned by fevers too.

Birket Foster himself, like the public of his own day, saw rural life as an idyllic refuge from the corruption, squalour and ugliness of an increasingly urbanised and industralised society. When Tennyson asked him why painters preferred tumble-down cottages he replied 'Because no one likes an unbroken line' – a point of view that reached its final and concrete expression in the 1890s with Edwin Lutyens's early and deliberately picturesque cottage style of architecture.

The leaves from a sketchbook of the 1860s (no. 187) are a reminder that Birket Foster continued throughout his life to draw from nature, a practice encouraged in his youth by his master, the engraver Landells (who had been a pupil of Thomas Bewick); although this aspect of his work is little known, such studies are among his most attractive.

George Price Boyce 1826–1897

188 *Streatley, Berkshire*

Watercolour; 134×387mm
Signed and dated: *G Boyce June '59*
1915-2-13-2 Presented by Mrs Gillum

As a young man Boyce trained as an architect, but in 1849 he met David Cox and decided to become a landscape painter. Until well into the 1850s Boyce was still painting broad atmospheric studies of Welsh scenery in the spirit of his teacher, but towards the end of the decade his watercolours developed a distinctly Pre-Raphaelite character as in this view of Streatley, dated 1859. His architectural training is reflected in his meticulously detailed attention to the farm buildings, and it is characteristic of his manner of composition that they should act as a screen across the design. The bright colouring (especially the sharp tones of green) and the detailed handling are also distinctly Pre-Raphaelite.

Boyce had independent means (his father, like Ruskin's, had been a prosperous wine merchant) and was an avid collector both of the work of his Pre-Raphaelite friends – including Rossetti, Inchbold and Seddon – and of French artists. He kept a diary between 1851 and 1875 (which reflects an attractive, if unnecessary, degree of modesty about his own talents), an important source of information about the Pre-Raphaelite circle.

George Price Boyce 1826–1897

189 *'Backs of some old Houses in Soho'*

Watercolour on two pieces of paper joined together; 197×190mm
Signed and dated: *G. P. Boyce. April 26 1866.*
1942-10-10-9 Presented by C.F. Bell *Plate 134*

A note on the back of this drawing records that the view was taken from the first floor of a house overlooking the churchyard of St Anne's, Soho. This was probably a room above the shop of Foord and Dickinson, carvers and gilders, at 90 Wardour Street. The watercolour, which was subsequently owned by Dante Gabriel Rossetti, was exhibited at the Society of Painters in Water-Colours in 1866: 'Mr G. P. Boyce . . . finds the secret beauty of a dingy place, such as the churchyard of St Anne's, Soho, where a flash of smoky sunlight on a soot grained wall, a line of grimy old houses and the struggles of town foliage into

verdure are with a gas lamp and a mural gravestone made by his feeling and skill into a poem and a picture' (*The Athenaeum*, 1 December 1866). However, the inscriptions suggest that the 'mural gravestone' was in fact a notice-board.

William Henry Millais 1828–1899

190 *A Scottish Farm*

Watercolour and bodycolour with touches of gum arabic;
179×330mm
Signed: *W. H. Millais*
1974-6-15-8 *Plate 136*

Overshadowed by the success of his younger brother John Everett Millais, William never took the step of becoming a professional artist; nevertheless, during the 1850s he produced a number of works, mainly watercolours, which show the application of Pre-Raphaelite principles to the painting of landscapes. During the summers of 1851 to 1853 he spent long periods sketching from nature; this watercolour may date from 1853 when he accompanied his brother and the Ruskins on the fateful visit to the Trossachs when the attachment developed between John Millais and Effie Ruskin that was to lead to their marriage in 1855. The intense colouring, in particular the use of violet-blue and emerald green, is characteristically Pre-Raphaelite.

Dante Gabriel Rossetti 1828–1882

191 *Writing on the Sand*

Watercolour; 267×241mm
Inscribed: *DGR 1859* (initials in monogram)
1886-6-7-14 (L.B. 2) *Plate 135*

Rossetti's forte was inventive design: as Madox Brown noted in his diary in 1854, 'I see Nature bothers him'. At the outset of their friendship Ruskin hoped that Rossetti could be persuaded to take a serious interest in landscape, and offered to send him on a sketching tour to Wales. Characteristically, Rossetti's response was that he would take the money to go to Paris, but would not paint landscapes in Wales. The present watercolour is perhaps the nearest that he ever came to painting a landscape, but it is significant that the background was in fact based on two sketches by G. P. Boyce of Babbacombe on the Devonshire coast which Rossetti borrowed in June 1858.

A pen drawing of the same subject shows Elizabeth Siddal as the girl and the features of the figure in the watercolour closely resemble hers. The model for the man is traditionally said to have been Richard Holmes, later Librarian at Windsor Castle.

Alfred William Hunt 1830–1896

192 *Dolwydellan Castle*

Watercolour with scratching out; 274×384mm
Signed: *A. W. Hunt April 1856*
1958-7-12-350 Lloyd Bequest *Plate 137*

Unusually for a professional artist, Hunt could have followed an academic career. A scholar of Corpus Christi College, Oxford, and in 1851 winner of the Newdigate Prize with a poem on 'Nineveh', in 1853 he was elected to a Fellowship which he held until his marriage in 1861 (celibacy being then an essential condition of a Fellowship). On the other hand, he had always been encouraged to paint by his father, himself a landscape painter and friend of David Cox, and in 1850 was already exhibiting in Liverpool. By the mid-1850s he had decided to make art his profession, the chief formative influences on his mature style being the drawings of Turner and the writings of Ruskin. He was never, in the full sense of the term, a 'Pre-Raphaelite' – his notion of landscape painting as involving an annual sketching tour must have seemed rather old-fashioned – but he was associated with their circle in the late 1850s and his watercolour landscapes, many of which were painted out of doors, have something of the Pre-Raphaelite quality of intensity. Inspired apparently by the chapters on geology in volume IV of Ruskin's *Modern Painters* (1856) and by the Pre-Raphaelite emphasis on painting entire pictures from nature, Hunt developed an obsessive, quasi-scientific, interest in rocks, pebbles and lichenous stones, painstakingly stippled in and scratched at. Allen Staley has aptly characterised the stippling in Hunt's watercolours as 'exhausting', and even Ruskin came to denounce his 'plethoric labour' as a debasement of the Pre-Raphaelite 'truth to nature' that he had once championed; but for Hunt's many admirers the technical virtuosity and dramatic colouring of his watercolours produced an ideal combination of poetical imagination and scientific truth which made him a worthy heir of Turner.

Dolwydellan in North Wales was a favourite subject: in 1865 he painted a similar view, with spectacular effects of light, *A November Rainbow – Dolwydellan Valley* (Ashmolean Museum, Oxford).

George John Pinwell 1842–1875

193 *King Pippin*

Watercolour; 131×165mm
1939-7-11-6 *Plate 133*

Like his slightly older contemporary Fred Walker, Pinwell began his career in the 1860s as an illustrator of books and periodical publications (especially *Good Words* and *Once a Week*) and became one of the leading draughtsmen of rustic and landscape subjects. He is among the most underrated artists of his generation partly because he died at the age of only thirty-three and partly because most of his work consisted of black and white illustrations reproduced by wood-engraving, the drawing itself being made on the wood-block and destroyed by the engraver. But his illustrations, and, even more, his water-colours, reveal a delicate and most poetic talent, a distillation of Pre-Raphaelite sentiment and lively observation.

Frederick Walker 1840–1875

194 *An Amateur*

Watercolour and bodycolour; 177×253mm
Signed: *F W*
1954-5-8-21 Bequeathed by Cecil French *Plate 138*

Fred Walker began his career as one of the most distinguished of the group of draughtsmen, including his friends G.J. Pinwell and J.W. North, who in the early 1860s specialised in making drawings for book illustration. He soon turned to painting, and evolved a highly-wrought and elaborate water-colour technique involving much use of bodycolour, denounced by Ruskin as 'a semi-miniature, quarter fresco, quarter wash manner of his own'. The term 'painting in watercolour' is exactly applicable to these drawings, which are so like his oil-paintings in subject and treatment that in reproduction, when there is no indication of scale, the two cannot be told apart.

Inevitably, Walker was influenced by the Pre-Raphaelites. In accordance with their strict principle of absolute fidelity to nature, he did his best, in conditions of difficulty and often even hardship, to paint large-scale canvases out of doors (see George Marks, *Life and Letters of Frederick Walker ARA*, 1896), but he was never a pure landscape artist. Though natural appearances are always minutely observed and sensitively rendered – as J.W. North wrote, 'his knowledge of nature was sufficient to disgust him with the ordinary conventions that do duty for grass, leaves and boughs' – the figures in his pictures are never subordinated to the landscape setting. In Pre-Raphaelite paintings the figures tend to be seen in some intensely charged moment of spiritual or moral crisis; in his, their action is usually incomplete and only vaguely definable. It might be said of him that he painted subject-pictures without subjects. Moreover, there is about his figures an element of poetic idealisation that sets his art apart from the obsessive truth-to-nature of the realistic wing of Pre-Raphaelitism. In his own personal and intensely English way Walker might be seen as a parallel to such Continental contemporaries as Giovanni Costa or Jules Breton: but unfortunately Walker died before he was able to resolve his stylistic contradictions. It is interesting that he should have been greatly admired by Van Gogh, who in a letter of 1885 says, of Walker and Pinwell: 'They did in England exactly what Maris, Israëls, Mauve, have done in Holland, namely restored nature over convention; sentiment and impression over academic platitudes and dullness . . . They were the first tonists'.

Addendum to the Catalogue

Julius Caesar Ibbetson 1759–1817 and John 'Warwick' Smith 1749–1831

195 *The Hon. Robert Fulke Greville's Phaeton crossing the mountains between Pont Aberglaslyn and Tan y Bwlch*

Watercolour; 318×438mm
Purchased January 1985

In the summer of 1792 Ibbetson and 'Warwick' Smith accompanied Robert Fulke Greville on a sketching tour of Wales; this watercolour (the figures in which are by Ibbetson, and the landscape by Smith) depicts the crossing of the precipitous Pass of Aberglaslyn, with Ibbetson placing a rock behind the wheels of the phaeton to act as a brake. Ibbetson worked this subject up into an oil painting in 1798 (Temple Newsam House, Leeds), in which he heightened the drama of the scene by changing the fine summer weather of the watercolour into a thunderstorm – the artist contending with the elements.

John Sell Cotman *Greta Bridge* (no.121)

Select Bibliography

Allderidge, Patricia, *The Late Richard Dadd 1817–1866*, exhibition catalogue, Tate Gallery, London, 1974

Barbier, Carl Paul, *William Gilpin, His Drawings, Teaching and Theory of the Picturesque*, Oxford, 1963

Bayard, Jane, *Works of Splendor and Imagination: The Exhibition Watercolour 1770–1870* exhibition catalogue, Yale Center for British Art, New Haven, 1981.

Bicknell, Peter, *Beauty, Horror and Immensity. Picturesque Landscape in Britain 1750–1850*, exhibition catalogue, Fitzwilliam Museum, Cambridge, 1981.

Bury, Adrian, *Francis Towne, Lone Star of Watercolour Painting*, London, 1962

Brown, David, *Samuel Palmer 1805–1881*, exhibition catalogue, Hazlitt, Gooden and Fox, London, 1982

Chandler, Richard, *Travels in Asia Minor*, London 1975. (Edited and abridged by Edith Clay with an appreciation of William Pars by Andrew Wilton.)

Clarke, Michael, *The Tempting Prospect: A Social History of Watercolours*, London, 1981

Cohn, Marjorie B., *Wash and Gouache: A Study of the Development of the Materials of Watercolour*, exhibition catalogue, Fogg Art Museum, Cambridge, Mass. 1977

Colnaghi Ltd., *Cornelius Varley*, exhibition catalogue by S. Somerville, London, 1973

Conner, Patrick, *William Alexander, an English Artist in Imperial China*, exhibition catalogue, Royal Pavilion Art Gallery and Museum Brighton, 1981

Croft-Murray, Edward and Paul Hulton, *Catalogue of British Drawings* [in the British Museum] Volume One: XVI & XVII centuries, 2 vols., London, 1960.

Crouan, Katherine, *John Linnell. A Centennial Exhibition*, exhibition catalogue, Fitzwilliam Museum, Cambridge, 1982

Dayes, Edward, *The Works of the late Edward Dayes*. Originally published London, 1805, republished London, 1971, with an introduction by R. W. Lightbown

Farington, Joseph (ed. J. Greig), *The Farington Diary*, 8 vols., London, 1922–8. (A typescript copy of Farington's full diary, in the Royal Library at Windsor, is deposited in the Print Room of the British Museum. The original diary is currently being published for the Paul Mellon Centre for Studies in British Art by the Yale University Press, edited by Kenneth Garlick, Angus Macintyre and Kathryn Cave. Vols I–XIV have appeared to date.)

Fleming-Williams, Ian, *Constable Landscape Drawings and Watercolours*, London, 1976

Gilpin, Rev. William, *Three Essays on Picturesque Beauty; on Picturesque Travel; and on Sketching Landscape; to which is added a poem, on Landscape Painting*, London, 1792.

Girtin, Thomas and David Loshak, *The Art of Thomas Girtin*, London, 1954

Griffiths, Antony and Gabriela Kesnerová, *Wenceslaus Hollar: Prints and Drawings from the Collections of the National Gallery, Prague, and the British Museum, London*, exhibition catalogue, London, 1983

Grigson, Geoffrey, *Samuel Palmer, The Visionary Years*, London, 1947

Guiterman, Helen, *David Roberts R.A. 1796–1864*, London, 1978

Hamilton, Jean, *The Sketching Society 1799–1851*, exhibition catalogue, Victoria and Albert Museum, London, 1971

Hardie, Martin (ed. Dudley Snelgrove, Jonathan Mayne and Basil Taylor) *Watercolour Painting in Britain*, 3 vols., London, 1966–8

Harley, Rosamund D., *Artists' pigments c.1600–1835: a study of English documentary sources*, London, 2nd edn., 1982

Hawcroft, Francis, *Watercolours by John Robert Cozens*, exhibition catalogue, Whitworth Art Gallery, Manchester, and Victoria and Albert Museum, London, 1971

Hawcroft, Francis, *Watercolours by Thomas Girtin*, exhibition catalogue, Whitworth Art Gallery, Manchester, and Victoria and Albert Museum, London, 1975

Hayes, John, *The Drawings of Thomas Gainsborough*, 2 vols., London, 1970

Hedley, Gill, *The Picturesque Tour in Northumberland and Durham c.1720–1830*, exhibition catalogue, Laing Art Gallery, Newcastle-upon-Tyne, 1982

Hofer, Philip, *Edward Lear as a Landscape Draughtsman*, Harvard, 1967

Holloway, James and Lindsay Errington, *The Discovery of Scotland*, exhibition catalogue, National Gallery of Scotland, Edinburgh, 1978

Jones, Thomas (ed. A. P. Oppé), 'Memoirs', *The Walpole Society*, vol. XXII (1946–48)

Kitson, Sydney D., *The Life of John Sell Cotman*, London, 1937

Lambourne, Lionel and Jean Hamilton, *British Watercolours in the Victoria and Albert Museum, An Illustrated Summary Catalogue*, London, 1980

Lewis, Frank, *Myles Birket Foster 1825–1899*, Leigh-on-Sea, 1973

Lister, Raymond, *Edward Calvert*, London, 1962

Lister, Raymond, *Samuel Palmer and 'The Ancients'*, exhibition catalogue, Fitzwilliam Museum, Cambridge, 1984

Lucas, S. T., *Bibliography of Water Colour Painting and Painters*, London, 1976

Mallalieu, H. L., *The Dictionary of British Watercolour Artists up to 1920*, Woodbridge, 1976

Oppé, A. P., 'Francis Towne, Landscape Painter', *The Walpole Society*, vol. VIII (1919–20), pp.95–126

Oppé, A. P., *The Drawings of Paul and Thomas Sandby . . . at Windsor*, London, 1947

Oppé, A. P., *Alexander and John Robert Cozens*, London, 1952

Owen, Felicity and Eric Stanford, *William Havell 1782–1857*, exhibition catalogue, Spink and Son Ltd., London 1981; Reading Museum and Art Gallery, 1982; Abbot Hall Art Gallery, Kendal, 1982

Parris, Leslie, *Landscapes in Britain c.1782–1857*, exhibition catalogue, Tate Gallery, London, 1973

Parris, Leslie and Ian Fleming-Williams, *Constable*, exhibition catalogue, Tate Gallery, London, 1976

Pidgley, Michael, 'Cornelius Varley, Cotman and the Graphic Telescope', *The Burlington Magazine*, November 1972, pp.781–6

Pragnell, Hubert, *The London Panoramas of Robert Barker and Thomas Girtin*, London Topographical Society, 1968

Rajnai, Miklos (ed.), *John Sell Cotman 1782–1842*, exhibition catalogue, Victoria and Albert Museum, London, 1982 (touring exhibition arranged by the Arts Council of Great Britain, 1982–3)

Reynolds, Graham, *The Later Paintings and Drawings of John Constable*, 2 vols., New Haven and London, 1984

Roget, John Lewis, *A History of the 'Old Water-Colour Society'*, 2 vols., London, 1891

Roundell, James, *Thomas Shotter Boys*, 1974

Ruskin, John, *Notes on Samuel Prout and William Henry Hunt*, London, 1879

Russell, John and Andrew Wilton, *Turner in Switzerland*, Zurich, 1976

Scrase, David, *Drawings and Watercolours by Peter de Wint*, exhibition catalogue, Fitzwilliam Museum, Cambridge, 1979

Shanes, Eric, *Turner's Picturesque Views in England and Wales 1825–1838*, London, 1979

Sim, Katherine, *David Roberts RA 1796–1864*, London, 1984

Skelton, Jonathan (ed. Brinsley Ford), 'The Letters of Jonathan Skelton written from Rome and Tivoli in 1758', *The Walpole Society*, vol. XXXVI (1956–8), pp.23–82

Smith, Bernard, *European Vision and the South Pacific 1768–1850*, Oxford, 1960

Spencer, Marion, *Richard Parkes Bonington*, exhibition catalogue, Nottingham Museum and Art Gallery, 1965

Stainton, Lindsay, *British Artists in Rome 1700–1800*, exhibition catalogue, The Iveagh Bequest, Kenwood, 1974

Staley, Allen, *The Pre-Raphaelite Landscape*, Oxford, 1973

Surtees, Virginia, *The Paintings and Drawings of Dante Gabriel Rossetti 1828–1882*, Oxford, 1971

Taylor, Basil, *Joshua Cristall*, exhibition catalogue, Victoria and Albert Museum, London, 1975

Walton, Paul, *The Drawings of John Ruskin*, Oxford, 1972

White, Christopher, *English Landscape 1630–1850: Drawings, Prints and Books from the Paul Mellon Collection*, exhibition catalogue, Yale Center for British Art, New Haven, 1977

Whitley, William T., *Whitley Papers* (deposited in the Print Room, British Museum)

Wildman, Stephen, with Richard Lockett and John Murdoch, *David Cox 1783–1859*, exhibition catalogue, Birmingham City Art Gallery, 1983 and Victoria and Albert Museum, London, 1984

Williams, Iolo A., *Early English Watercolours*, London, 1952

Wilton, Andrew, *Turner in the British Museum*, exhibition catalogue, British Museum, London, 1975

Wilton, Andrew, *British Watercolours 1750–1850*, Oxford, 1977

Wilton, Andrew, *The Life and Work of J. M. W. Turner*, London, 1979

Wilton, Andrew, *The Art of Alexander and John Robert Cozens*, exhibition catalogue, Yale Center for British Art, New Haven, 1980

Witt, Sir John, *William Henry Hunt 1790–1864*, London, 1982

Woodbridge, Kenneth, *Landscape and Antiquity: Aspects of English Culture at Stourhead 1718–1838*, Oxford, 1970

Index of Artists

The Plates

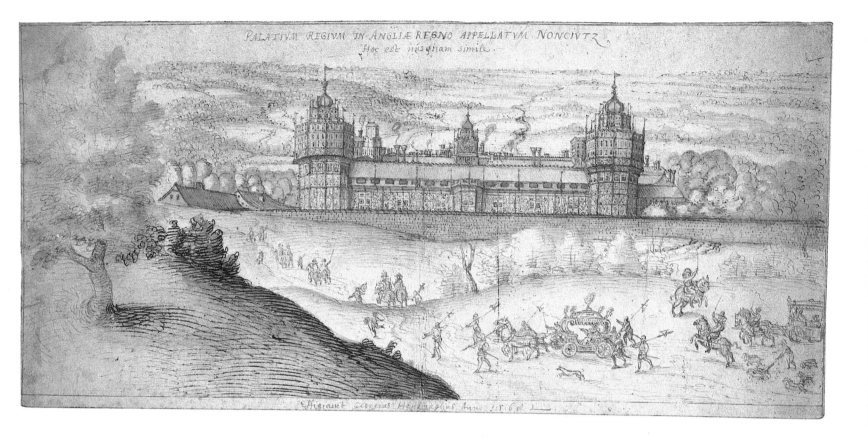

PALATIVM REGIVM IN ANGLIÆ REGNO APPELLATVM NONCIVTZ
Hoc est nusquam simile

Effigiauit Georgius Hoefnaglius Anno 1568 2

Plate 1 Joris Hoefnagel *Nonsuch Palace, Surrey* (no. 1)

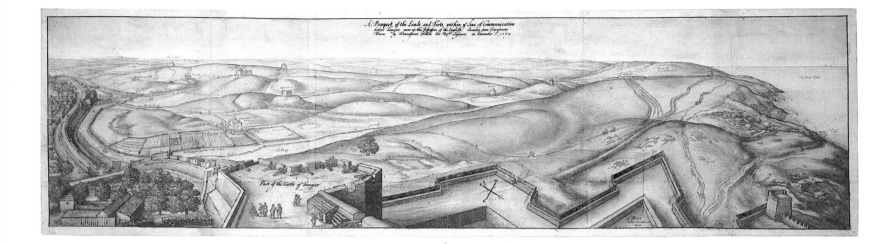

Plate 2 Wenceslaus Hollar *'A Prospect of the Lands and Ports . . . before Tangier . . . drawne from Peterborow Tower'* (no. 2)

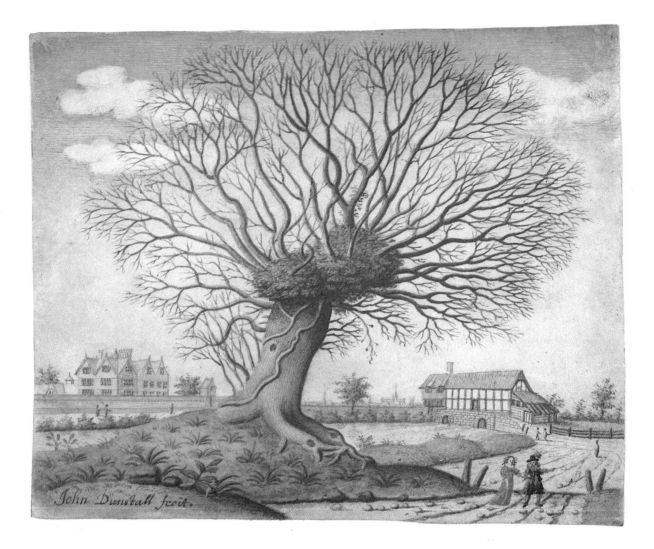

Plate 3 John Dunstall *A Pollard Oak near West Hampnett Place, Chichester* (no. 4)

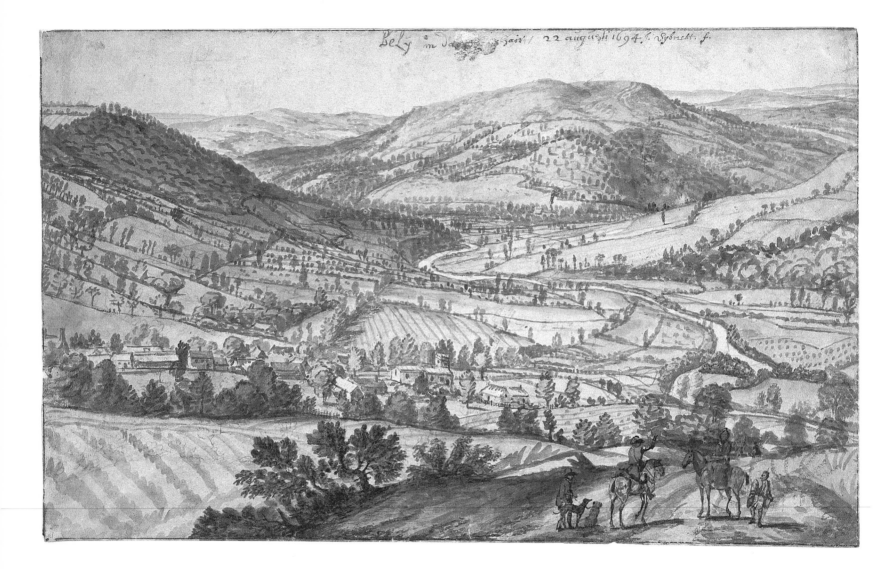

Plate 4 Jan Siberechts *Views of Beeley, near Chatsworth* (no. 5)

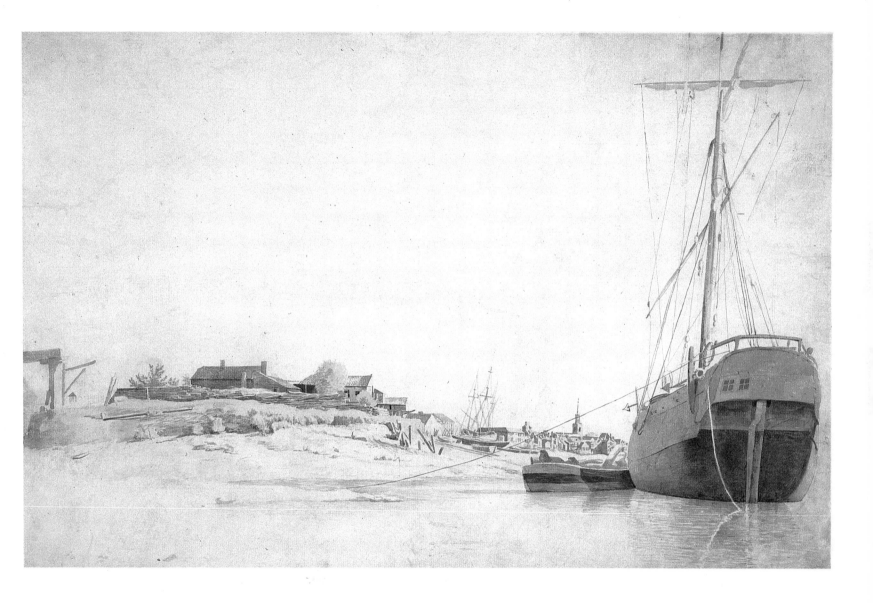

Plate 5 Samuel Scott *The Thames below Rotherhithe* (no. 8)

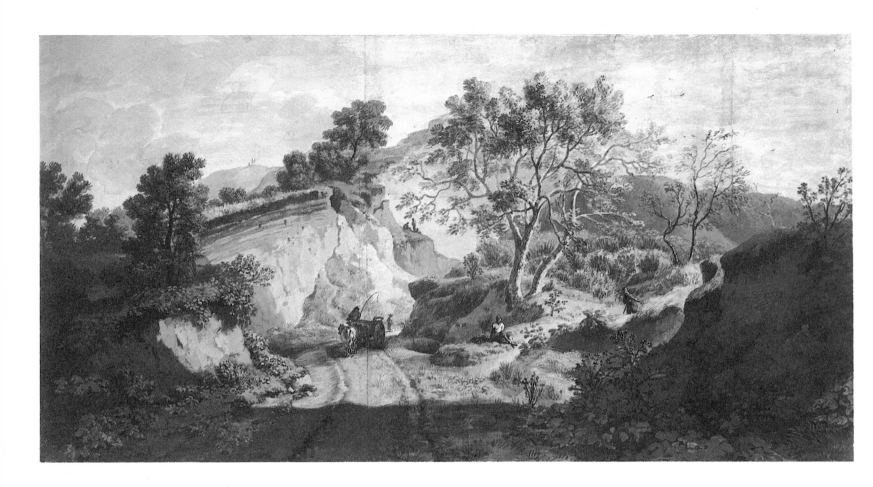

Plate 6 William Taverner *A Sandpit at Woolwich* (no. 10)

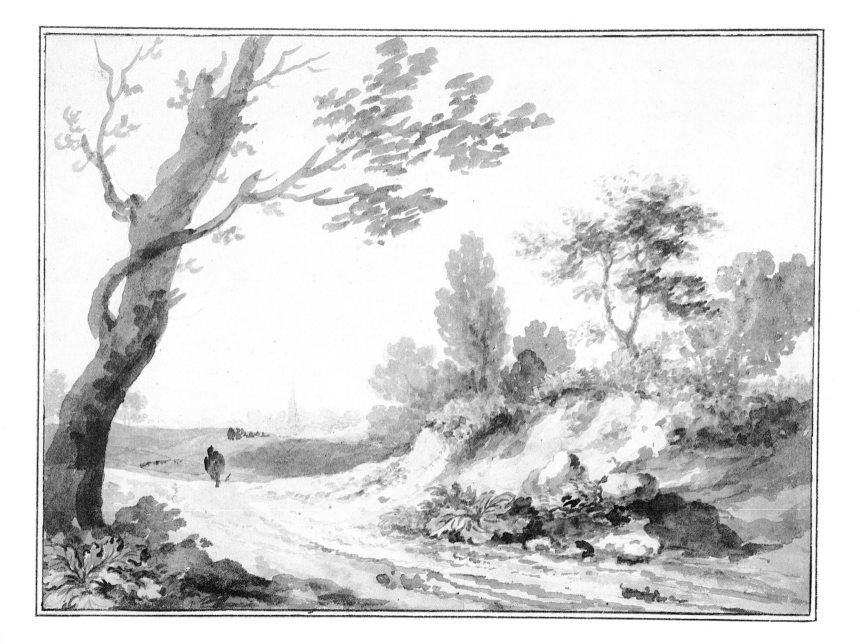

Plate 7 William Taverner *A Country Road leading to a Church* (no. 11)

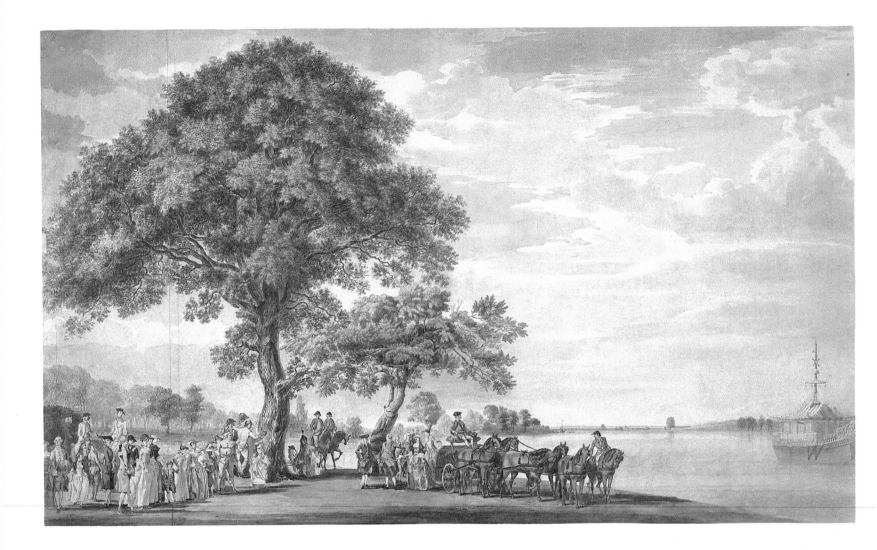

Plate 8 Thomas Sandby *View from the North Side of the Virginia River near the Manour Lodge* (no. 13)

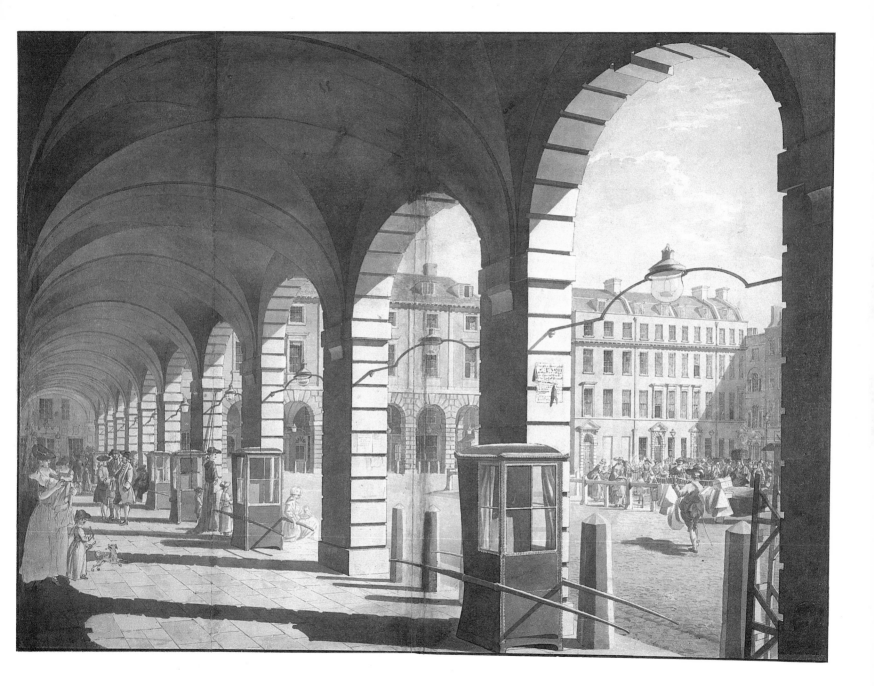

Plate 9 Thomas Sandby *The Piazza, Covent Garden* (no. 14)

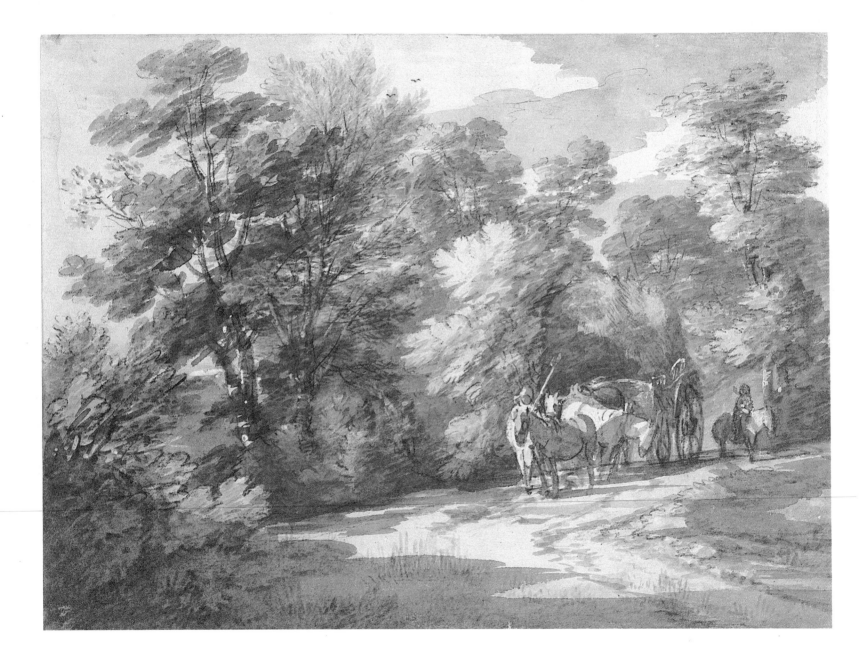

Plate 10 Thomas Gainsborough *A Cart Passing along a winding Road* (no. 17)

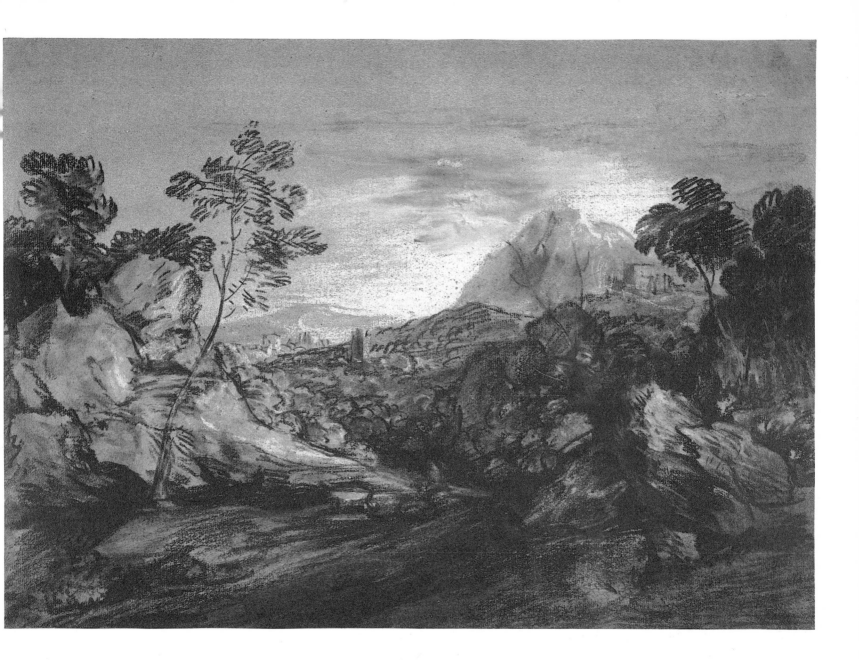

Plate 11 Thomas Gainsborough *A Rocky Wooded Landscape with a Figure driving sheep* (no. 18)

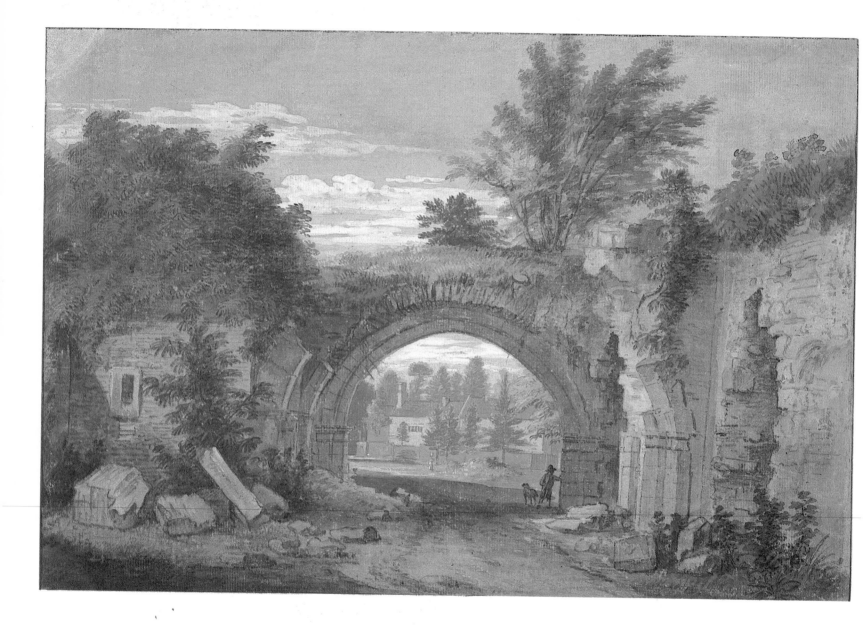

Plate 12 Paul Sandby *The Gate of Coverham Abbey, Yorkshire* (no. 20)

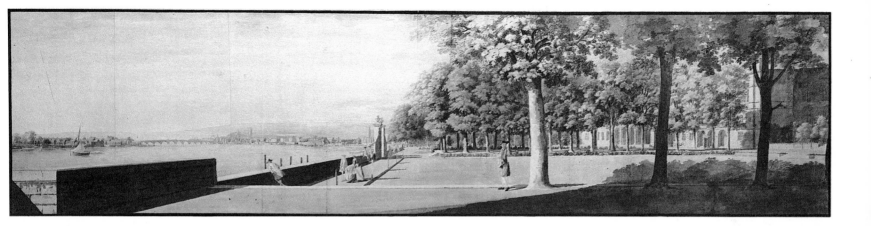

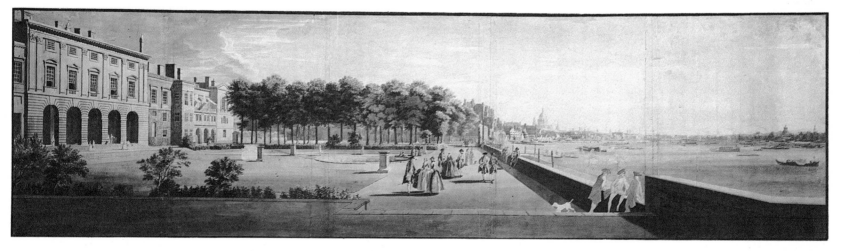

Plate 13 Paul Sandby (above) *View from the Gardens of Somerset House, looking West* (no. 21a)
(below) *The same, looking East* (no. 21b)

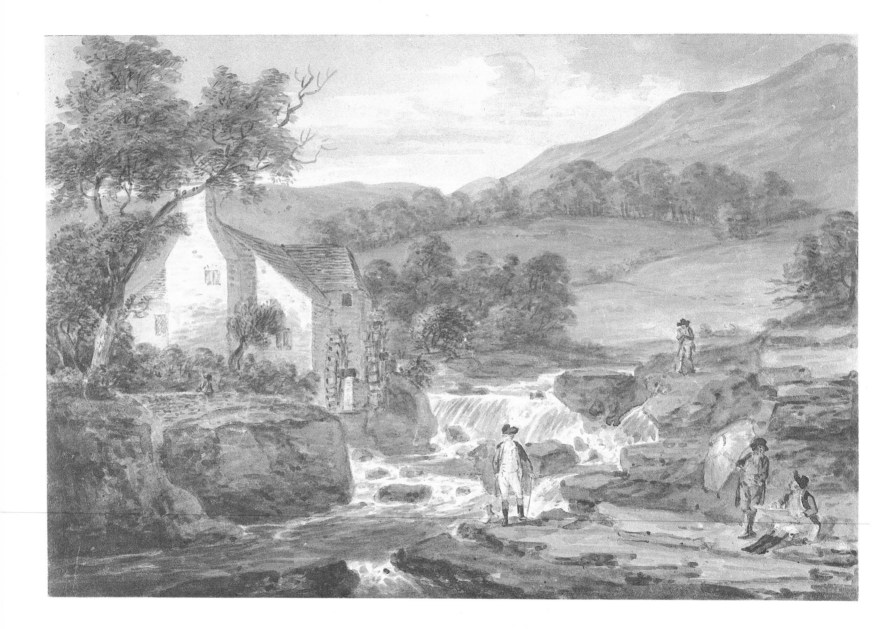

Plate 14 Paul Sandby *The Iron Forge at Barmouth* (no. 22)

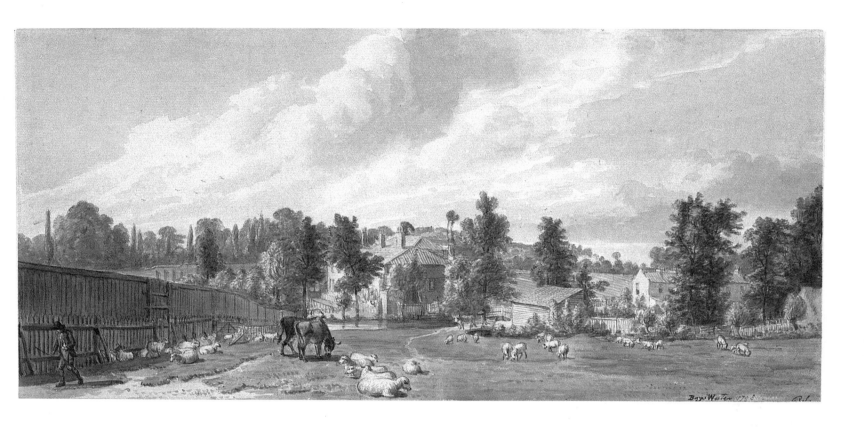

Plate 15 Paul Sandby *Bayswater* (no. 26)

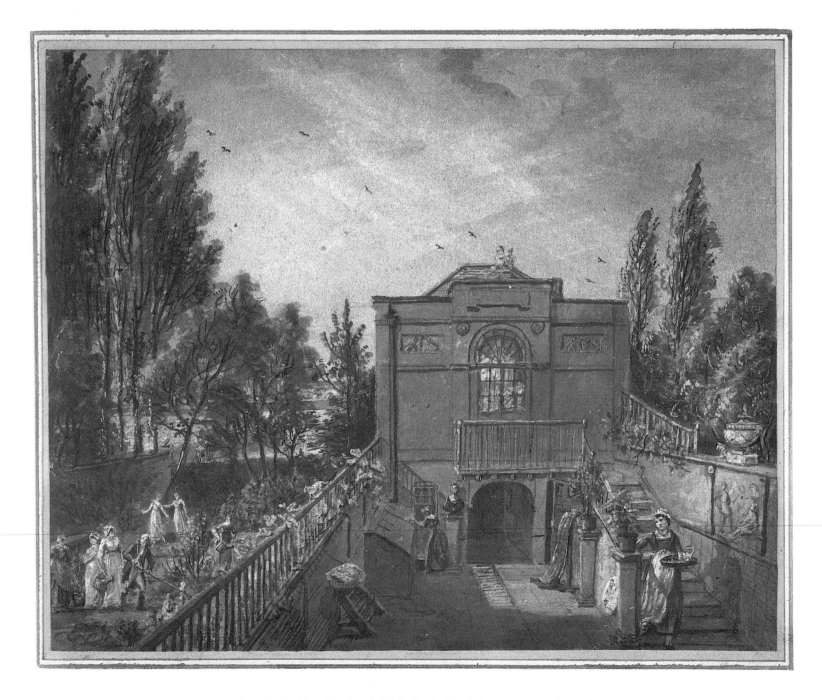

Plate 16 Paul Sandby *The Artist's Studio, St George's Row, Bayswater* (no. 25)

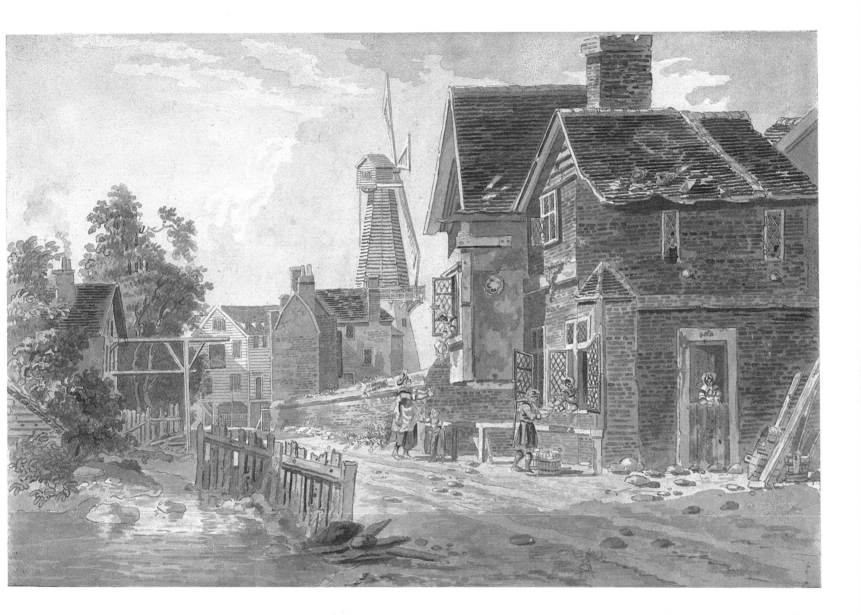

Plate 17 James Miller *A Suburban Scene, probably beside the Thames* (no. 27)

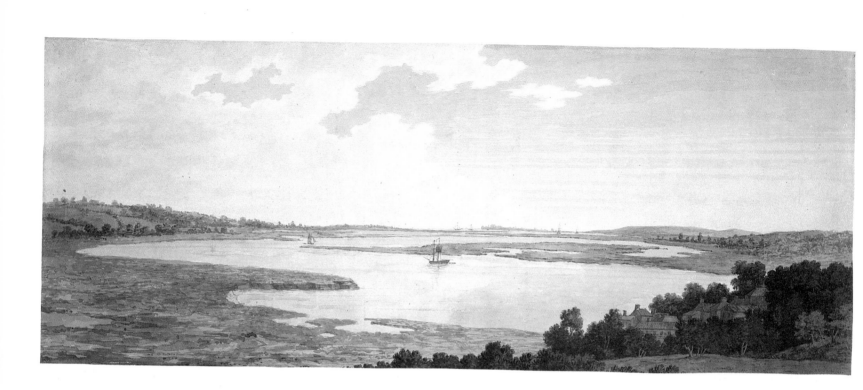

Plate 18 Jonathan Skelton *The Medway near Sheerness* (no. 30)

Plate 19 Francis Towne *Near the Arco Oscuro* (no. 33)

Plate 20 Francis Towne *SS Giovanni e Paolo, Rome* (no. 32)

Plate 21 John 'Warwick' Smith *SS Giovanni e Paolo, Rome, with S. Stefano Rotondo in the distance* (no. 52)

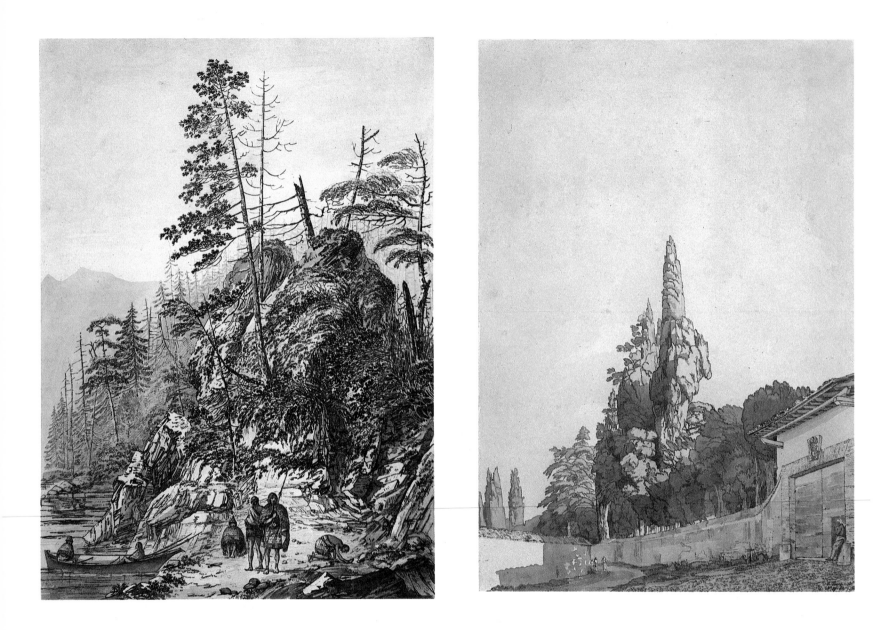

Plate 22 (left) John Webber *View in Nootka Sound, on the Pacific Coast of North America* (no. 55)
(right) Francis Towne *A Gateway to the Villa Ludovisi* (no. 34)

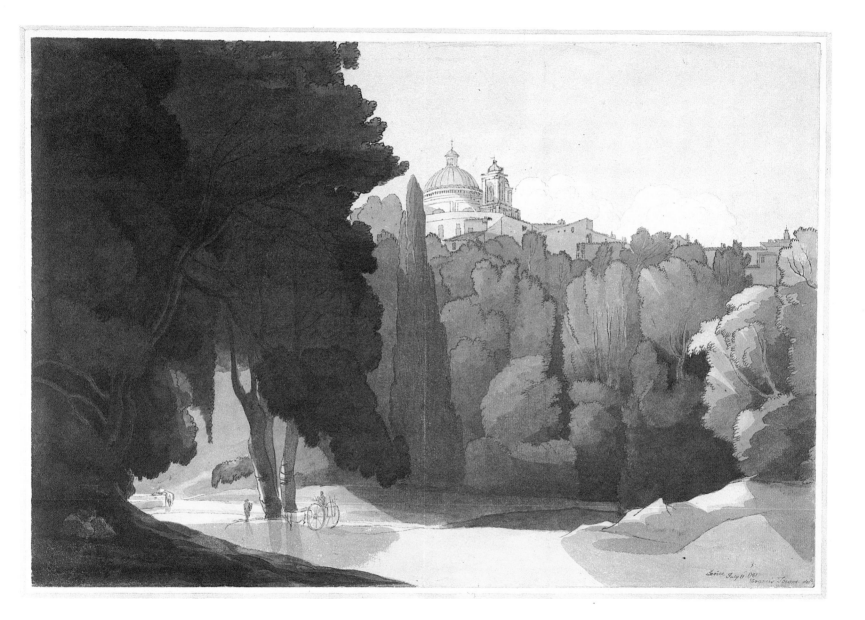

Plate 23 Francis Towne *Ariccia* (no. 36)

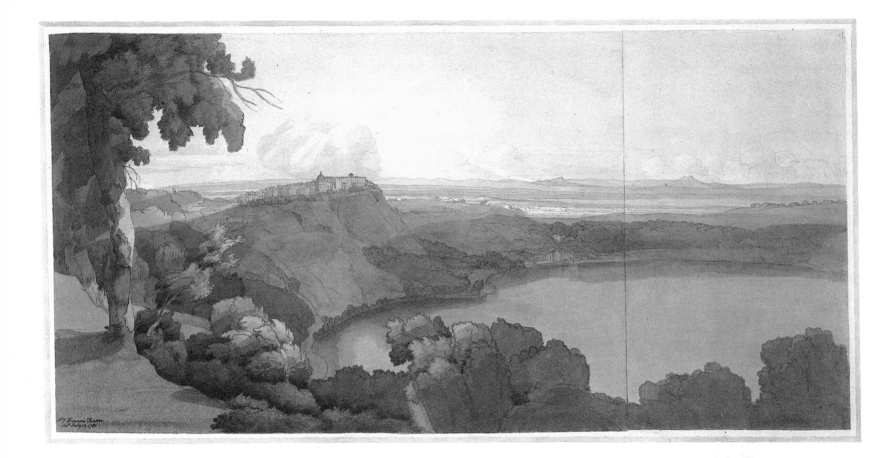

Plate 24 Francis Towne *Lake Albano with Castel Gandolfo* (no. 37)

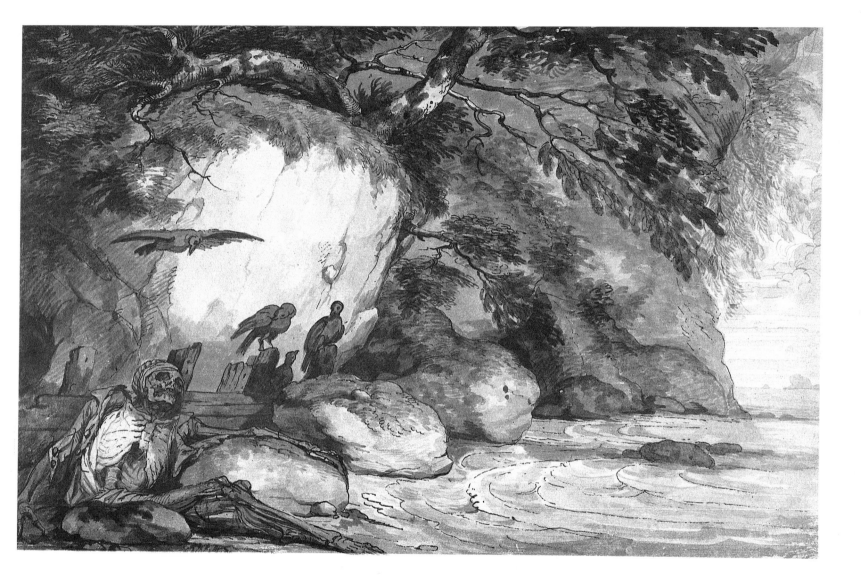

Plate 25 John Hamilton Mortimer *Carrion Crows hovering over a Skeleton on a Seashore* (no. 38)

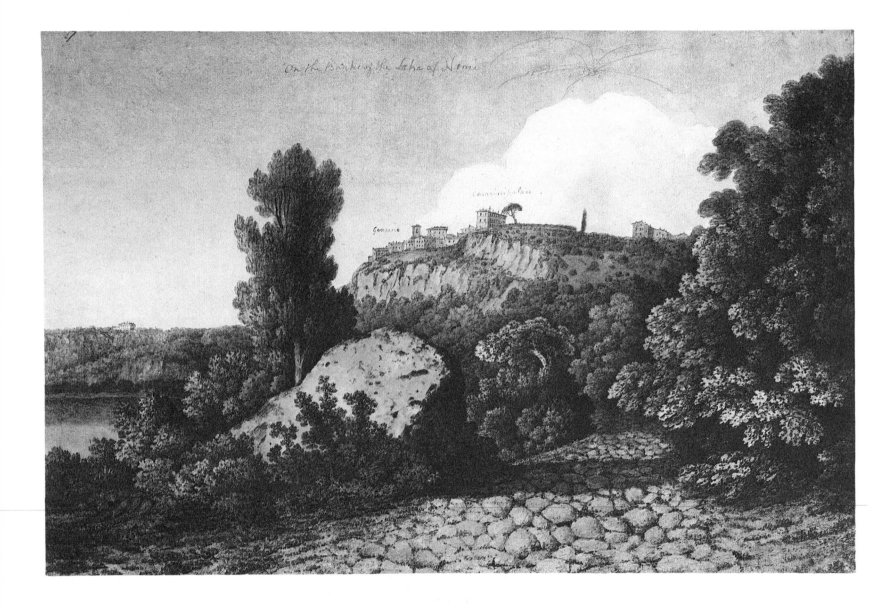

Plate 26 Thomas Jones *Lake Nemi* (no. 40)

Plate 27 Thomas Jones *Houses in Naples* (no. 41)

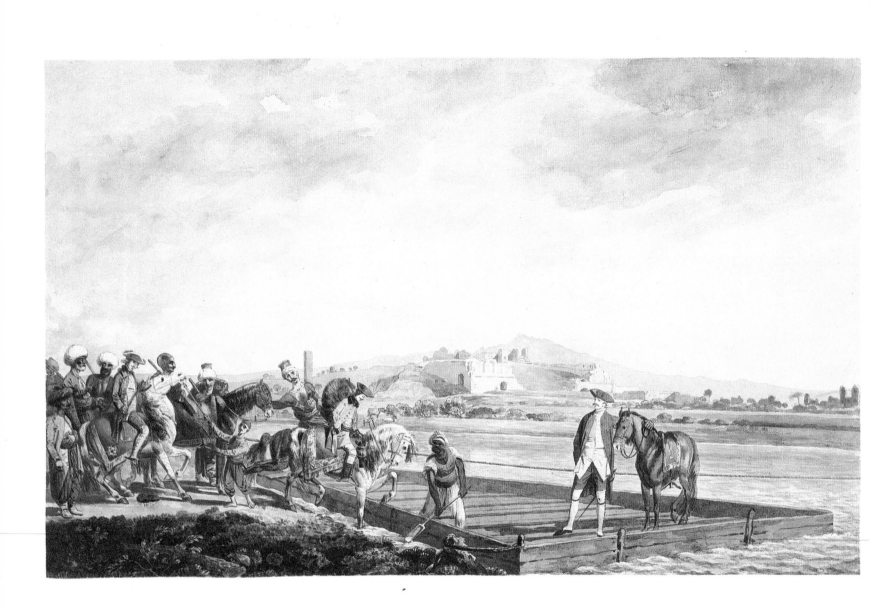

Plate 28 William Pars *The Theatre at Miletus* (no. 42a)

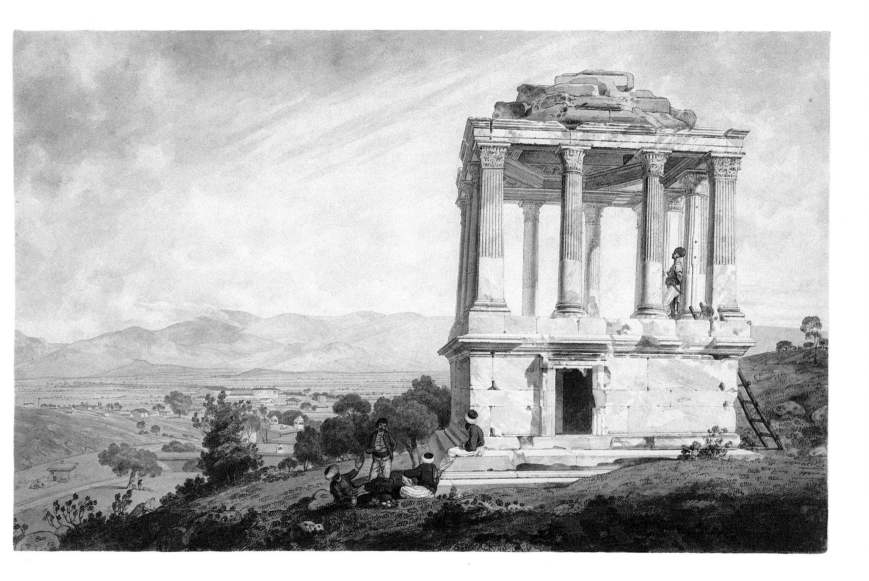

Plate 29 William Pars *A Sepulchral Monument at Mylasa* (no. 42b)

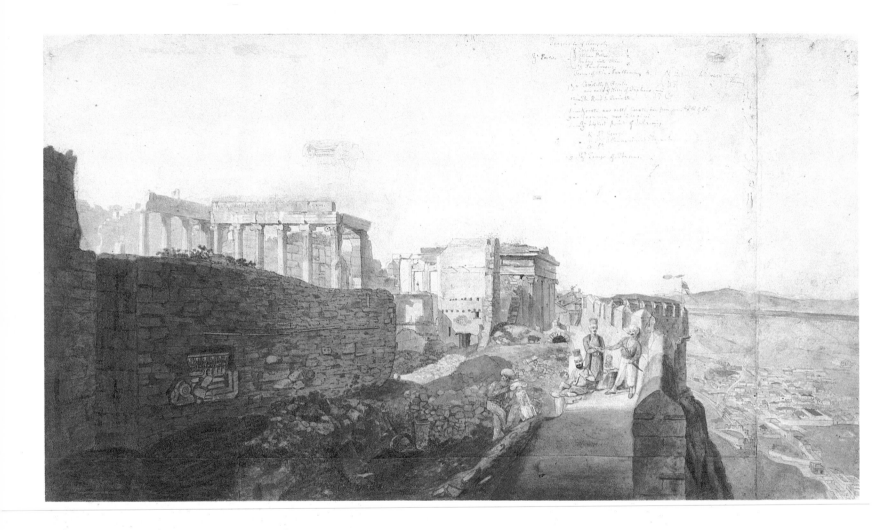

Plate 30 William Pars *The Temple on the Acropolis in Athens known as the Erectheum, looking towards the West* (no. 42d)

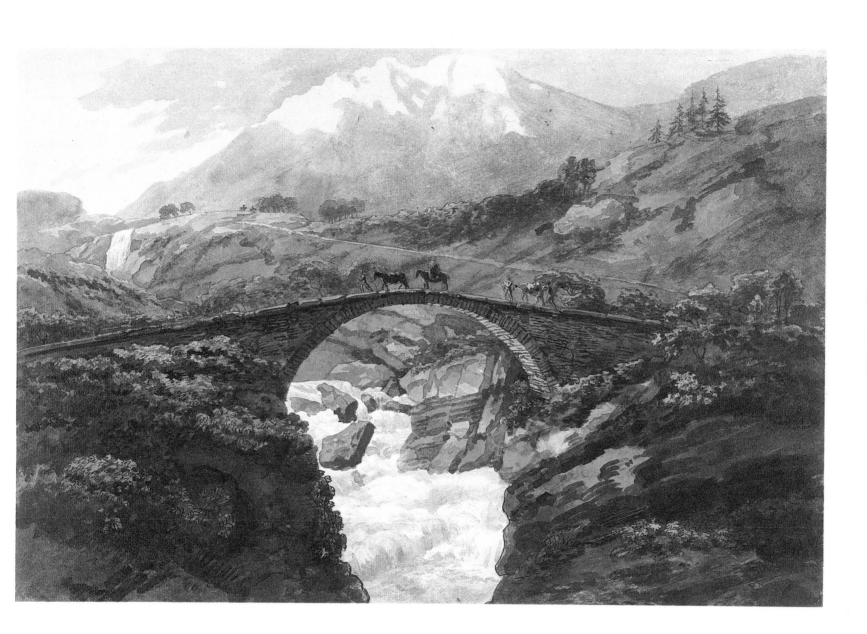

Plate 31 William Pars *A Bridge near Mont Grimsel* (no. 43c)

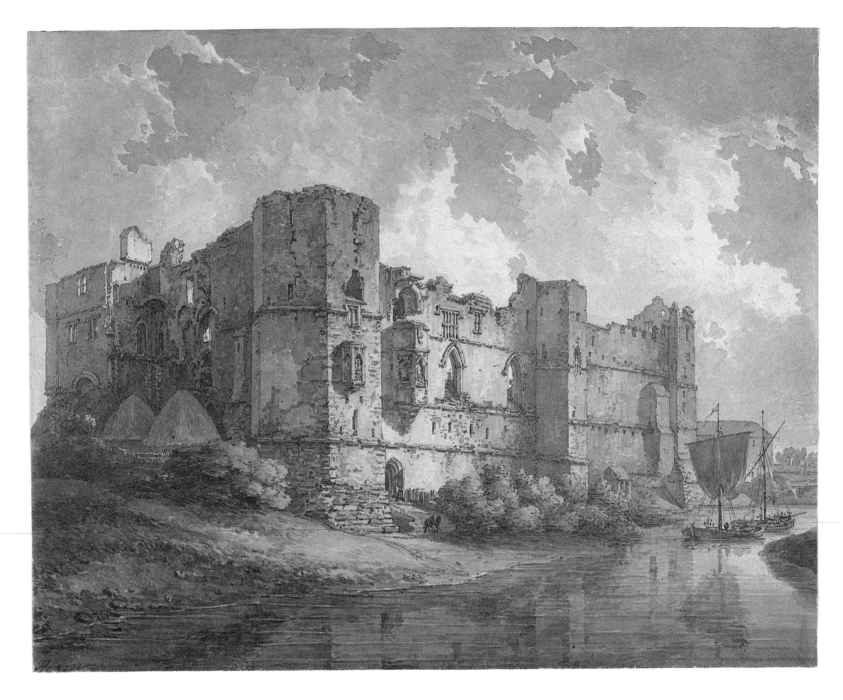

Plate 32 Thomas Hearne *Newark Castle, Nottingham* (no. 45)

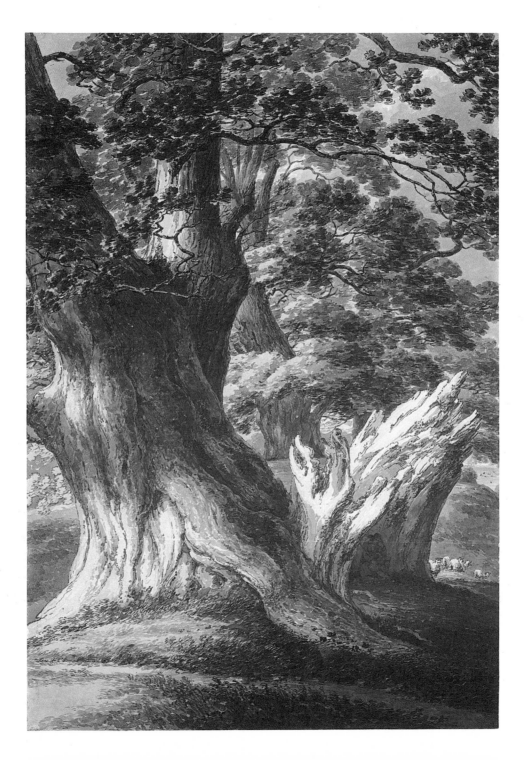

Plate 33 Thomas Hearne
An Oak Tree (no. 47)

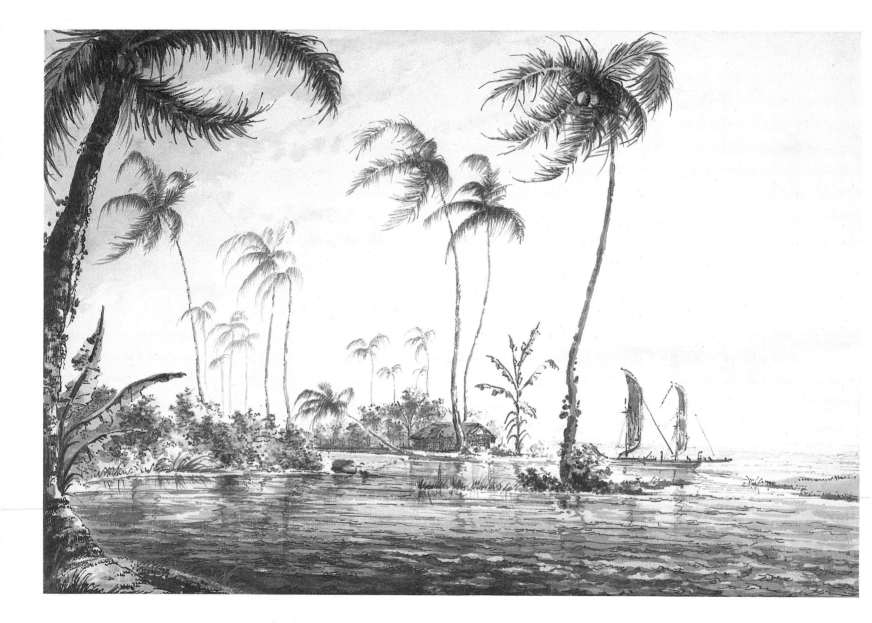

Plate 34 William Hodges *View on the Island of Otaheite (Tahiti)* (no. 48)

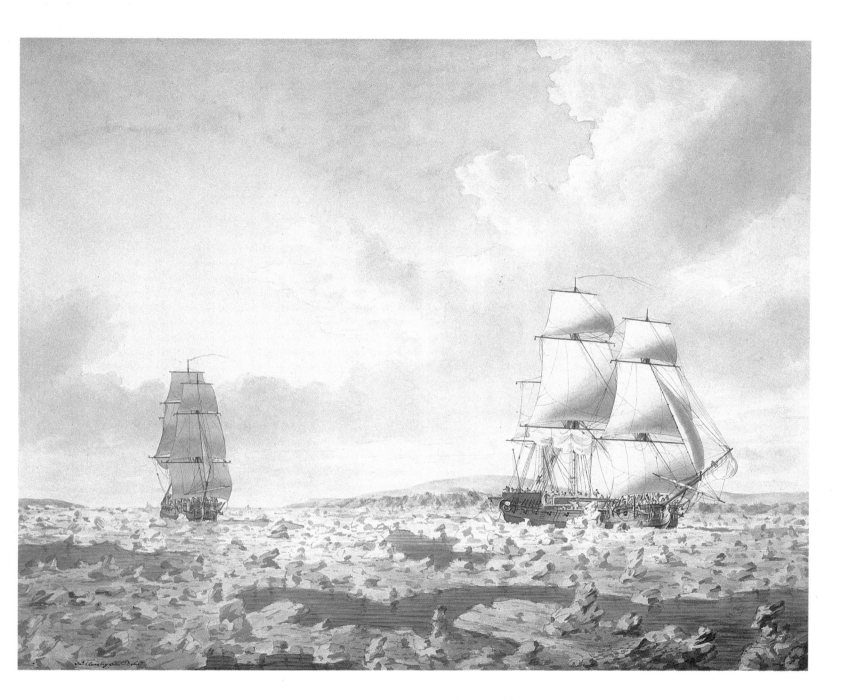

Plate 35 John Cleveley the Younger *The 'Racehorse' and 'Carcass' forcing their way through the Ice, August 10th 1773* (no. 49)

Plate 36 Thomas Malton *St Lawrence Jewry and the Guildhall* (no. 50)

Plate 37 John 'Warwick' Smith *The Church of SS Trinità dei Monti, Rome* (no. 51)

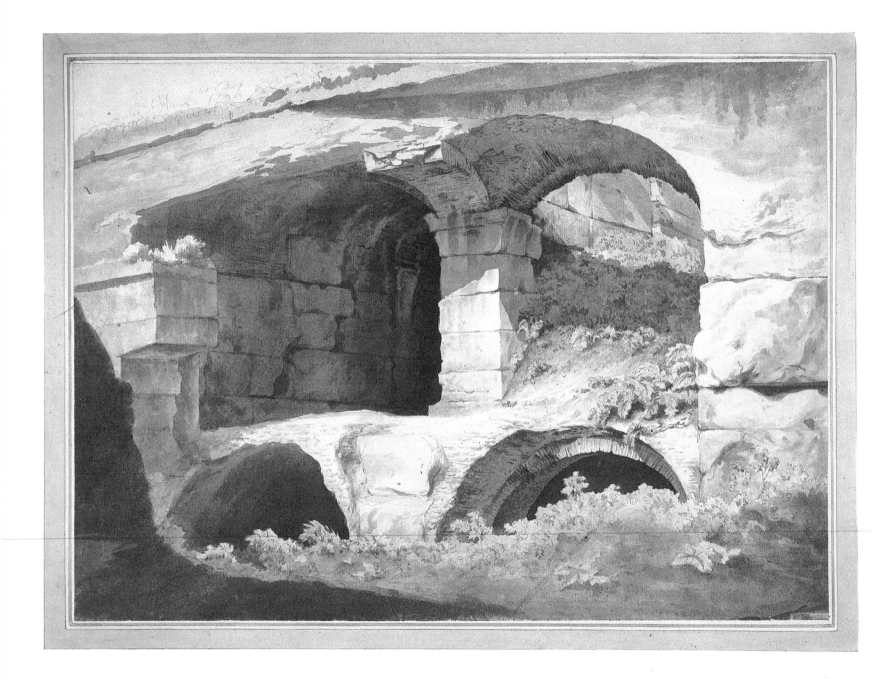

Plate 38　John 'Warwick' Smith　*Stonework in the Colosseum*　(no. 54)

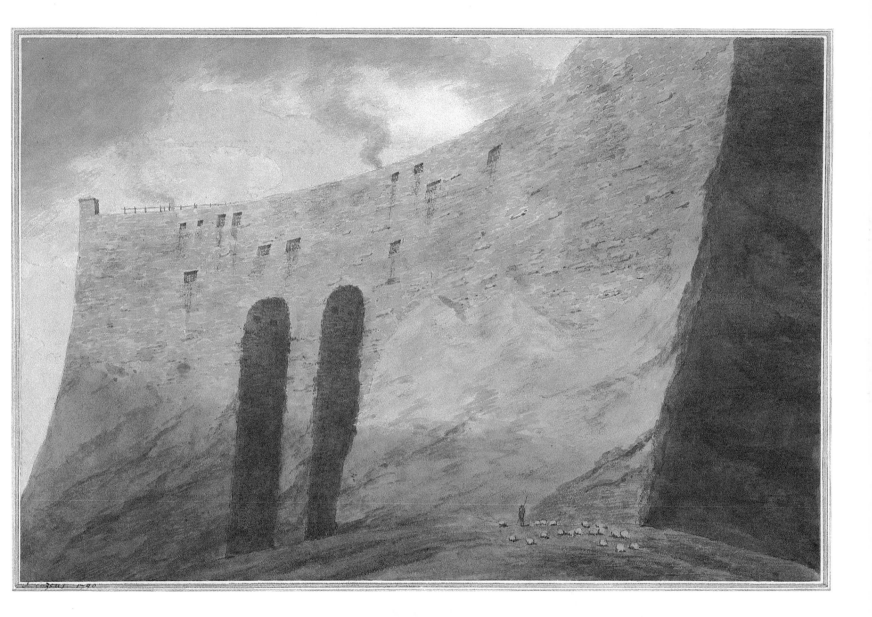

Plate 39 John Robert Cozens *The Castle of St Elmo, Naples* (no. 60)

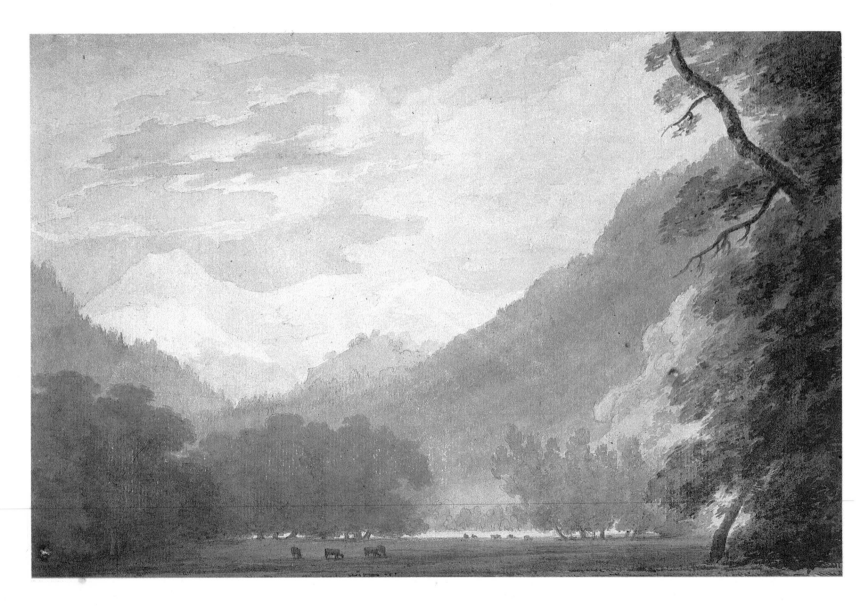

Plate 40 John Robert Cozens *From the Road between the Lake of Thun and Unterseen* (no. 57)

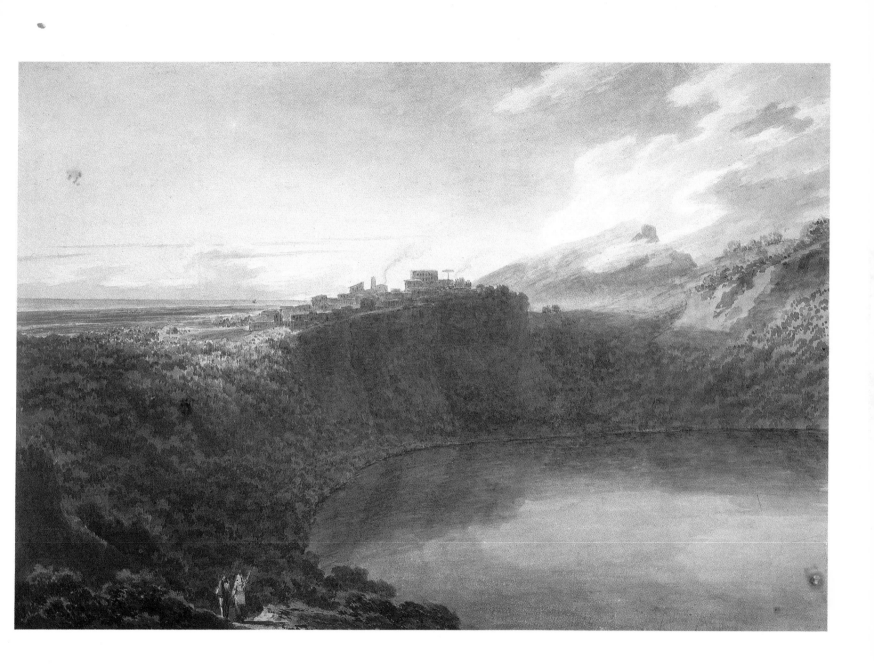

Plate 41 John Robert Cozens *Lake Nemi* (no. 59)

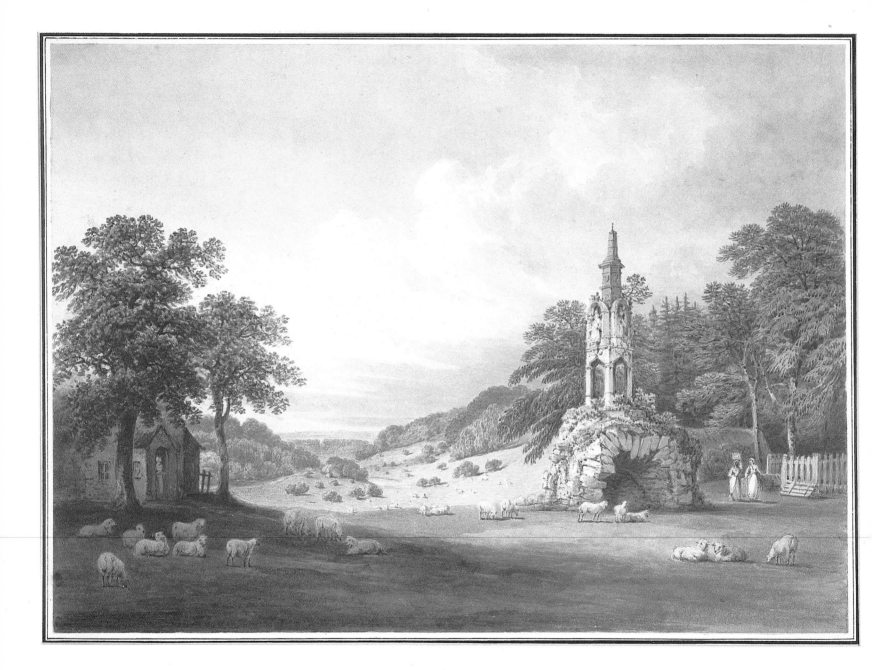

Plate 42 Francis Nicholson *Stourhead: The Bristol High Cross* (no. 61b)

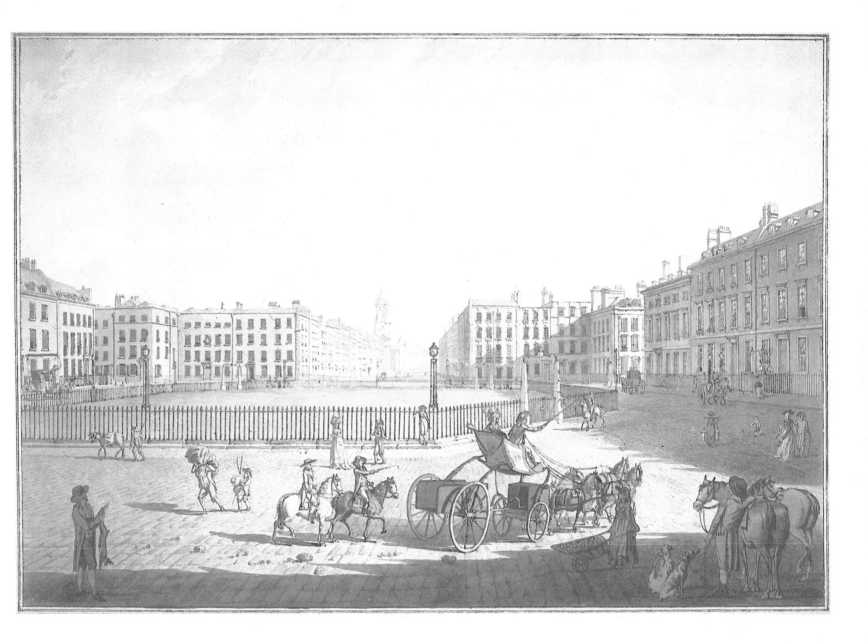

Plate 43 Edward Dayes and Robert Thew *Hanover Square* (no. 64)

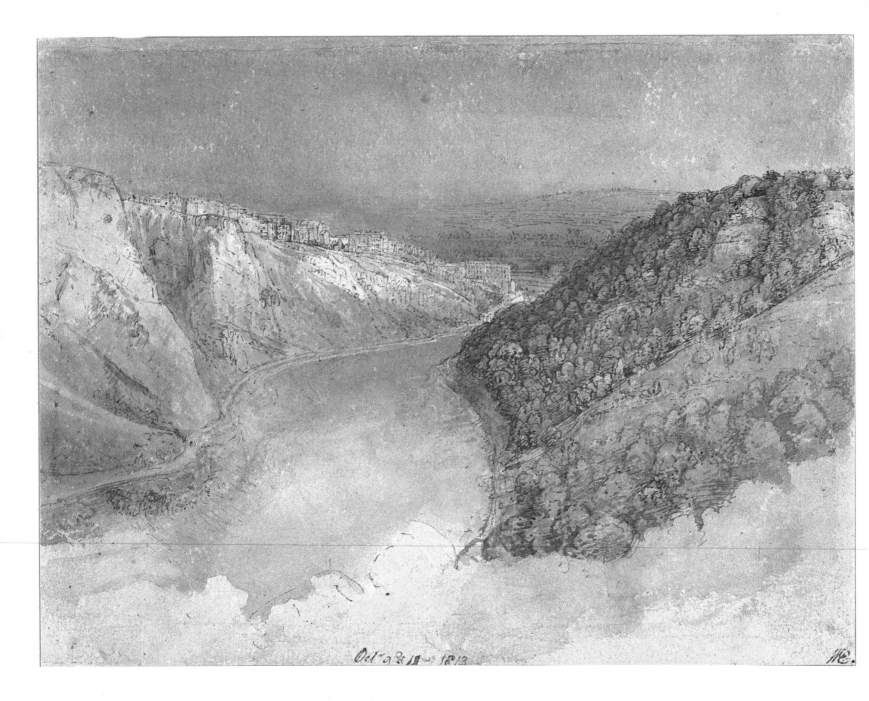

Oct 9 & 10 1813.

Plate 44 Thomas Stothard *The Avon at Clifton* (no. 62)

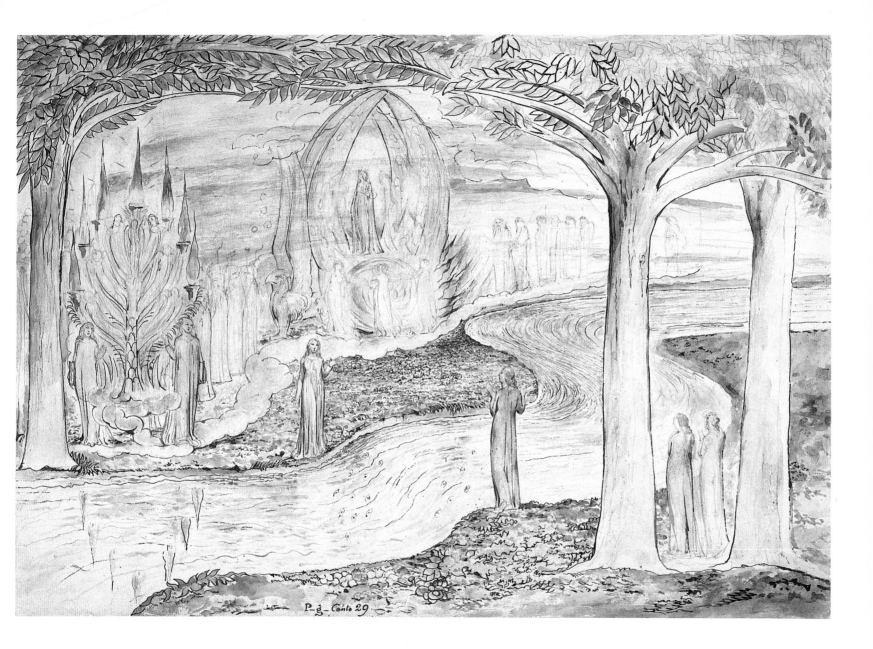

Plate 45 William Blake *Beatrice on the Car, Matilda and Dante* (no. 63)

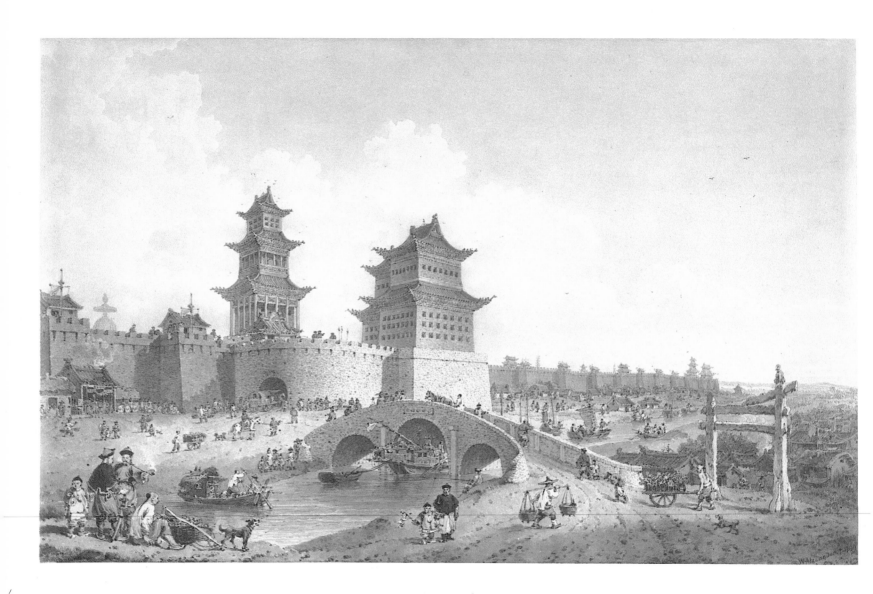

Plate 46 William Alexander *Pingze Men, the Western Gate of Peking* (no. 66)

Plate 47 John Glover *A Rocky Gorge* (no. 68)

Plate 48 Joshua Cristall *A Cottage at St Laurence, Isle of Wight* (no. 69)

Plate 49 Joseph Michael Gandy *Landscape with Temples* (no. 72)

Plate 50 Samuel Owen *Loading Boats in an Estuary* (no. 70)

Plate 51 Thomas Girtin *Wetherby Bridge, Yorkshire* (no. 73)

Plate 52 Thomas Girtin *Near Beddgelert* (no. 75)

Plate 53 Thomas Girtin *Near Beddgelert* (no. 76)

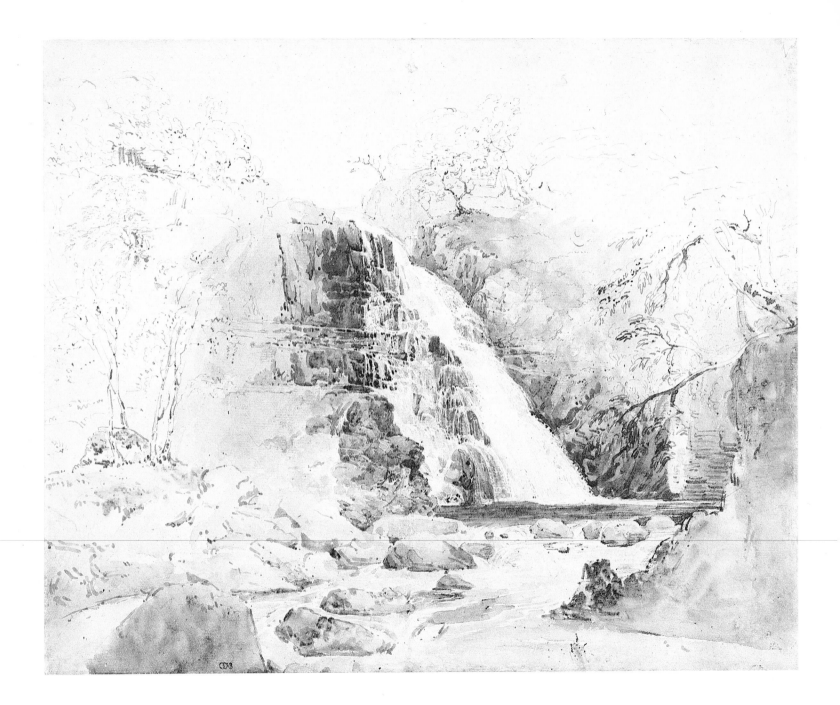

Plate 54 Thomas Girtin *Cayne Waterfall, North Wales* (no. 77)

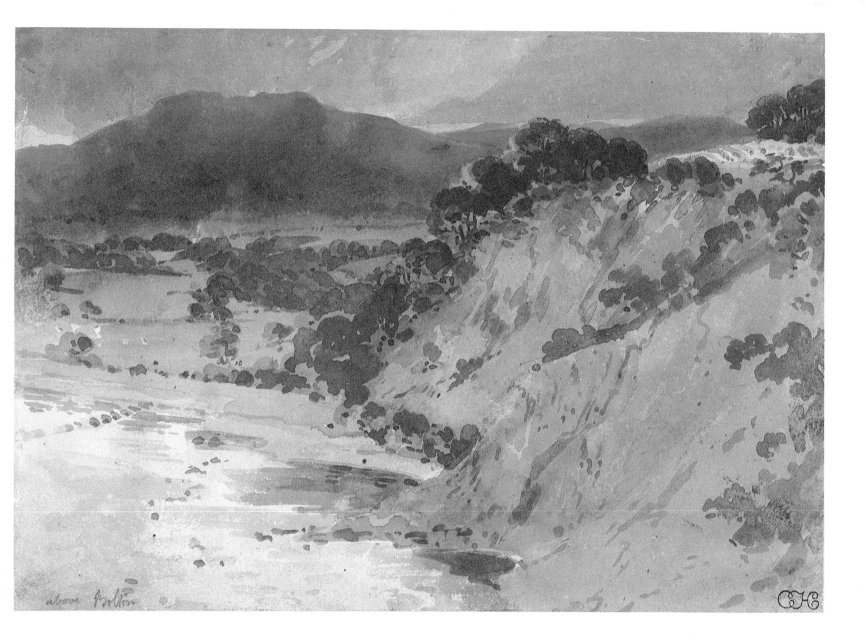

Plate 55 Thomas Girtin *Above Bolton* (no. 80b)

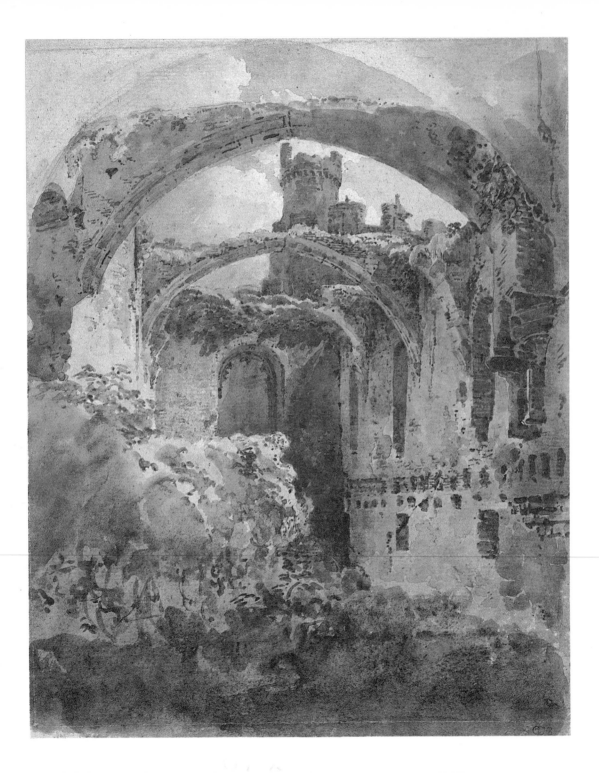

Plate 56 Thomas Girtin
The Great Hall, Conway Castle (no. 78)

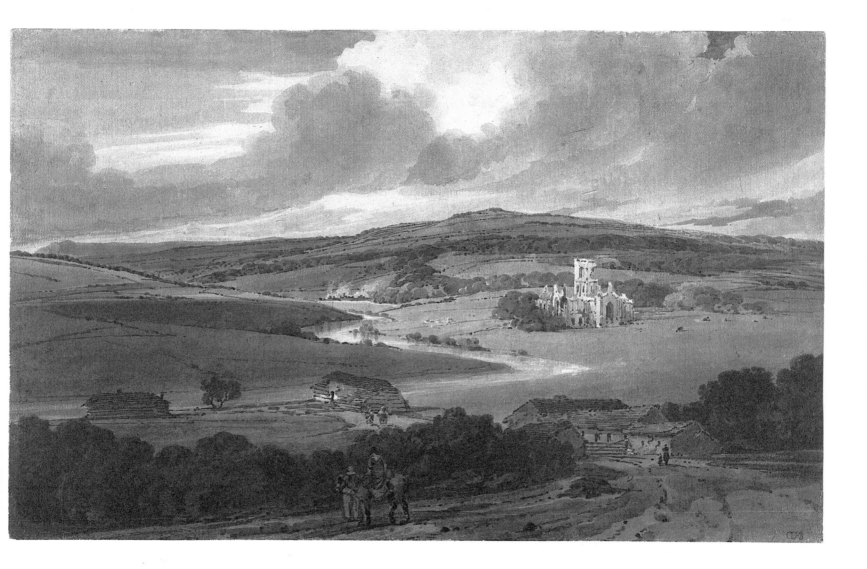

Plate 57 Thomas Girtin *Kirkstall Abbey* (no. 79)

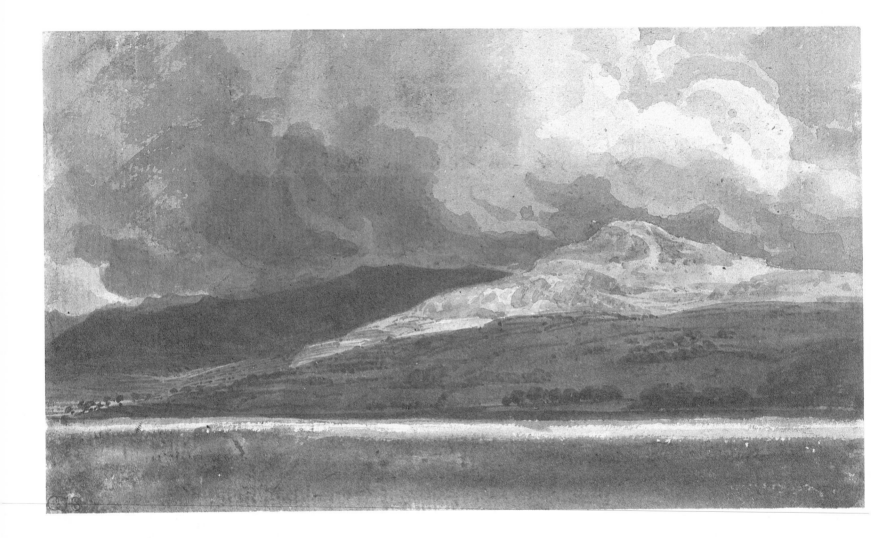

Plate 58 Thomas Girtin *Hills and River* (no. 81b)

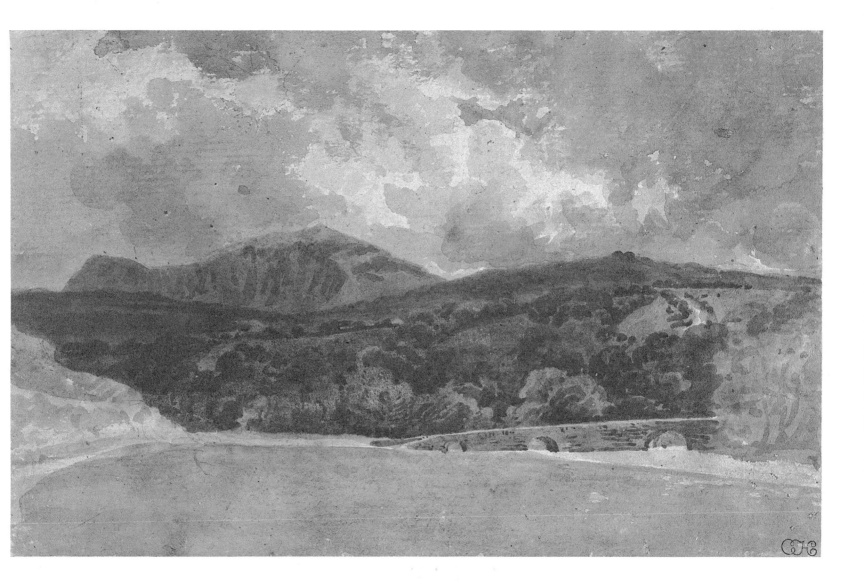

Plate 59 Thomas Girtin *Landscape with Hill and Cloud* (no. 81c)

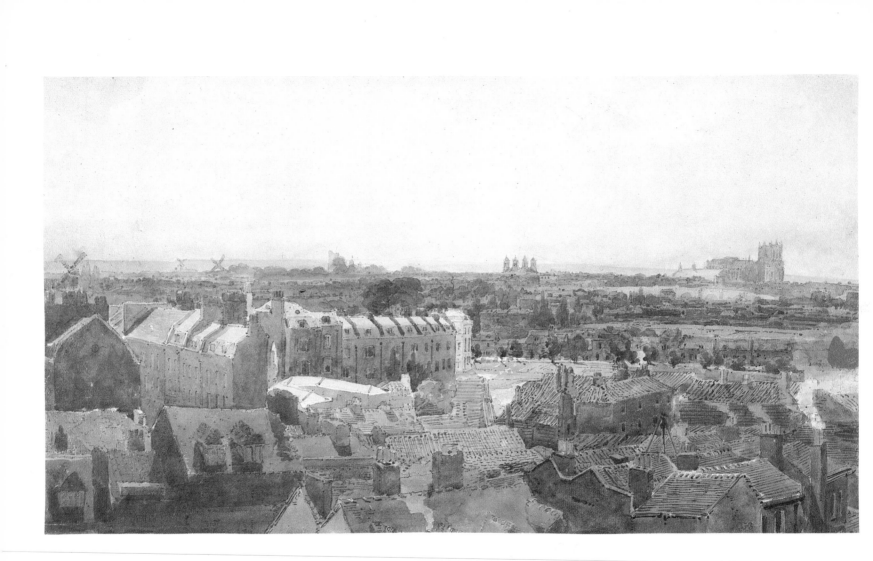

Plate 60 Thomas Girtin *Westminster and Lambeth* (no. 82a)

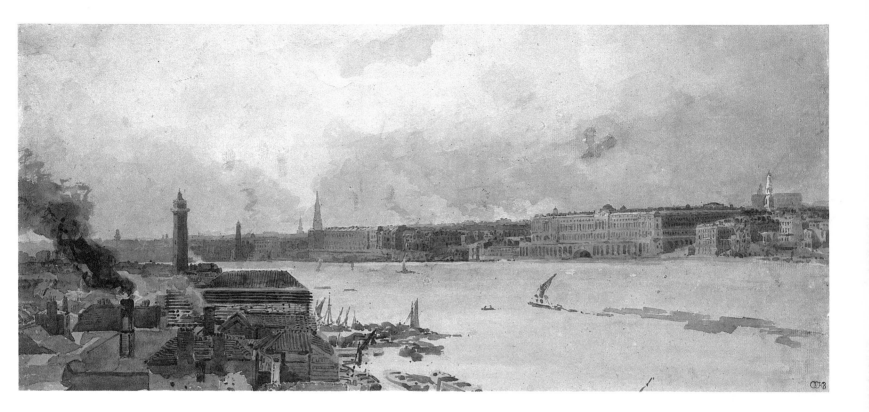

Plate 61 Thomas Girtin *The Thames from Westminster to Somerset House* (no. 82b)

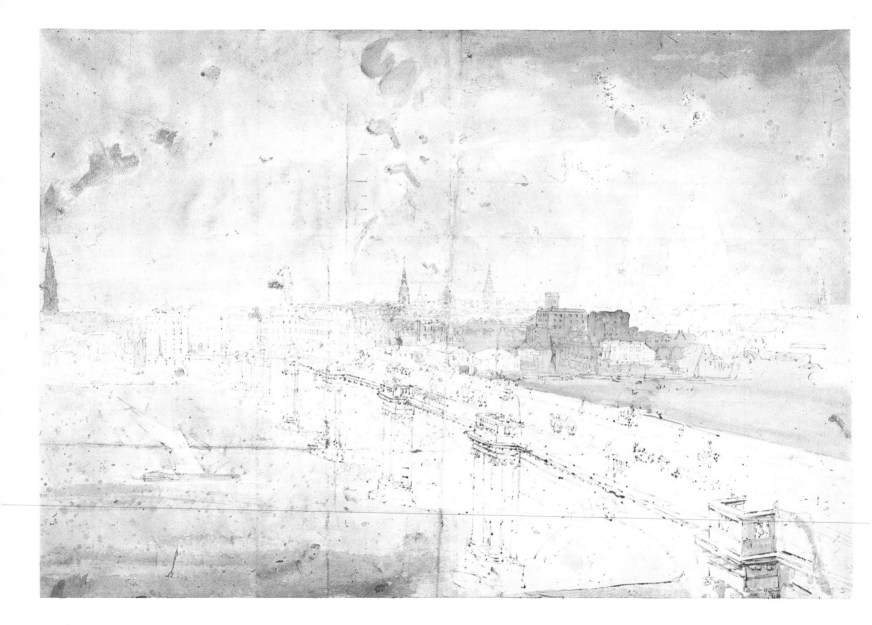

Plate 62 Thomas Girtin *Blackfriars Bridge and St Paul's* (no. 82d)

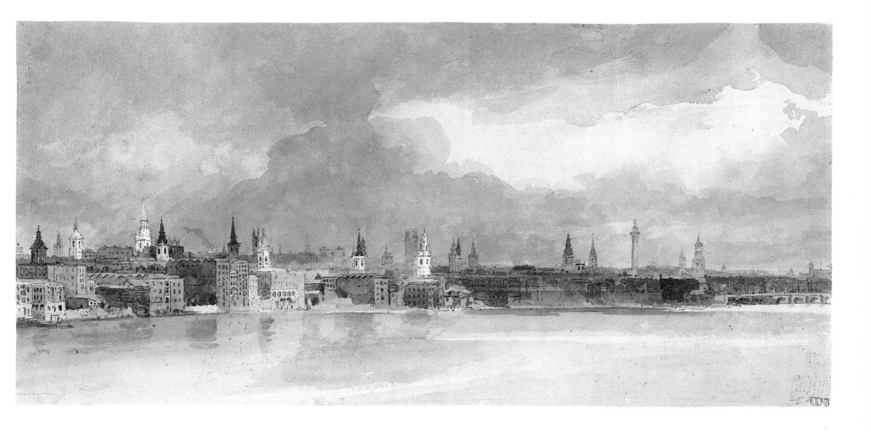

Plate 63 Thomas Girtin *The Thames from Queenhithe to London Bridge* (no. 82e)

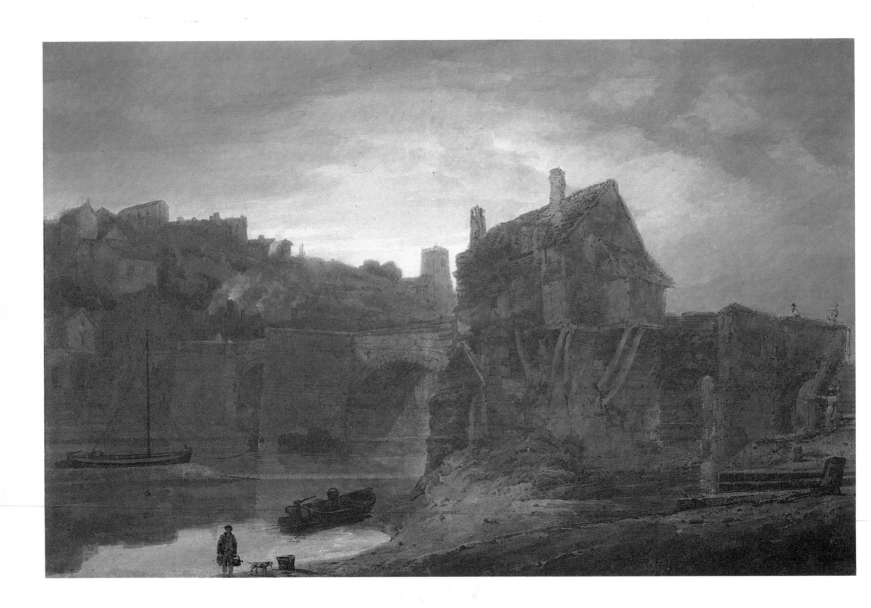

Plate 64 Thomas Girtin *Bridgnorth* (no. 84)

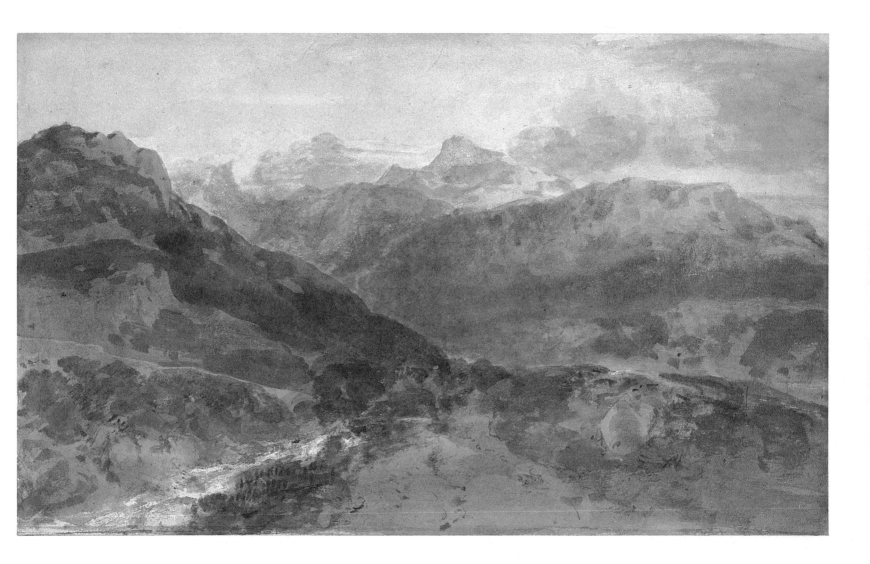

Plate 65 J.M.W. Turner *A View in North Wales?* (no. 86)

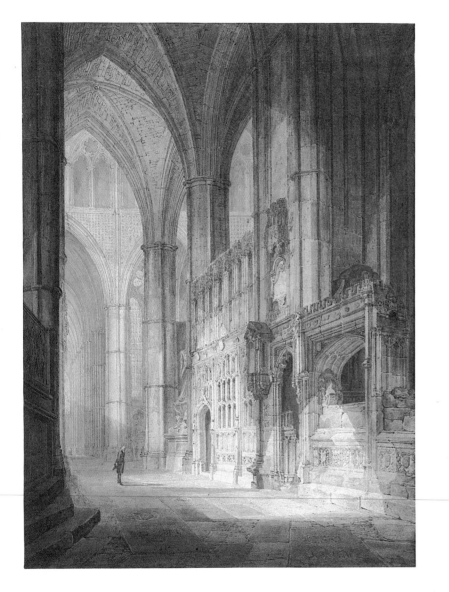

Plate 66 J.M.W. Turner (left) *The Interior of Westminster Abbey, with the Entrance to Bishop Islip's Chapel* (no. 85)
(right) *Essays in Colour to try his Palette* (no. 101)

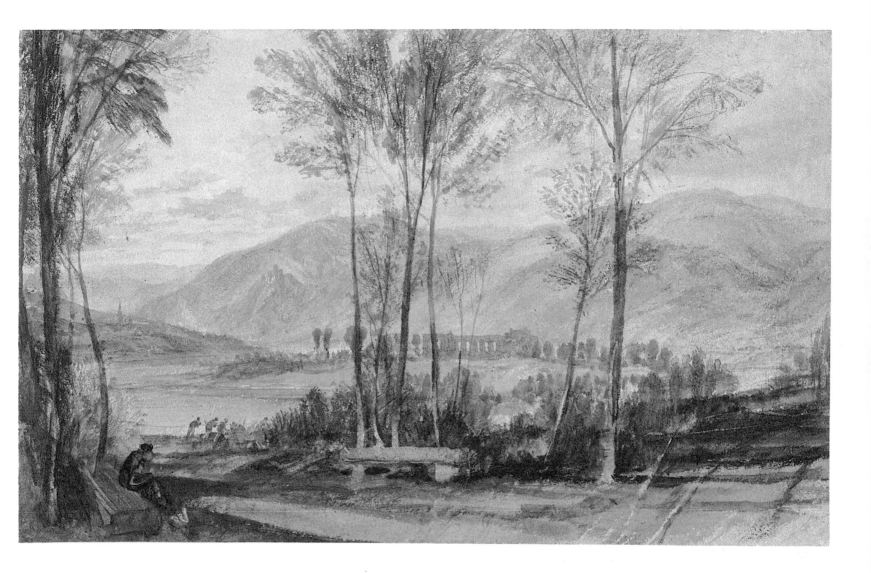

Plate 67 J.M.W. Turner *An Abbey near Coblenz* (no. 89a)

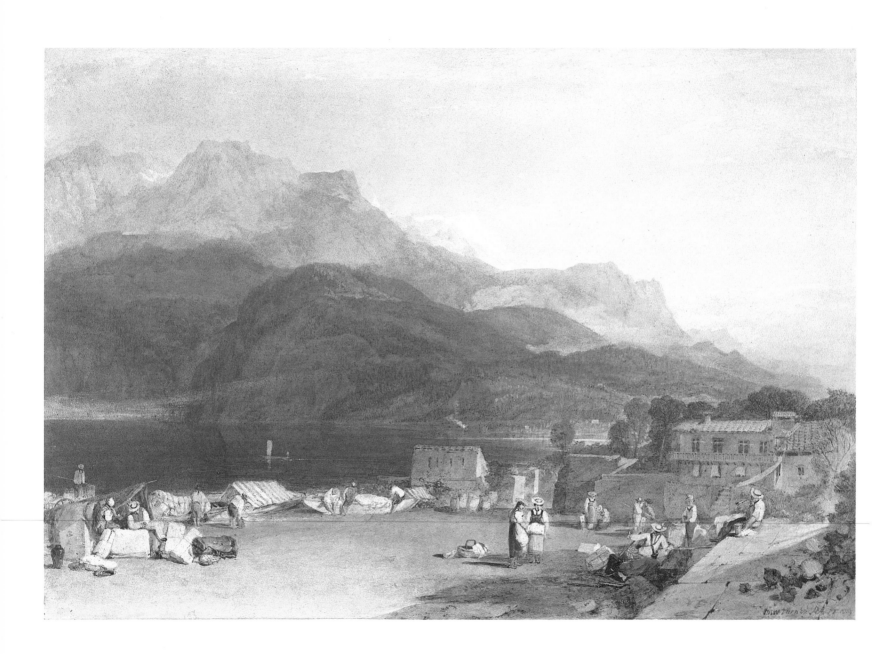

Plate 68 J.M.W. Turner *The Lake of Brienz* (no. 88)

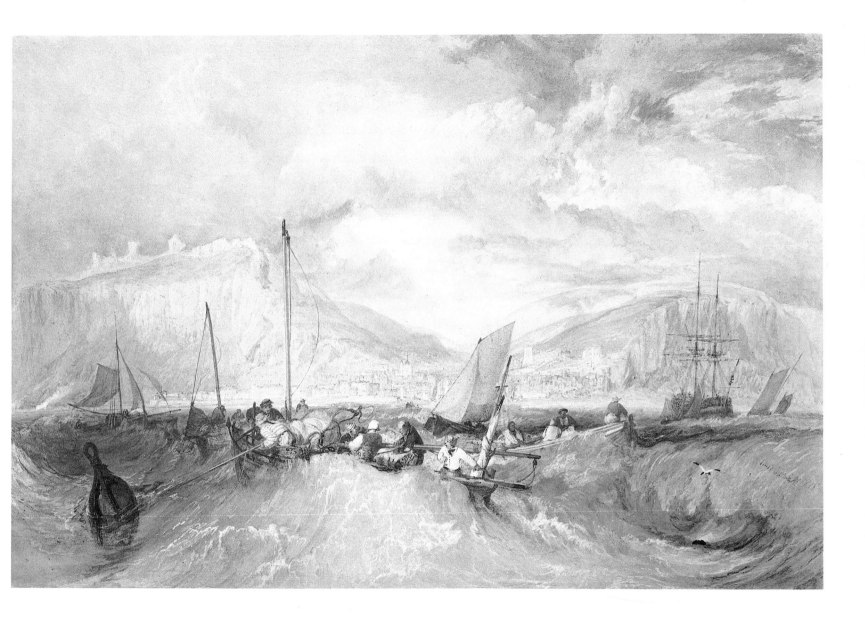

Plate 69 J.M.W. Turner *Hastings from the Sea* (no. 90)

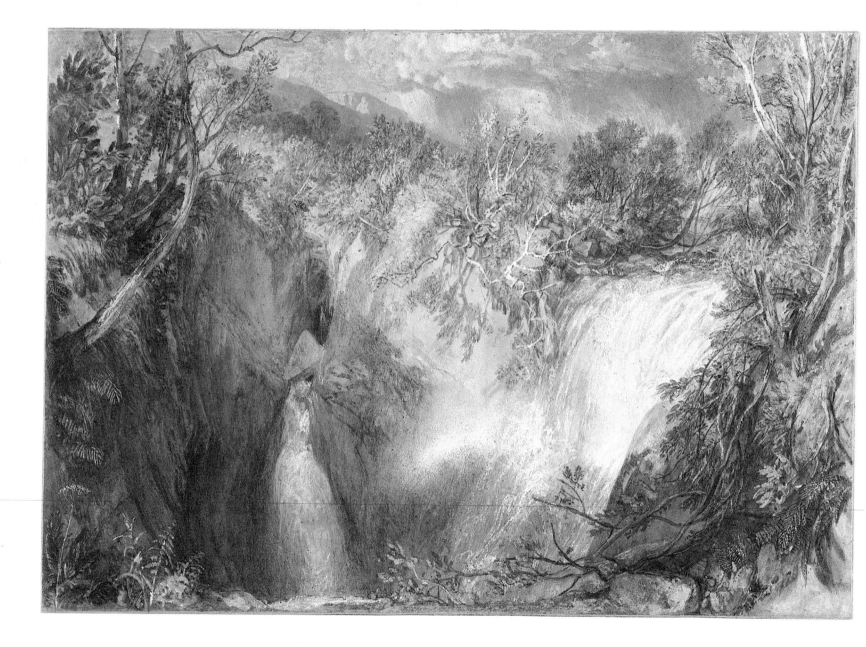

Plate 70 J.M.W. Turner *Weathercote Cave, near Ingleton* (no. 91)

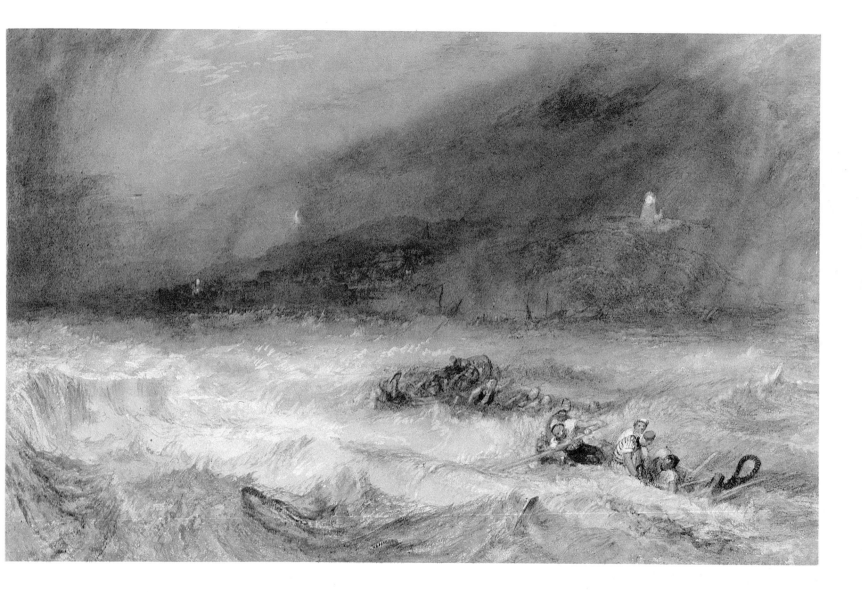

Plate 71 J.M.W. Turner *Lowestoffe* (no. 95)

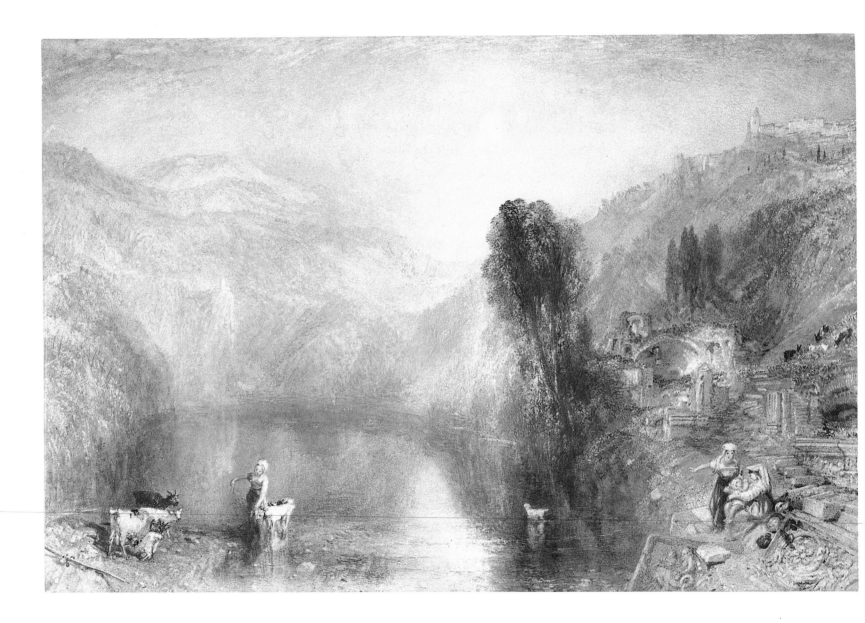

Plate 72 J.M.W. Turner *Lake Nemi* (no. 97)

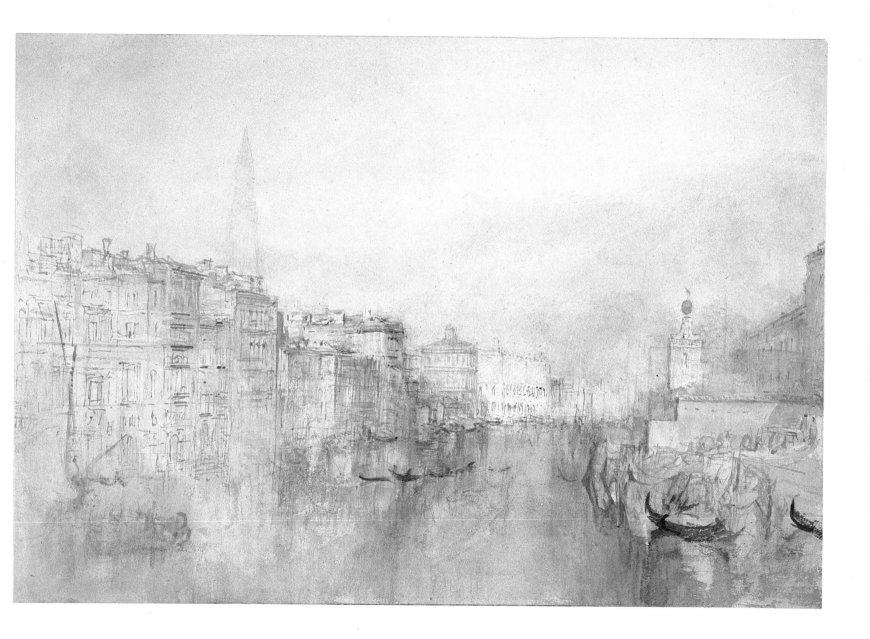

Plate 73 J.M.W. Turner *Venice: the Grand Canal, looking towards the Dogana* (no. 98)

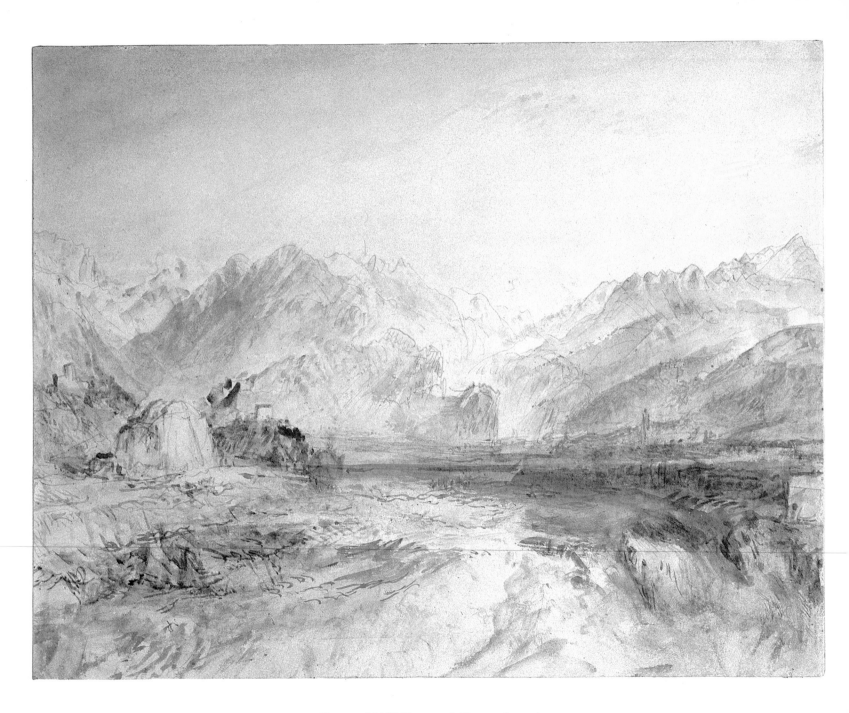

Plate 74 J.M.W. Turner *Bellinzona* (no. 99)

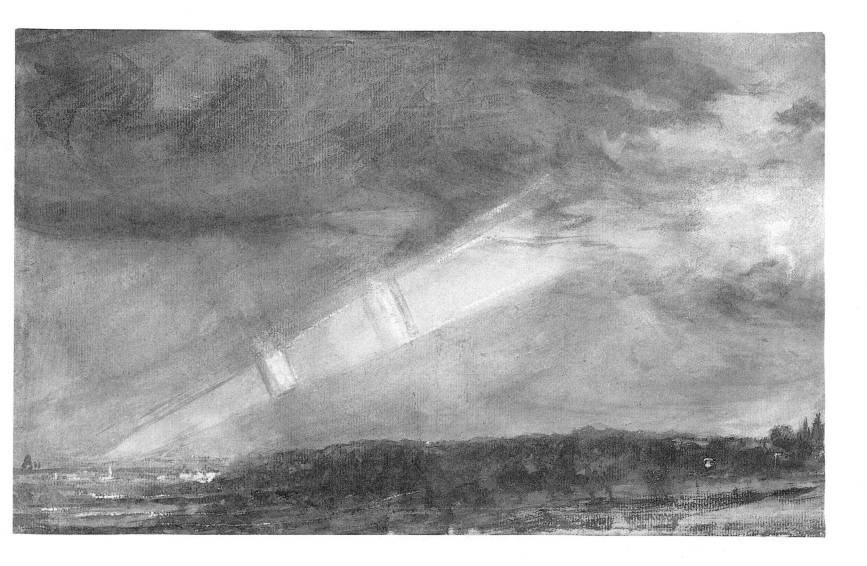

Plate 75 John Constable *London from Hampstead, with a double Rainbow* (no. 104)

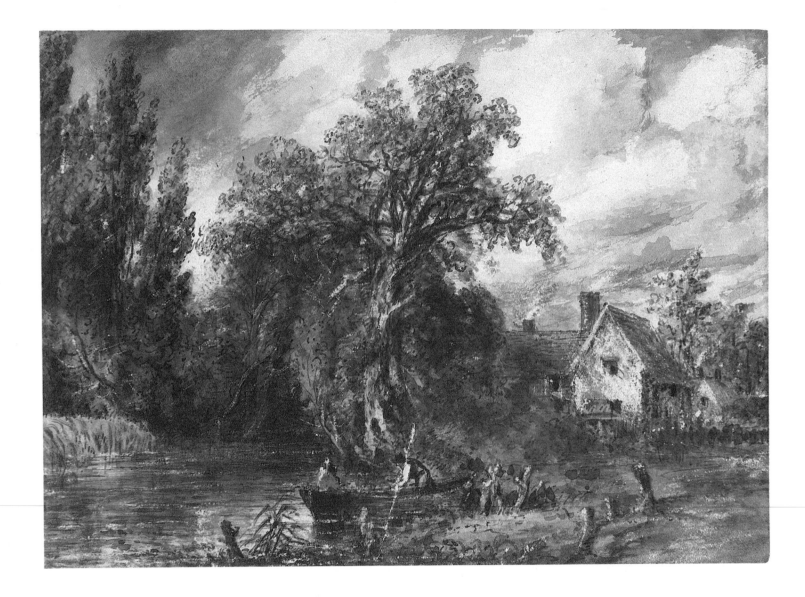

Plate 76 John Constable *A Farmhouse near the Water's Edge* (no. 105)

Plate 77 John Constable *Cowdray House: the Ruins* (no. 106a)

Plate 78 John Constable *Tillington Church* (no. 106b)

Plate 79 John Constable *Littlehampton: a stormy day* (no. 108)

Plate 80 John Constable *Folkestone Harbour, with a Rainbow* (no. 107)

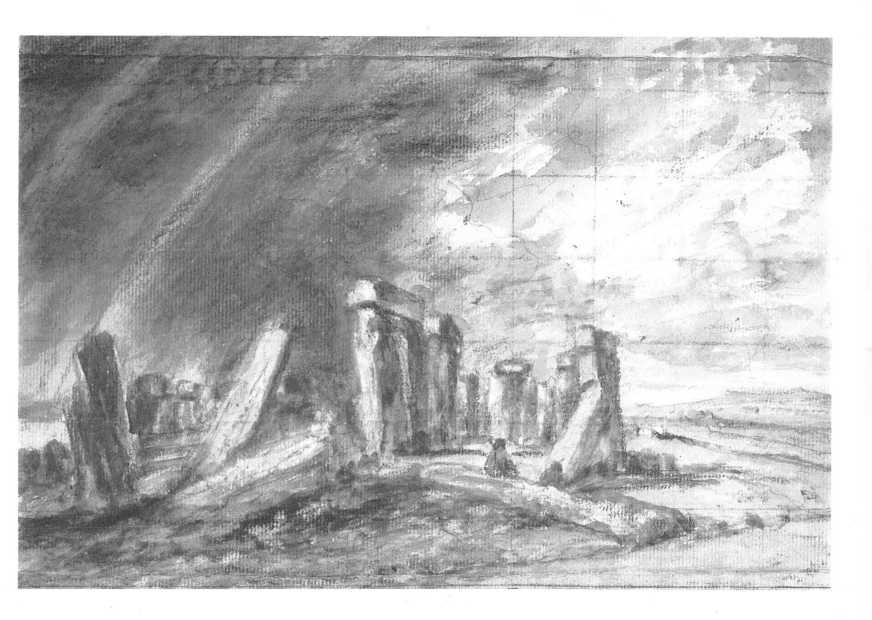

Plate 81 Constable *Stonehenge* (no. 109)

Plate 82 Cornelius Varley *Lord Rous's Park* (no. 111)

Plate 83 John Varley *Hackney Church* (no. 110)

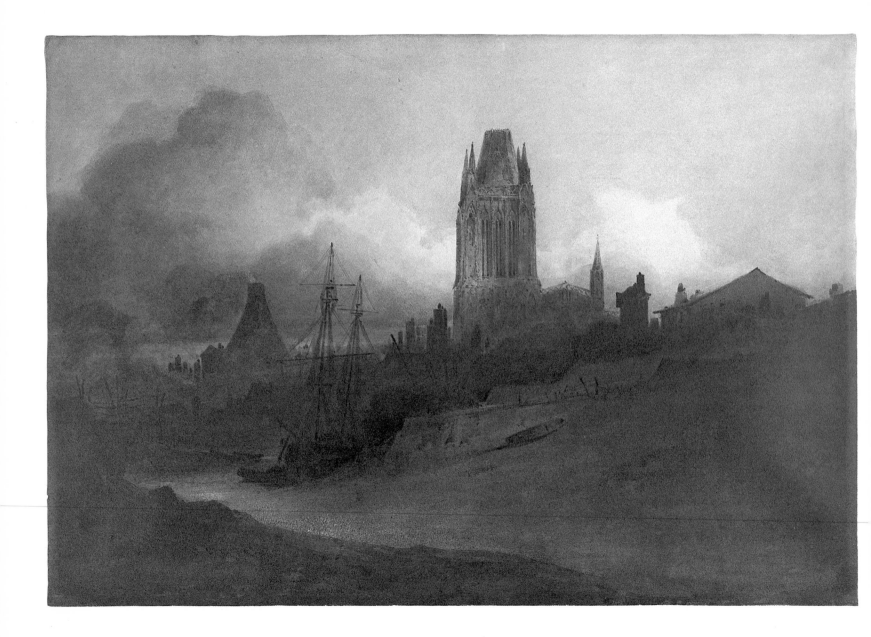

Plate 84 John Sell Cotman *St Mary Redcliffe, Bristol* (no. 114)

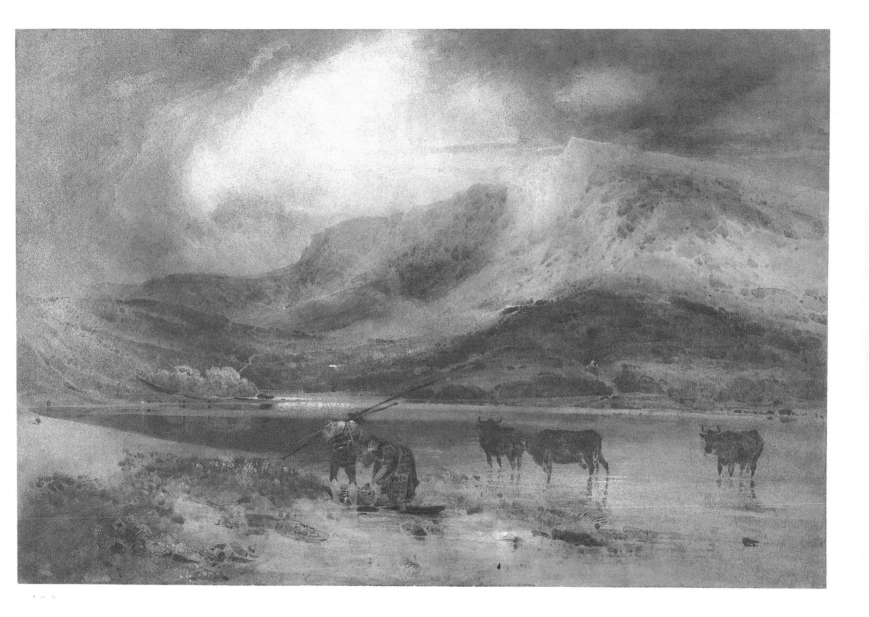

Plate 85 John Sell Cotman *Gormire Lake, Yorkshire* (no. 116)

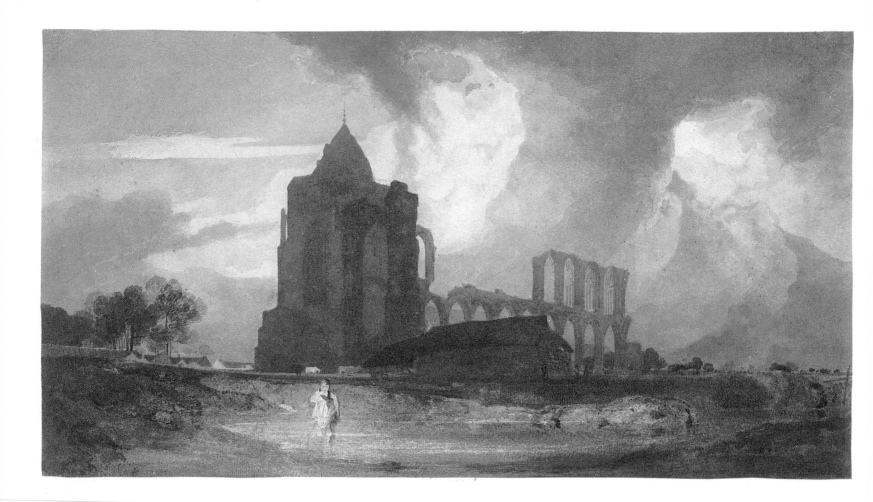

Plate 86 John Sell Cotman *Croyland Abbey, Lincolnshire* (no. 117)

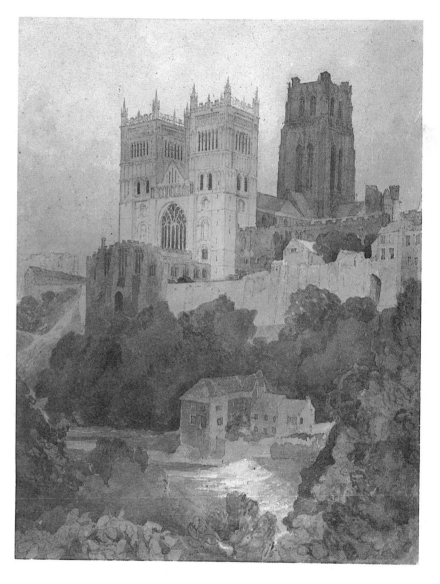

Plate 87 John Sell Cotman (left) *The Drop Gate, Duncombe Park* (no.118) (right) *Durham Cathedral* (no. 123)

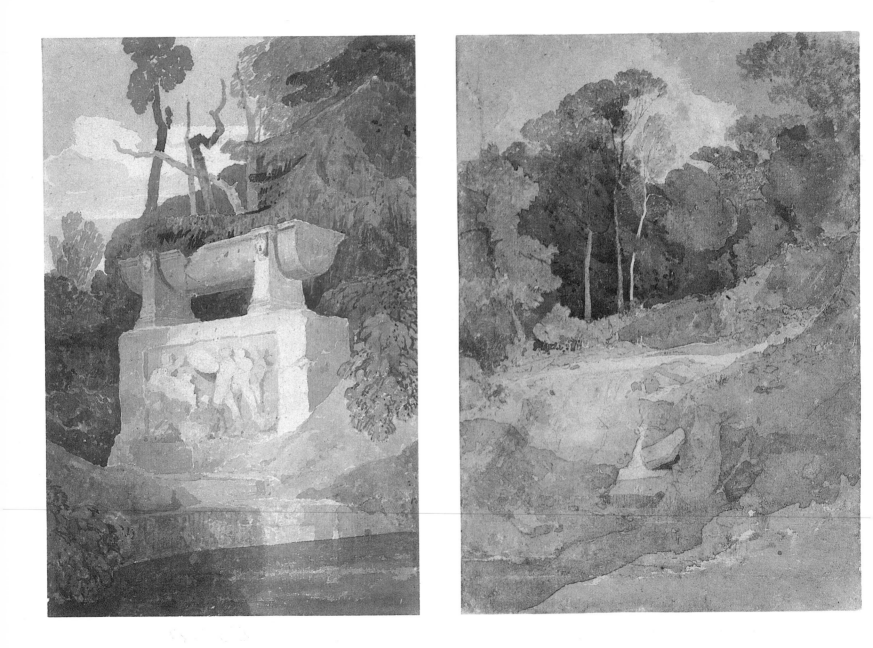

Plate 88 John Sell Cotman (left) *Composition: A Sarcophagus in a Pleasure-Ground* (no. 126)
(right) *Duncombe Park, Yorkshire?* (no. 119)

Plate 89 John Sell Cotman *The Schotchman's Stone on the Greta, Yorkshire* (no. 122)

Plate 90　John Sell Cotman　*Yarmouth River*　(no. 129)

Plate 91 John Sell Cotman *Fire at a Vinegar Works on the River Wensum* (no. 130)

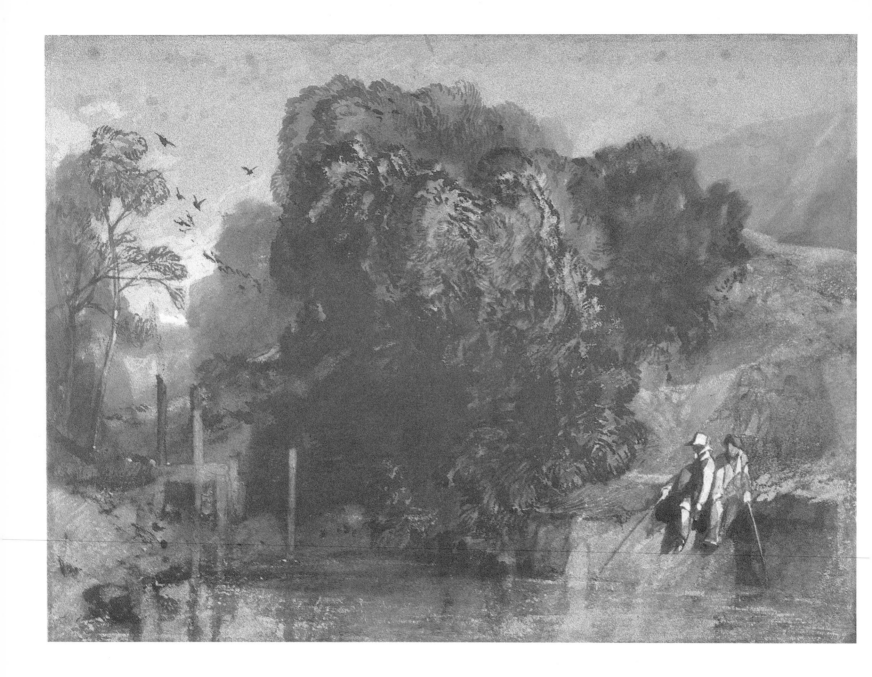

Plate 92 John Sell Cotman *Boys Fishing* (no. 133)

Plate 93 John Sell Cotman *A Mountain Tarn* (no. 131)

Plate 94 George Robert Lewis *The Valley of the Rocks, Lynton* (no. 135)

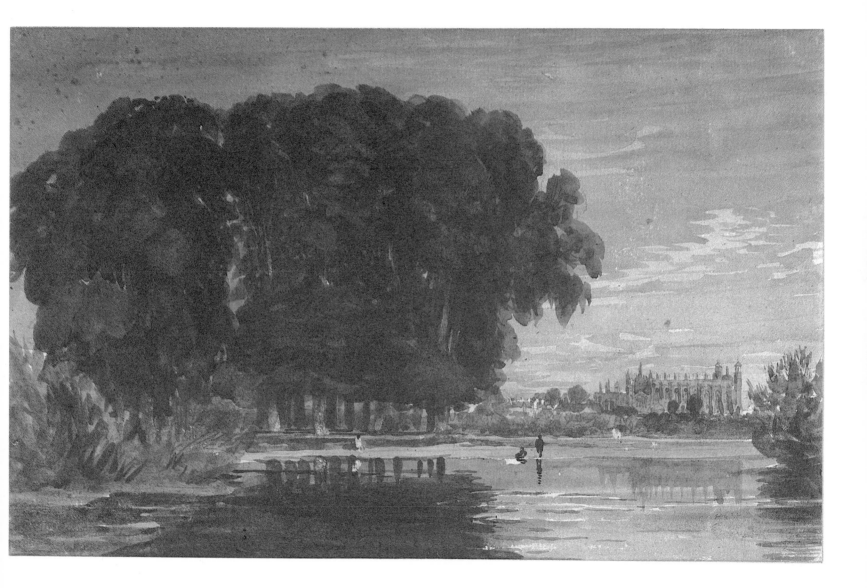

Plate 95 David Cox *The Brocas, Eton* (no. 137)

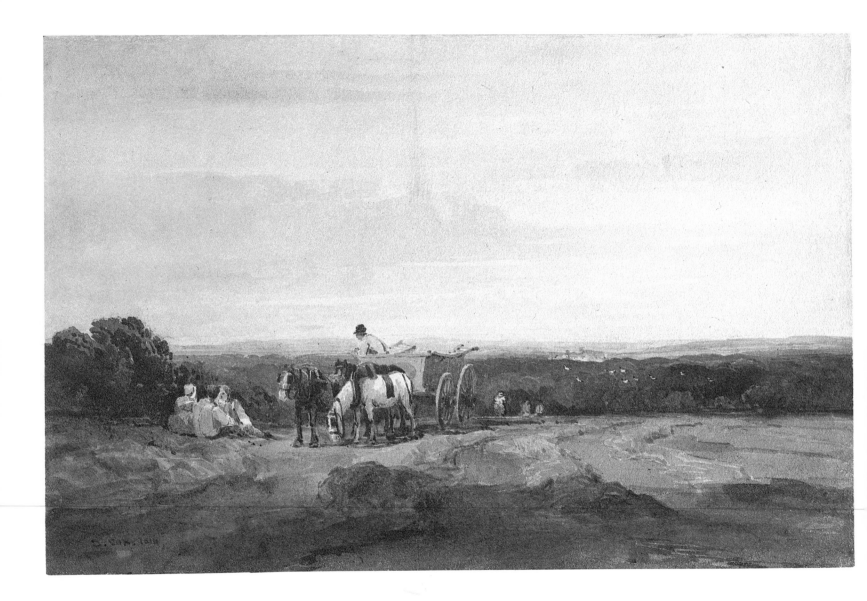

Plate 96 David Cox *A Cornfield* (no. 136)

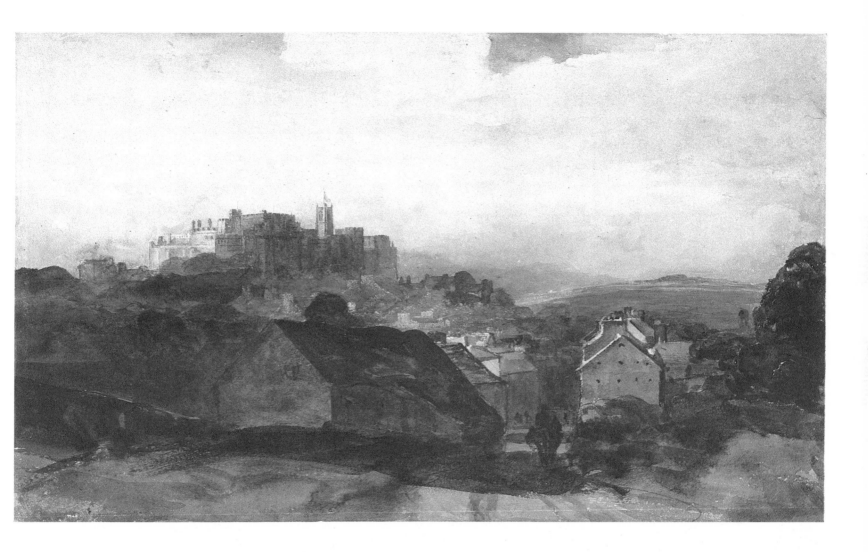

Plate 97 Peter De Wint *Lancaster* (no. 145)

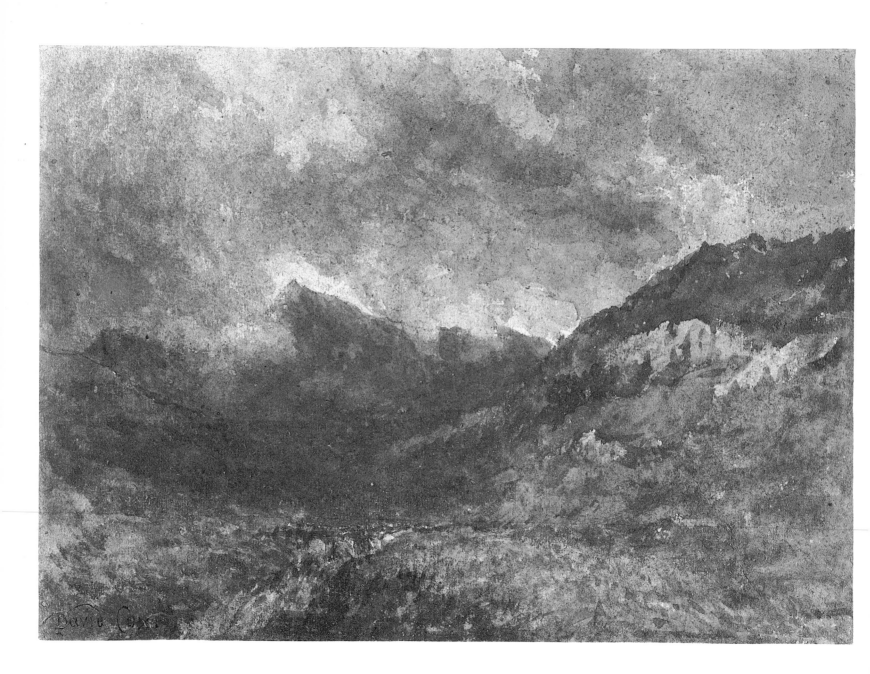

Plate 98 David Cox *Snowdon* (no. 139)

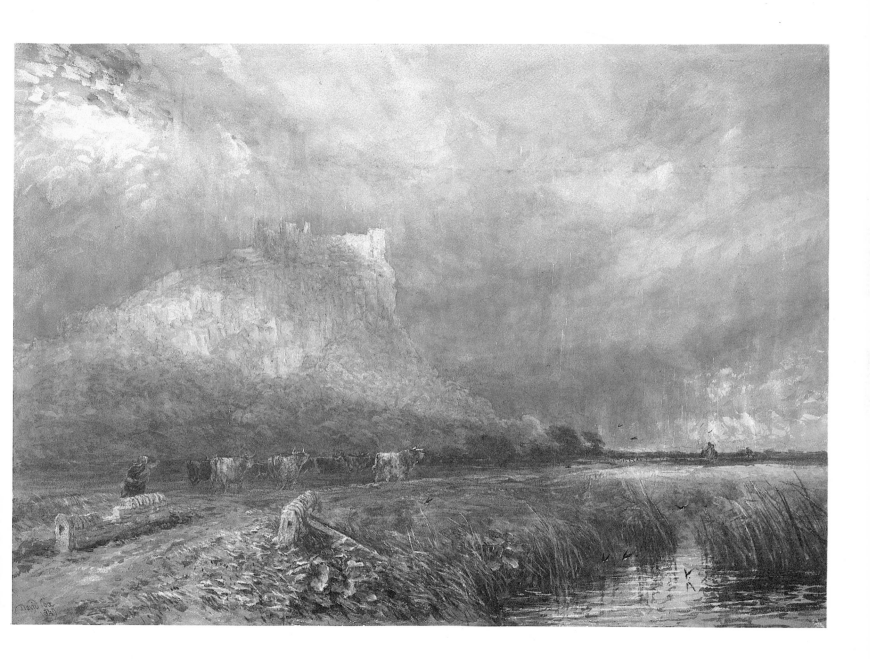

Plate 99 David Cox *Beeston Castle* (no. 140)

Plate 100 Peter De Wint *A Panoramic Landscape with a Donkey in the foreground* (no. 144)

Plate 101 Peter de Wint *Lincoln* (no. 146)

Plate 102 William Collins *A Cottage at Shedfield, Hampshire* (no. 147)

Plate 103 John Linnell *The Valley of the River Lea, Hertfordshire* (no. 153)

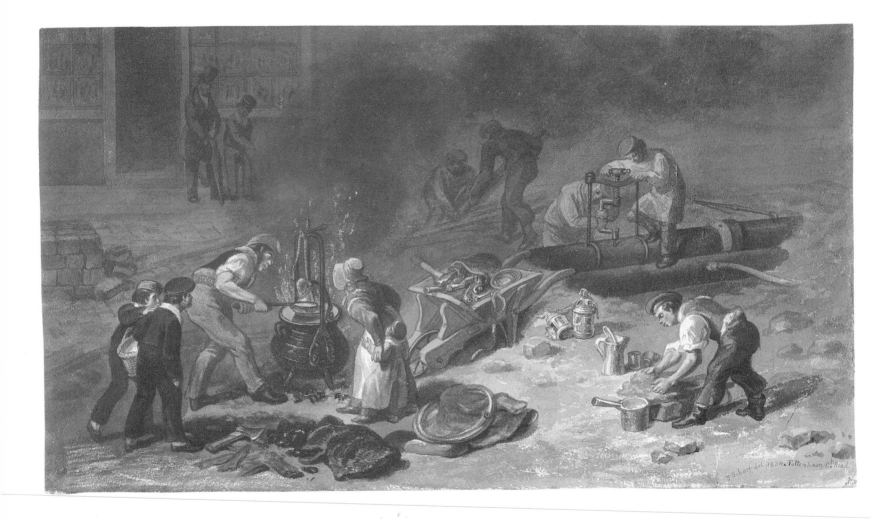

Plate 104 George Scharf *The Laying of the Water-Main in Tottenham Court·Road* (no. 148c)

Plate 105 George Scharf *Allen's Colourman's Shop, St Martin's Lane* (no. 148b)

Plate 106 William Henry Hunt *A Village in a Valley* (no. 151)

Plate 107 William Henry Hunt *Bushey Churchyard* (no. 150)

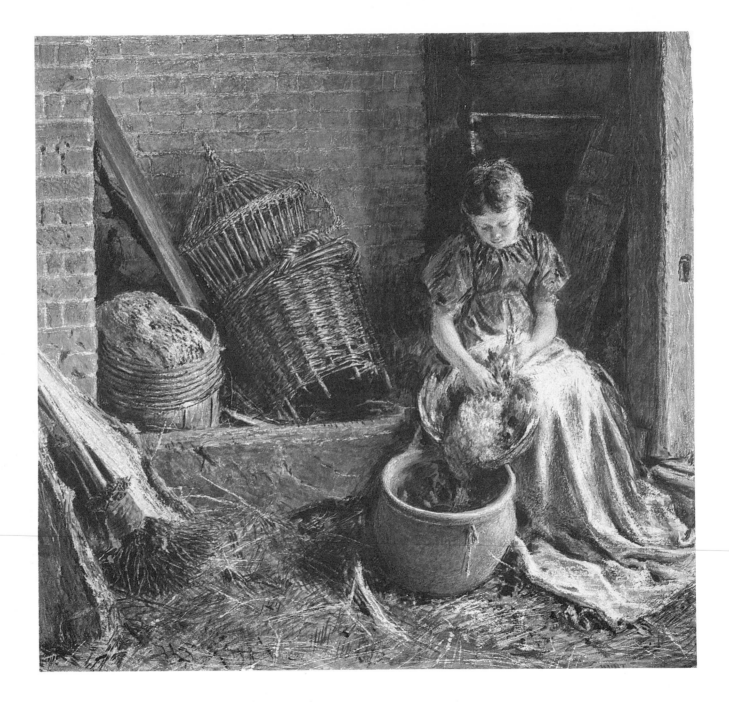

Plate 108 William Henry Hunt *Plucking the Fowl* (no. 152)

Plate 109 (left) David Roberts *The Interior of the Church of San Miguel, Xeres* (no. 157)
(right) Richard Parkes Bonington *Paris: The Institut seen from the quays* (no. 166)

Plate 110 Clarkson Stanfield *A Windmill near Fécamp, Normandy* (no. 154)

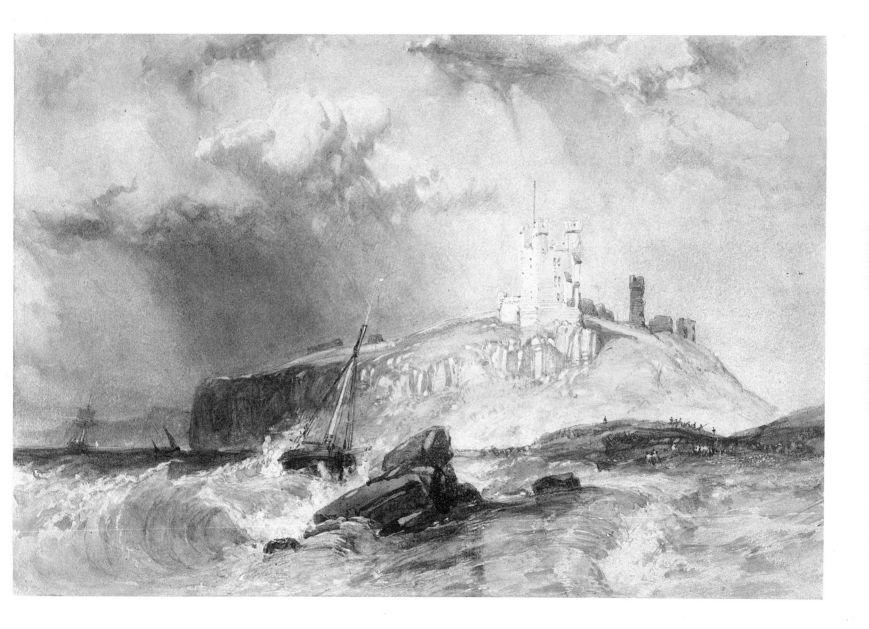

Plate 111 Duffield Harding *Dunstanborough Castle, Northumberland* (no. 159)

Plate 112 Joseph Stannard *The Beach at Mundesley, Norfolk* (no. 160)

Plate 113 Matilda Heming *A Backwater at Weymouth* (no. 168)

Plate 114 Richard Parkes Bonington
Rouen from the quays (no. 164)

Plate 115 Thomas Shotter Boys *The Boulevard des Italiens, Paris* (no. 167)

Plate 116 Richard Parkes Bonington *The Château of the Duchesse de Berri* (no. 165)

Plate 117　James Baker Pyne　*Shipyard on an Estuary*　(no. 163)

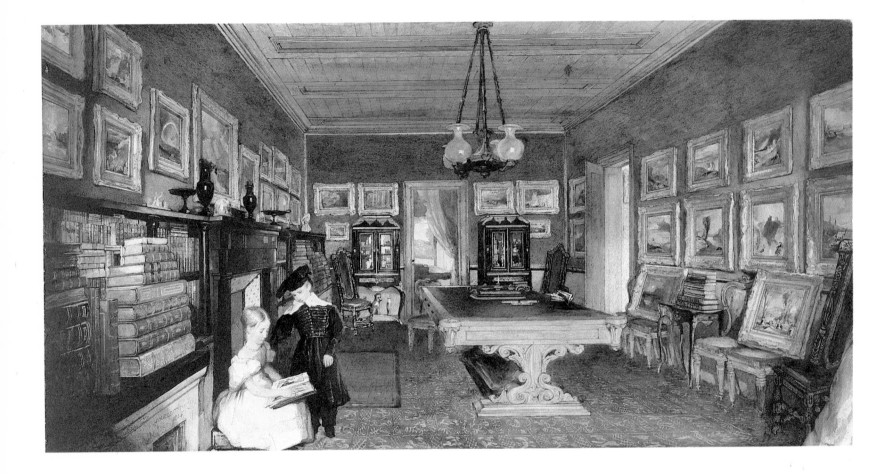

Plate 118 John Scarlett Davis *The Library at Tottenham, the Seat of B.G. Windus Esq.* (no. 169)

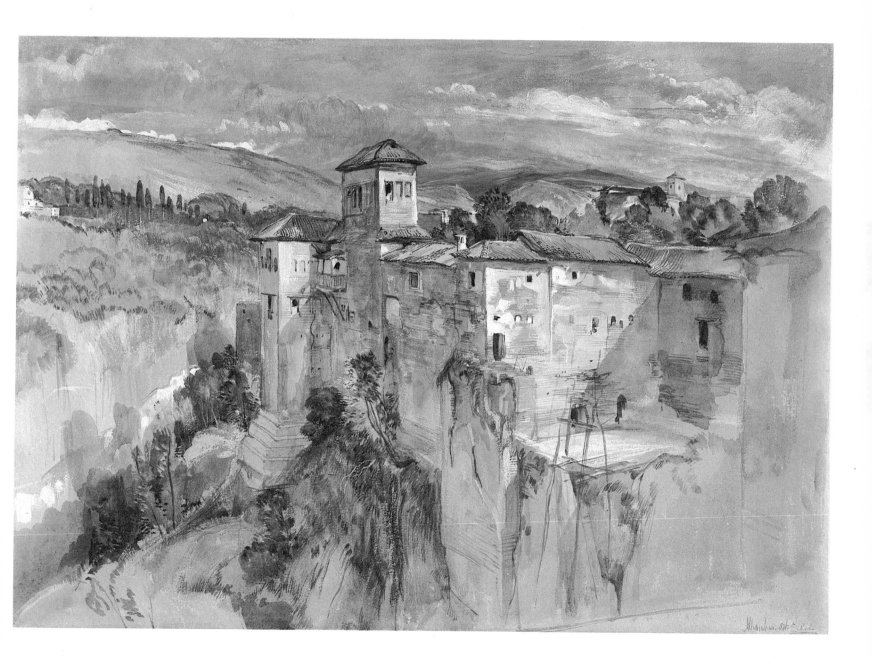

Plate 119 John Frederick Lewis *The Alhambra* (no. 171)

Plate 120 (left) Edward Lear *Choropiskeros, Corfu* (no. 179)
(right) William Leighton Leitch *S. Croce in Gerusaleme, Rome* (no. 170)

Plate 121　Samuel Palmer　*A Pastoral Landscape*　(no. 176)

Plate 122 Samuel Palmer *Leaves from the 1824–1825 Sketchbook* (no. 173)

Plate 123 Edward Calvert *A Primitive City* (no. 162)

Plate 124 Samuel Palmer *Tintagel Castle* (no. 175)

Plate 125 William James Müller *Tlos, Lycia, from the North-East* (no. 180)

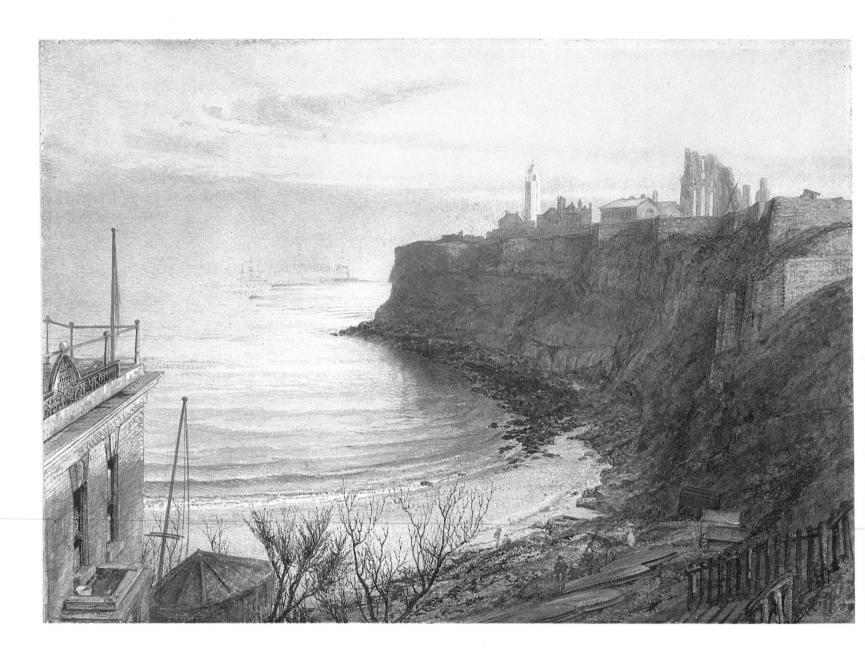

Plate 126 William Bell Scott *King Edward's Bay, Tynemouth* (no. 178)

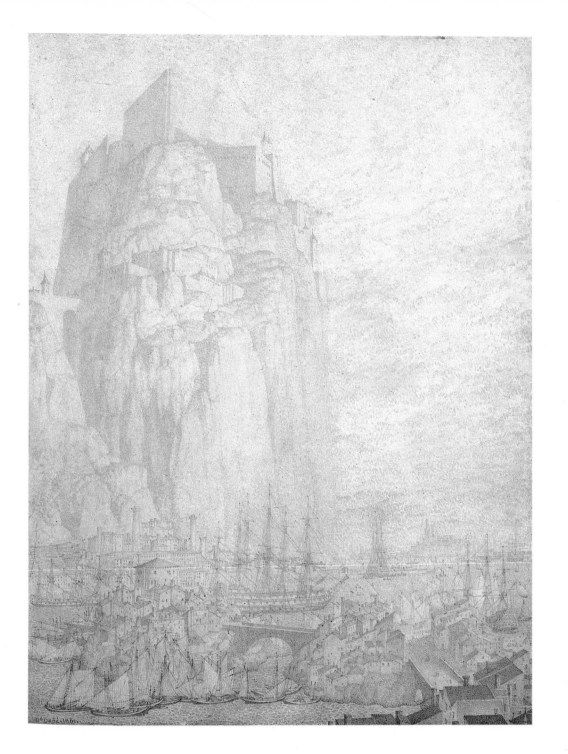

Plate 127　Richard Dadd
Port Stragglin　(no. 181)

Plate 128 Sam Bough *View of a Manufacturing Town* (no. 183)

Plate 129 John Ruskin *Fribourg* (no. 182)

Plate 130 William Simpson *Summer in the Crimea* (no. 184)

Plate 131 Richard Doyle *Under the Dock Leaves – an Autumnal Evening's Dream* (no. 185)

Plate 132 Myles Birket Foster *A Cottage Garden* (no. 186)

Plate 133 George John Pinwell *King Pippin* (no. 193)

Plate 134 George Price Boyce *Backs of some old Houses in Soho* (no. 189)

Plate 135 Dante Gabriel Rossetti *Writing on the Sand* (no. 191)

Plate 136 William Henry Millais *A Scottish Farm* (no. 190)

Plate 137 Alfred William Hunt *Dolwydellan Castle* (no. 192)

Plate 138 Frederick Walker *An Amateur* (no. 194)